Africa Lens

JACANA *Getaway* books

Getaway Books (a division of RamsayMedia Pty Ltd)
3 Howard Drive
Pinelands
7405
Cape Town

in association with Jacana Media Pty Ltd
10 Orange Street
Sunnyside
2092
Johannesburg

First published in 2009
Copyrights © in photographs: individual photographers as listed on page 144
Copyrights © in published edition: RamsayMedia

Publishers | Jacqueline Lahoud and Don Pinnock
Editor | Justin Fox
Sub-editor | Marion Whitehead
Production Manager | Sue Walker
Photographic research | Fatima Jakoet
Art Director | Rob House
Designer | Sandra Hansen

Reproduction by Virtual Colour, Cape Town
Printed and bound in Malaysia for Imago
ISBN: 987-1-77009-760-5

CONTENTS PAGE: African skimmers are frequently sighted on boat safaris from Mvuu Wilderness Lodge, Malawi. (2002)

Africa Lens

20 years of *Getaway* photography

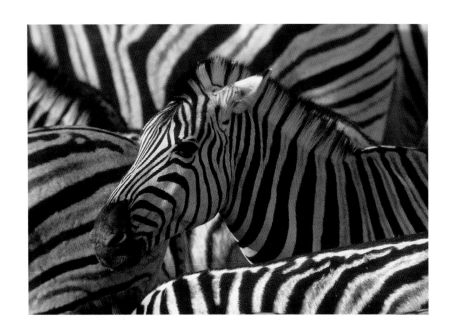

Edited by Justin Fox

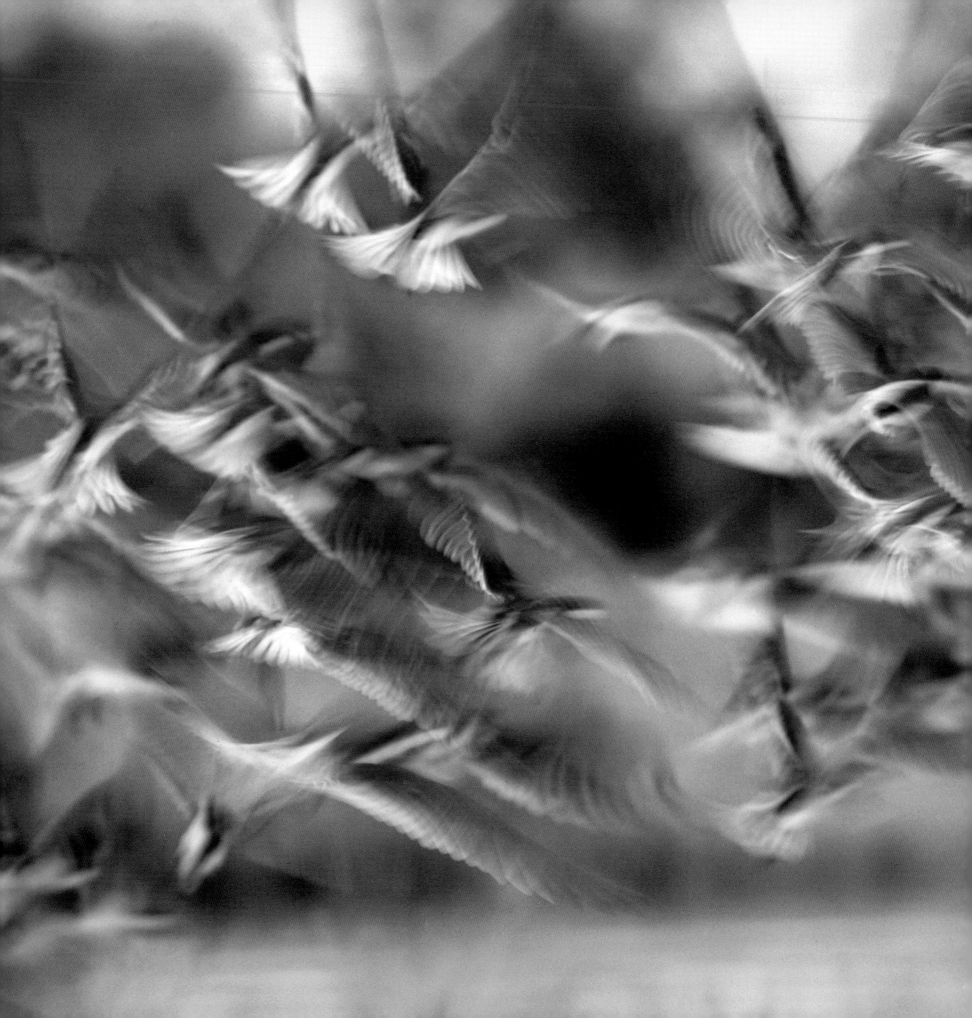

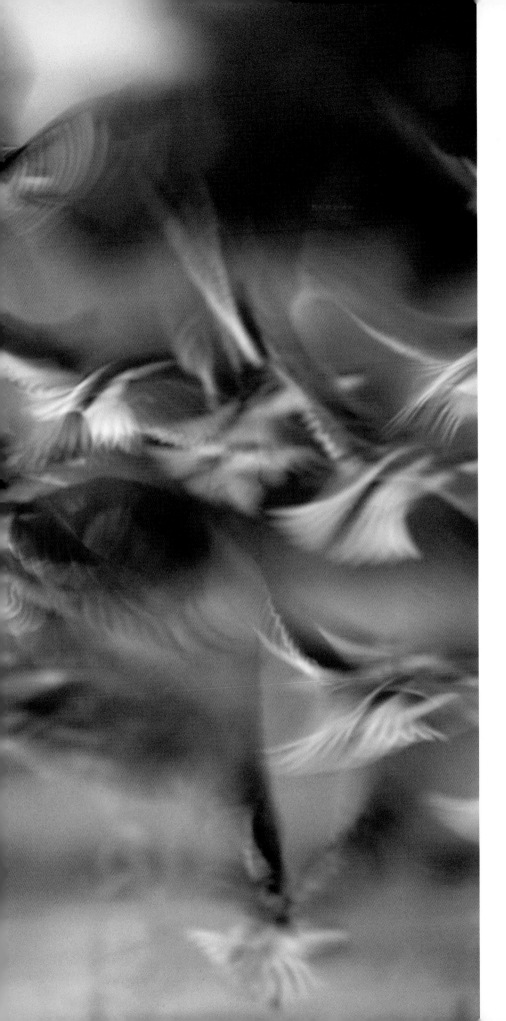

Contents

Introduction

The human need to travel and record what we see is a deep-seated impulse. Most travellers today don't budge without a camera. Our desire to view, capture and share our experiences is evident in more than a century of voracious travel photography. In Africa, there is probably no single entity that has produced as many varied images as *Getaway*. The magazine has portrayed the continent's people, fauna and landscapes in myriad indelible ways over the past 20 years.

Its journalists have built this enormous archive on journeys both near and far, into remote corners of Africa. Assignments for *Getaway* have found our photographers riding camels across the Sahara, being manhandled by gorillas in Rwanda, micro-lighting over the Victoria Falls or snowmobiling across the wastes of Antarctica. The photos brought back from these trips have become part of the bank of images through which Southern Africans perceive their continent.

Reintroducing Africa | *Getaway* was born at an auspicious time in South Africa's history, largely as a result of political developments. In 1989, FW de Klerk became president and announced the imminent unbanning of the ANC and release of Nelson Mandela. The country had been cut off from the continent during the latter stages of apartheid, but an era of reintegration was possible. Magazine company Ramsay, Son and Parker launched a travel publication that sought to reintroduce South Africans to Africa.

That period in our history also marked a profound shift in the photographic ethos of the country. During the 1970s and 80s, social documentary photography prevailed. Images were used as weapons in the struggle against apartheid. In the 1990s, local photographers needed to redefine their role. This resulted in a creative flowering and an engagement with postmodern and poststructural thinking. New causes were found; personal rather than political themes were explored; academic institutions encouraged conceptual and technical innovation. For *Getaway* journalists, who were somewhat removed from the mainstream, the political changes opened a window to discover the continent.

It's easy to find and photograph the bad in Africa. From famine and epidemics to civil war, the situation in the 1980s was particularly ugly on many parts of the continent. The magazine's goal, then, was to travel into Africa and celebrate the good we found, showing respect for subjects, capturing the picturesque, the traditional and the timeless, as well as recording the many new tourism ventures springing up and the growth of national parks.

Those first *Getaway* journalists were a new breed, armed only with cameras and curiosity. In their early ventures north, there was naivety and idealism, adventure and rich visual rewards. It was an exciting time to be working as a South African travel photographer.

Ways of seeing | The rules of *Getaway* photography were laid down by the founding editor, David Steele. He wanted bright, commercial images that showed the best places to go and things to do in Africa. Essentially, the early style imitated postcards and brochures.

The arrival of Patrick Wagner as senior photojournalist marked a change. Patrick had been a game ranger at Sabi Sabi and was a respected photographer in his own right, having just produced a fine book on the Otter Trail. His vision was more artistic and his passion for wildlife raised the bar, augmenting the traditional 'accommodation shots' *Getaway* was known for. During his decade at the magazine, he transformed the photographic ethic and, through his guidance and inspiration, propelled the team from being journalists who took pictures to a group of skilled photographers.

Many of the pioneering trips were led by Patrick, who returned with transparencies that became household images. After years cut off from the continent, his pictures of the Ethiopian highlands, the jade waters of Lake Turkana, cruising down the Nile or interacting with mountain gorillas were thrilling … and instrumental in making *Getaway* one of the most popular magazines in Southern Africa and the number one travel magazine in Africa.

Through the 1990s, the *Getaway* team continued to grow. Each photojournalist brought his or her own style and adapted the brief. Where Patrick loved underwater photography and the long lens, David Rogers had an affinity for portraiture, engaging with and revealing a particular empathy for his subjects. Cameron Ewart-Smith and Robyn Daly were known for their wildlife photography, Don Pinnock worked *contre jour* to great effect while Scott Ramsay became master of the self-timer.

Under the editorship of David Bristow, more experimentation was allowed and photographers became increasingly playful. Yes, the clichéd image of Table Mountain or a dozing lion was still required, but how could one reinterpret it? The introduction of more adventure sports into the publication saw journalists leaping out of aeroplanes, diving deep-sea wrecks, bungi jumping, scaling cliffs or white-water kayaking – always hanging on tight to their Nikons.

When Don Pinnock took over as editor in 2007, there was another subtle mind shift: journalists were to mould themselves as photographers who wrote, rather than the other way round. To this end, more space and a larger format were used to emphasise the journalists' photography. A dedicated Big Picture page was introduced and portfolios of in-house photographers were encouraged, as opposed to those of freelancers.

Learning curves | Over the years, the magazine's style evolved and everyone on the team has relished the learning environment. Working at *Getaway* is, in a sense, one long photographic workshop. In the early days, it was Patrick who pioneered the innovations, but others took his place. Getaway Gallery, a monthly showcase of

the best of our readers' photographs, has always been a source of inspiration and tension. Trying to keep up with their steady flow of breathtaking images has served as a useful spur. As Gallery was once the only place local photographers could have their work regularly published, it attracted many of the big guns in travel and nature photography. An extension of this has been *Getaway*'s involvement in the Agfa and Fuji Photographic Awards. We have become sponsors, taking part in the judging and publishing the winners.

Then there have been the regular portfolios and photographic series which have presented the work of some of the best photographers on the continent, often accompanied by useful tips. Dereck and Beverly Joubert, Frans Lanting, Daryl Balfour, Roger de la Harpe, Nigel Dennis, Obie Oberholzer, Herman Potgieter, Richard du Toit, Michael Poliza and many more have made their mark in the pages of the magazine.

In recent years, the change from film to digital has had a profound impact on our photography, although experimentation has always been part of the deal at *Getaway*. In the early days, there was much discussion around which film to use (before settling on Fuji Velvia), what ISO rating to employ and how much you could push different films in low light. Photographers had to become comfortable with every kind of situation: from studio shoots with models to underwater work and from wildlife to food pack shots. The shift to digital, pioneered by Don Pinnock and Robyn Daly and long resisted by the old guard like myself, changed the way we shoot and the way we see things. However, the '*Getaway* style' remains more or less the same and there is still a resistance to overt manipulation. Truth to subject remains the ideal.

On assignment | Every *Getaway* assignment is unique and each one poses different photographic challenges. Journalists have to be jacks of all trades, able to shoot a wide array of subjects in every kind of condition. To this end, they need to pack the right kit and come prepared. Do they need long lenses for wildlife, macro for food shots or details, underwater equipment or dry bags for water sports?

Conditions may not always be as taxing as those noted by Thomas Baines during his travels to Namibia and Victoria Falls in 1864: 'As for the difficulties in the way of a photographer, their name is legion … the impossibility of procuring clean water – the different conditions of atmosphere and intensity of the sun – the constant dust raised by our people or the wind, the whirlwinds upsetting the camera, and no end of other causes – combine to frustrate the efforts of the operator, and oblige us … to condemn many and many a picture.' (*Explorations in South-West Africa*, London, 1864, pp 148-9)

Although procuring clean water for washing photographic plates is no longer a concern, dust, salt water, insects, brutal baggage handlers, jouncing 4x4s, a lack of electricity, amorous camel drivers and the like often make working in remote parts a tricky affair.

Getaway photographers need to be flexible and resourceful. If there's no model, put the camera on a tripod, set the self-timer and shoot yourself. If it's raining, photograph interiors. No animals? Work the bugs and flowers. Getting 'the shot' might require waiting at a waterhole all day or swimming to an island holding the camera above your head. At times it can seem mechanical and routine as you struggle to make do with limited time, light and equipment; at others you're gripped by the moment or the scene and throw all your energy and creativity into capturing its essence. Whatever happens, the rule is that no-one comes home without a bag of publishable shots.

If a cover image is required from an assignment, the pressures are greater. In the early days, the cover was simply one of the better shots in your selection. Today, most of those images would end up in the bin. Shooting covers has become a complicated business – so much rides on them. There's lively competition among *Getaway* photographers (Patrick wins hands down with 39 covers; I'm a distant second with 30). Many hundreds of images in dozens of locations go into the making of a cover and the debate as to what will or won't sell is hotter than ever.

The lengths photographers have gone to and the corners they've found themselves in vary greatly. Cameron Ewart-Smith broke an ankle while trying to shoot mountain climbers on Namibia's Spitzkoppe, David Bristow had his canoe tipped over by an angry hippo and lost his entire camera kit, I was shot at by poachers in Zimbabwe (my Nikon proving no match in returning fire), while Robyn Daly dislocated a shoulder while being photographed lassoing from a galloping horse. Only after its third submersion in water did Jazz Kuschke's Nikon D200 finally give up the ghost. Between us, we've been ambushed by Ethiopian beggars, trodden on by elephants, arrested by stoned boy-soldiers with AK47s, stalked by buffaloes and chased down a beach by the Libyan antiquities police.

The costs have also been high. The most tragic incident was a plane crash in the Ngong Hills outside Nairobi which saw the deaths of Patrick Wagner and three *Getaway* associates (Roland Geiger, Herman Potgieter and Anton Scheepers). Apart from the great loss to South African photography, it served as a reminder of the risks associated with travelling and shooting in Africa. The highs are very high, but the lows can be disastrous.

Armchair Africa | *Getaway* has recorded the changing way middle-class Southern Africa has viewed itself in relation to travel and to Africa. It has excited the armchair traveller and inspired the adventurous to explore the continent. More than any other publication, it has captured the spirit of African travel, reaching millions of readers over the past two decades. The magazine has covered most of the great African subjects: the Serengeti migration, Mali's mud cities, the Namib's many moods, gorillas in the leafy mist, orthodox liturgies at Lalibela and Namaqualand's spring blooms. It has also recorded how things have changed: the glaciers on Kilimanjaro have shrunk with each of our ascents; Cape Town's Waterfront transforms itself in every successive aerial shoot; where Mozambique's parks have risen from the depredations of civil war, Zimbabwe's have sunk into disuse.

Getaway's images have provided a photographic passport to Africa. The vision is, perhaps, nostalgic. It's a celebration of the diversity of the continent, as opposed to the homogenising influences of globalisation, and a veneration of that which makes Africa great. Whether it be faces or places, landscapes or wildlife, it is a showcase of beauty … and a warning about the potential losses that global warming, unchecked development, corruption and human greed can wreak. By showing the good and the sublime, *Getaway* images seek to inspire an ethic of conservation in all its forms.

Photographs from our archive have, over the years, worked their way into almost every media avenue. From billboards to television and from coffee-table books to commercials, they are embedded in the South African memory. Never intended as art, the best of these pictures nonetheless have artistic merit, conveying an essence that goes beyond the merely illustrative.

As with good travel writing, a successful photographic assignment is one in which the journalist has captured the *genius loci* – the spirit of the place. It's often an indescribable and elusive element: a mood, a familiar scene rendered somehow unfamiliar, perhaps a fleeting moment where light and subject conspire in the viewfinder to give you something … more. The pictures reproduced in this book are just such moments.

Justin Fox
Cape Town
July 2009

African
Portraits

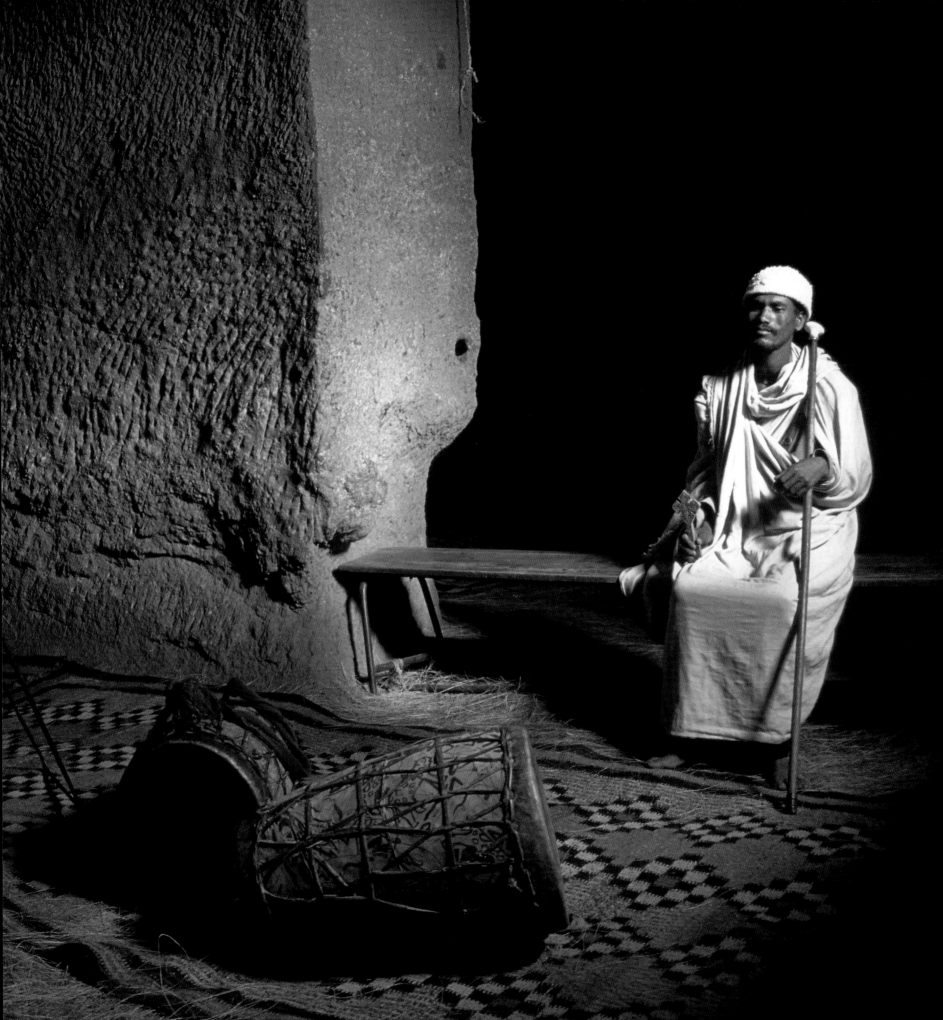

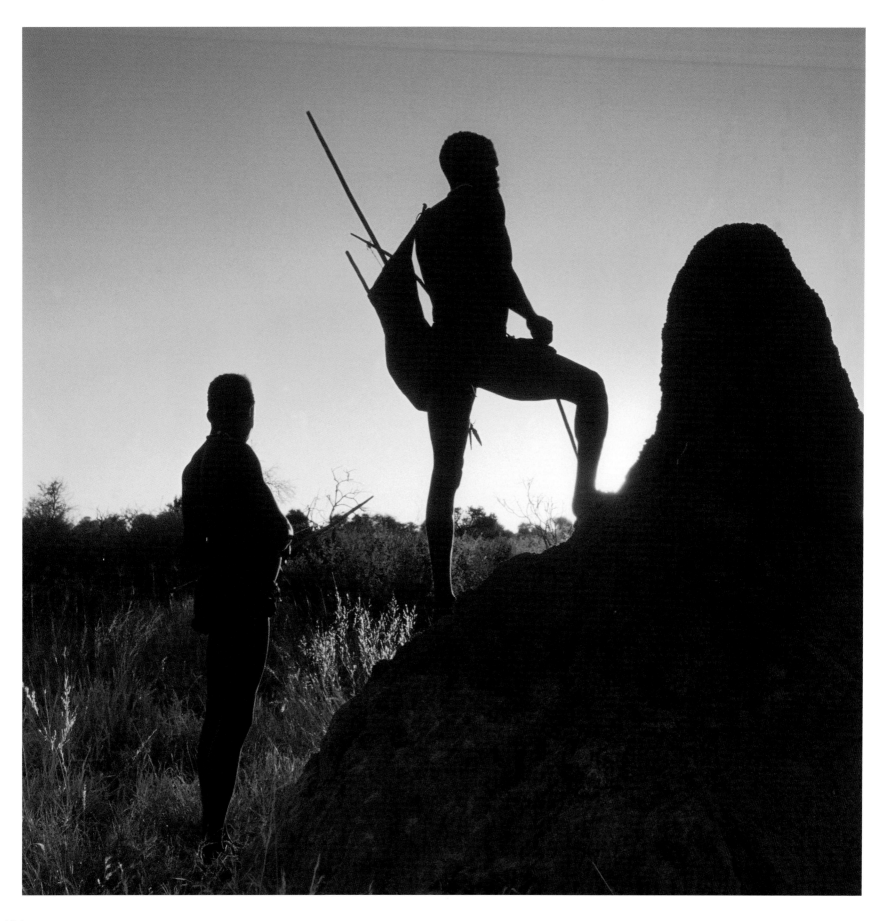

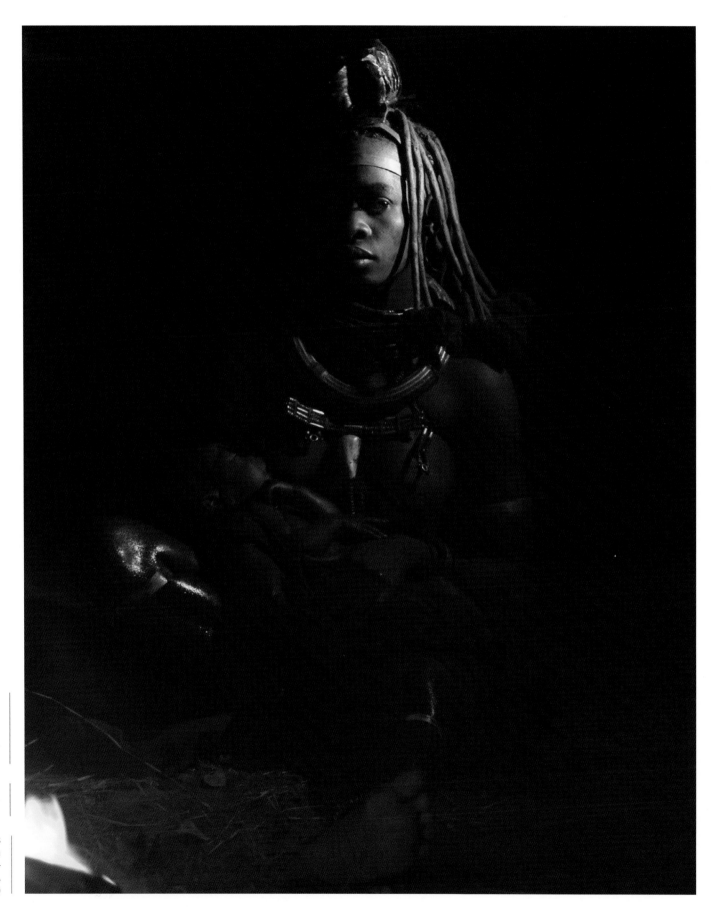

RIGHT: There are only around 7 000 Himba left in northern Namibia and southern Angola. They seem like dream people from another age whose way of life is passing. (2007)

OPPOSITE: Tracking with Naro Bushmen in the central Kalahari. (2002)

PREVIOUS SPREAD: Priests conduct services or sit in contemplation in the rock-hewn churches of Lalibela, Ethiopia. (1998)

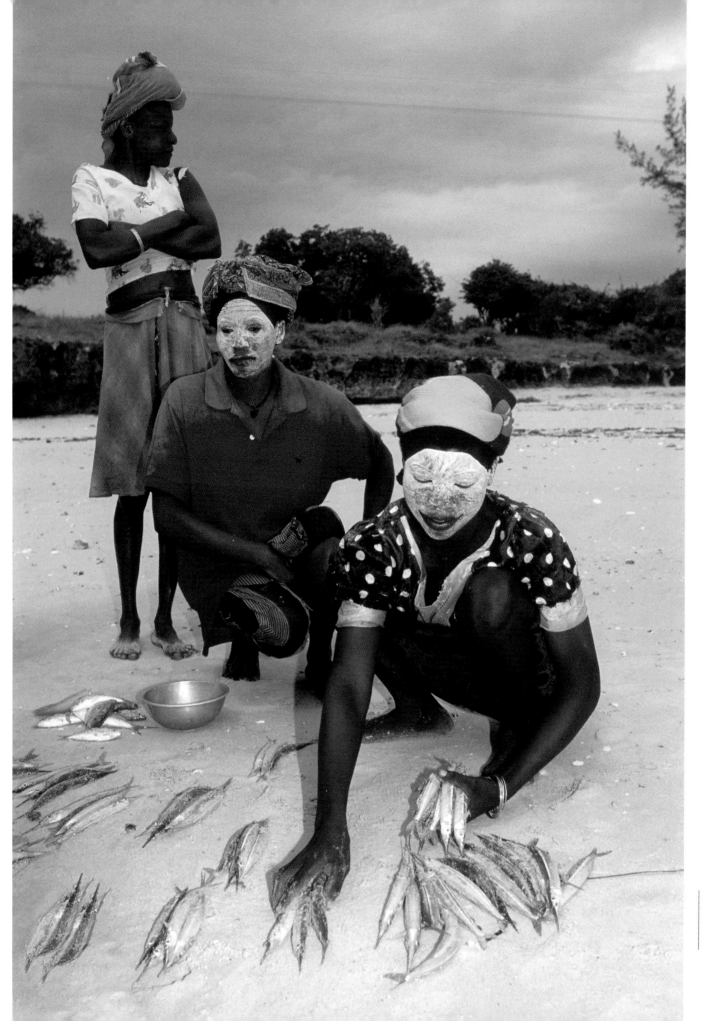

Makua women, their faces smeared with *nciro* paste, divide up the catch on Pangane Beach, northern Mozambique. (2000)

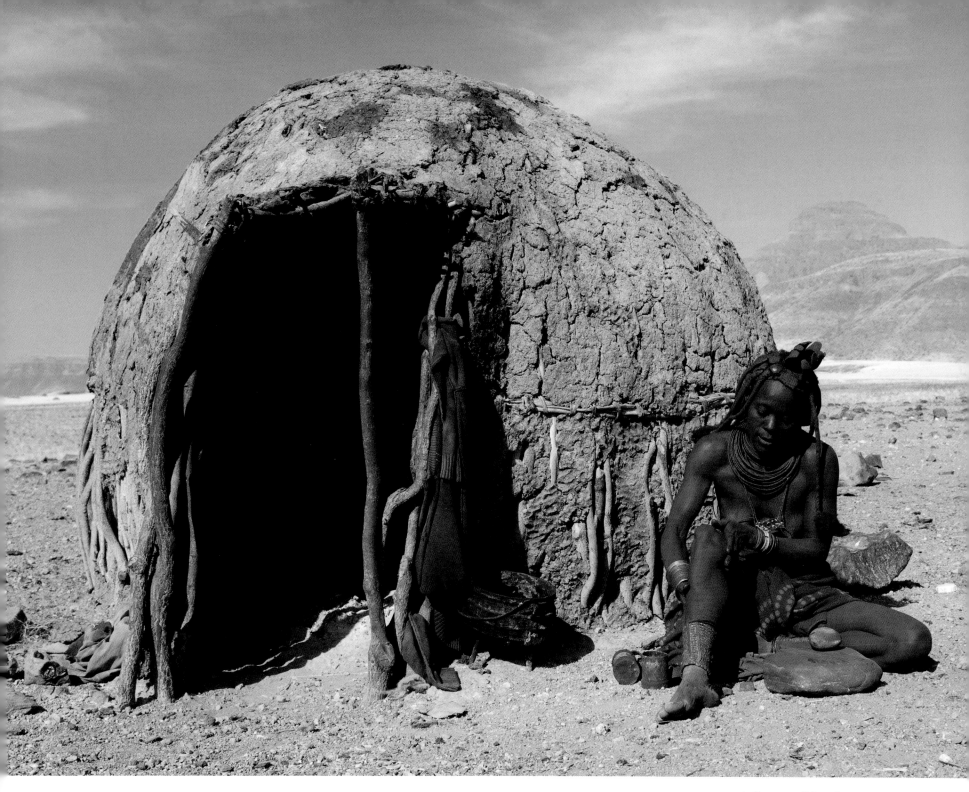

Kuangara Chipombu smears ochre onto her skin in the traditional Himba manner in the Khumib Valley, northern Namibia. (2009)

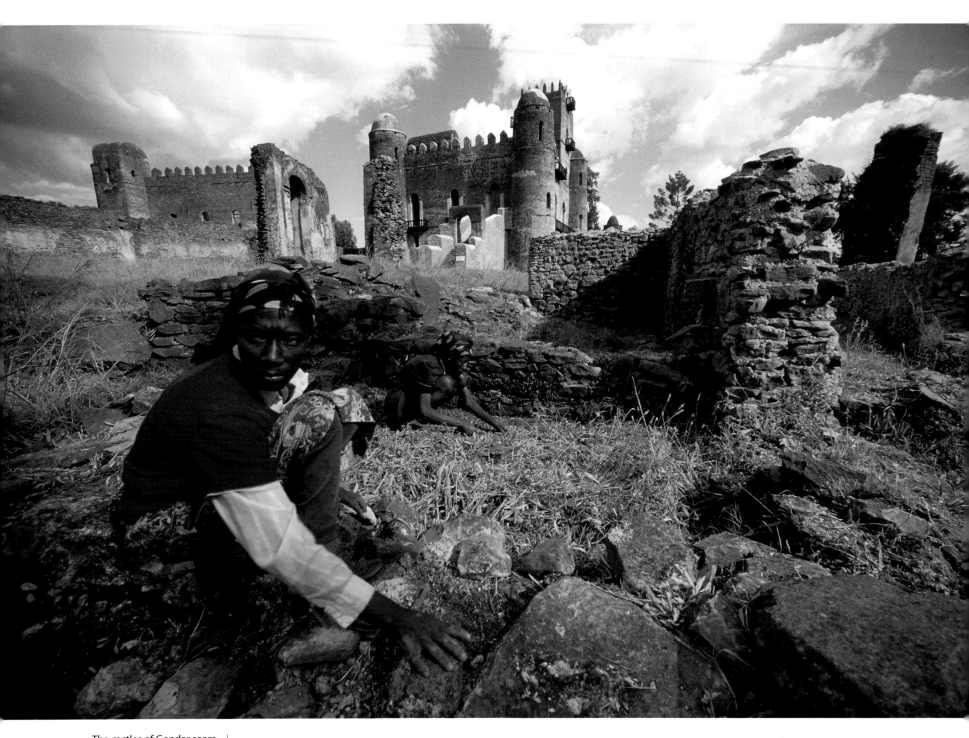

The castles of Gondar seem to have more in common with King Arthur and his knights than the Ethiopian highlands. (1998)

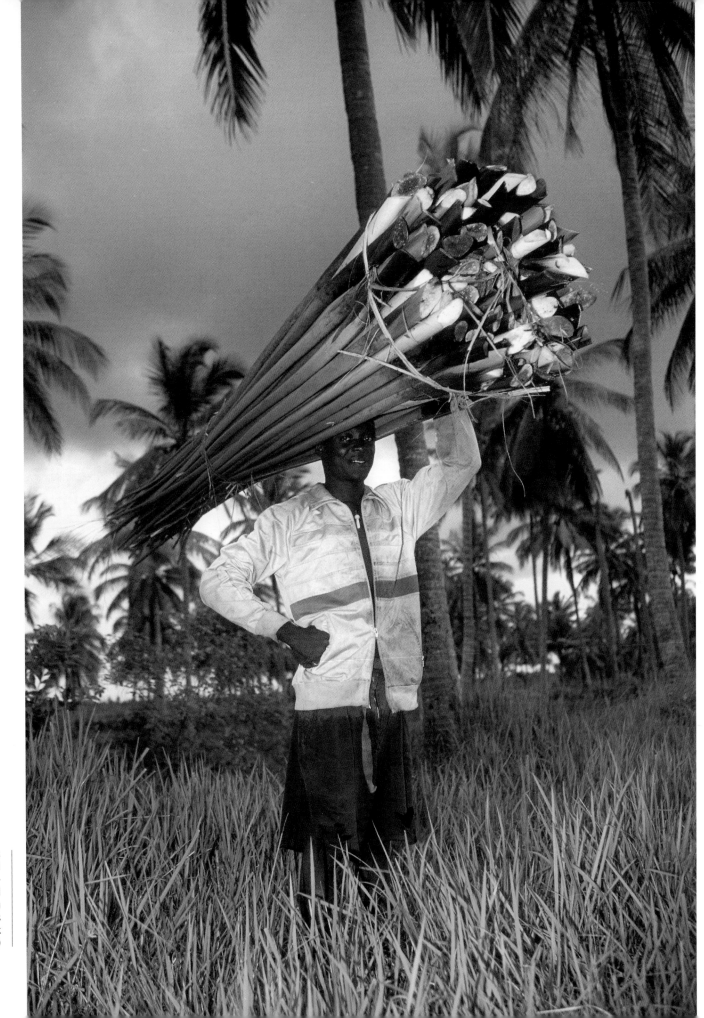

Coconut palms stretch as far as the eye can see round Quelimane in central Mozambique. The fronds are pruned regularly to make bedding and screens; the coconuts are collected for their milk and flesh. (2000)

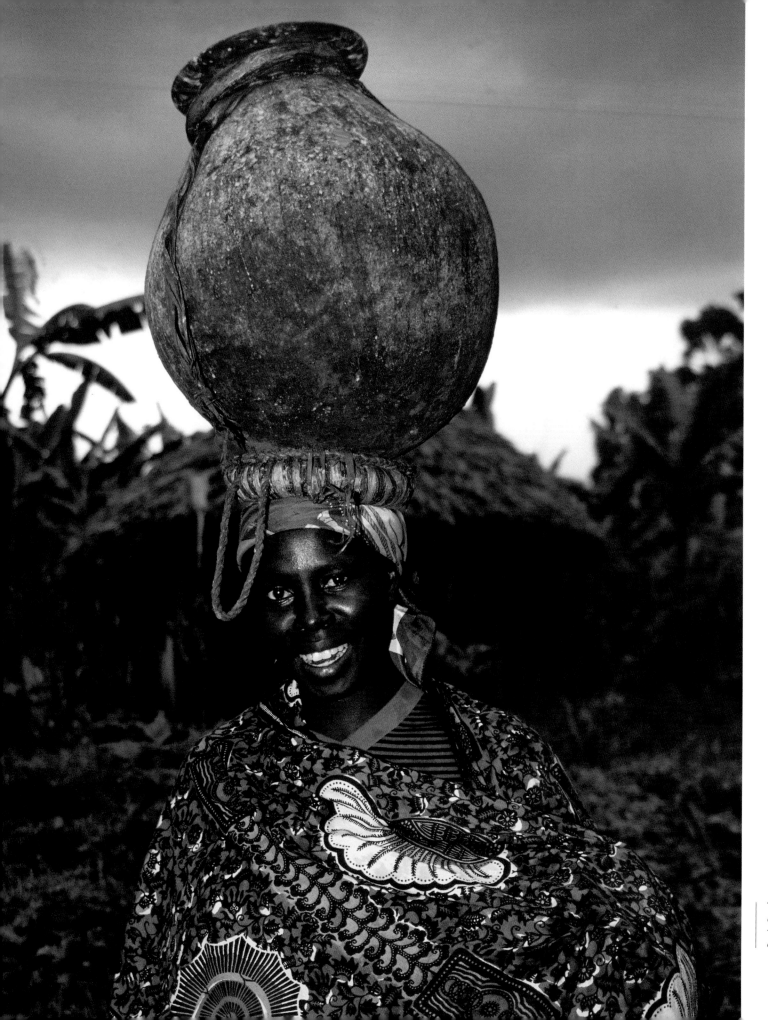

This fieldworker was photographed just outside Kisoro in the southwestern corner of Uganda. (1994)

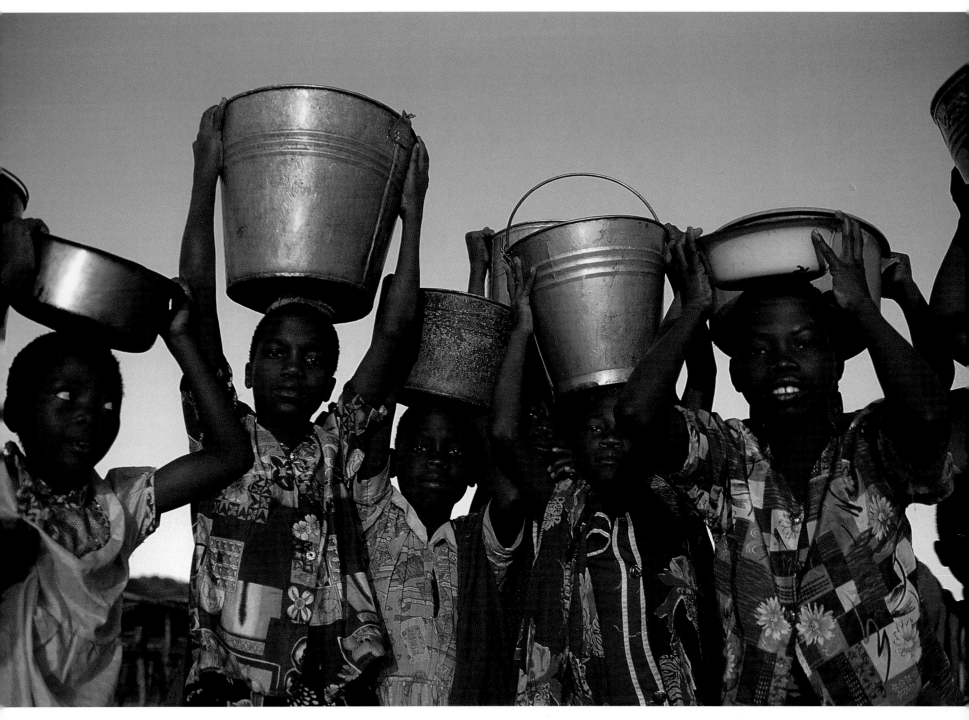

It's tricky taking pictures of just one child in an African village, so David Rogers told these kids he wanted to photograph only the girl with the bucket on her head. That's when they all fetched buckets. (2001)

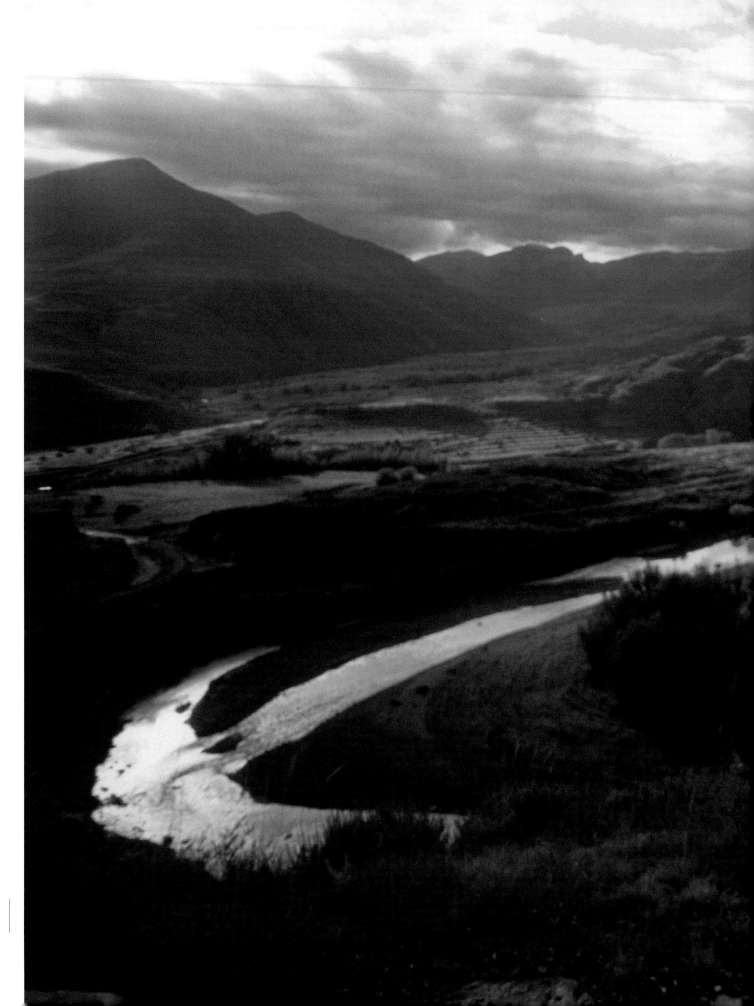

A Basotho horseman rides up the Makhaleng Valley near Ramabanta, Lesotho. (2005)

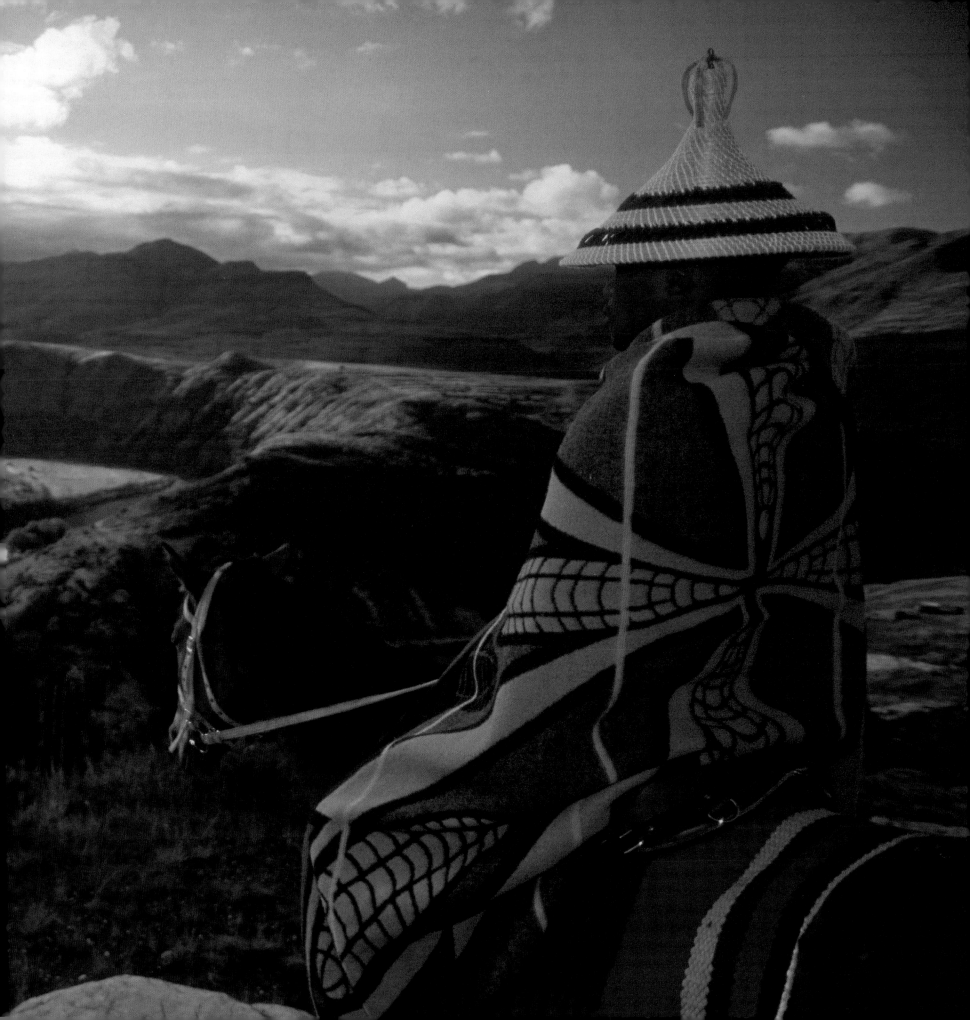

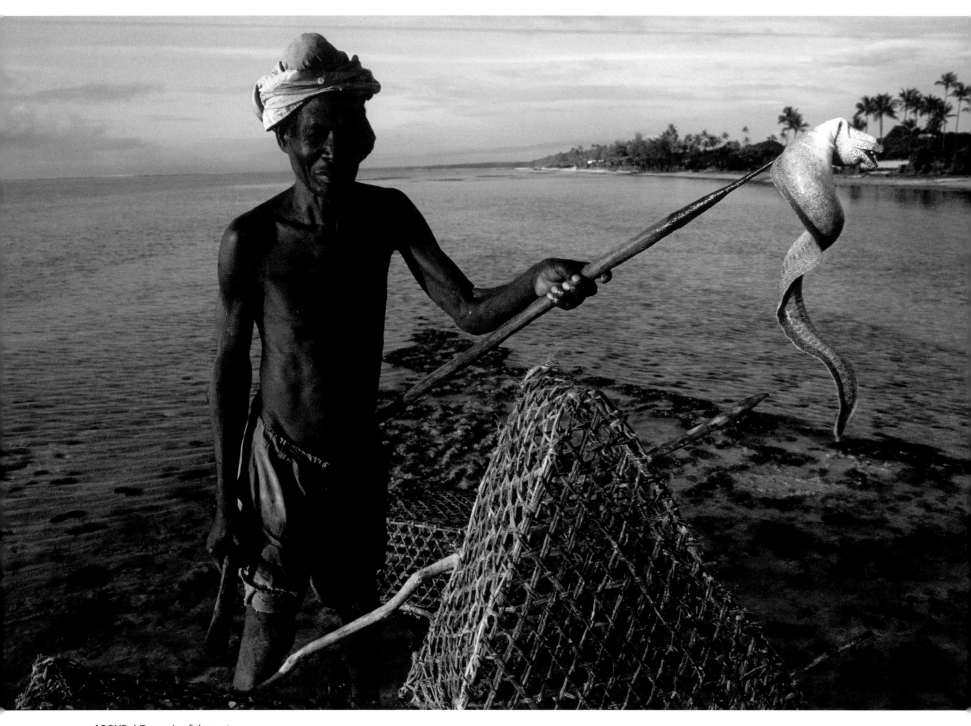

ABOVE: A Tanzanian fisher-
man holds up his moray eel
catch near Matemwe on
Zanzibar. (1998)

OPPOSITE: The palm-weave
collar on this Samburu woman
in northern Kenya signals
her married status. (1996)

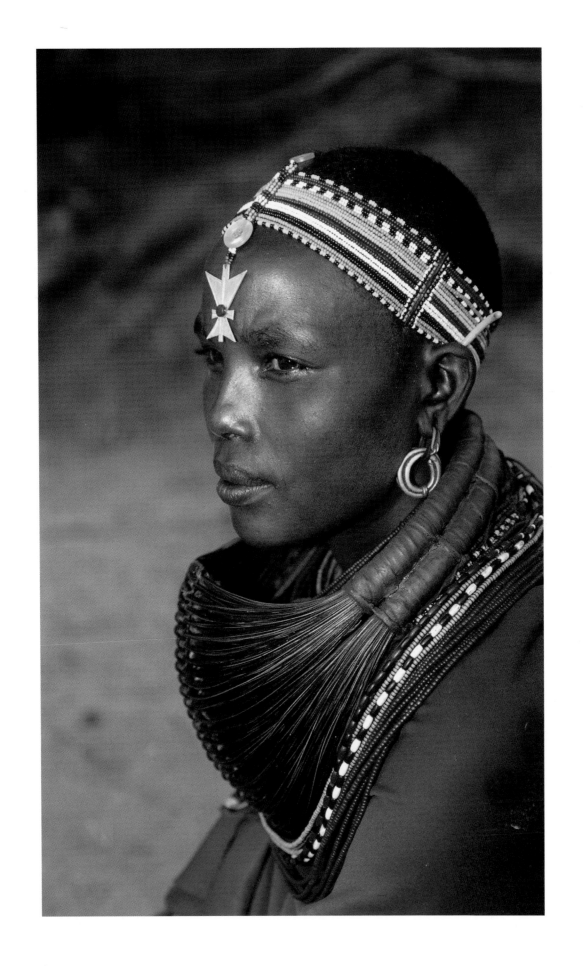

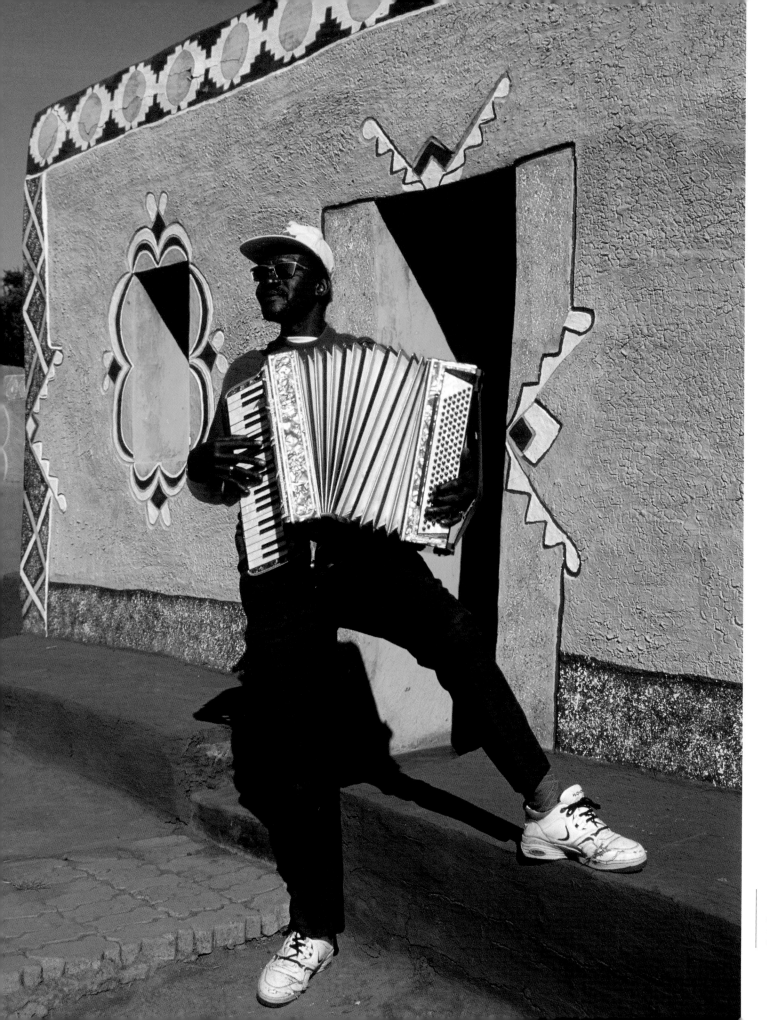

Resident musician Johannes Motsoari gives visitors a taste of local music outside the Basotho Cultural Village in the eastern Free State. (1996)

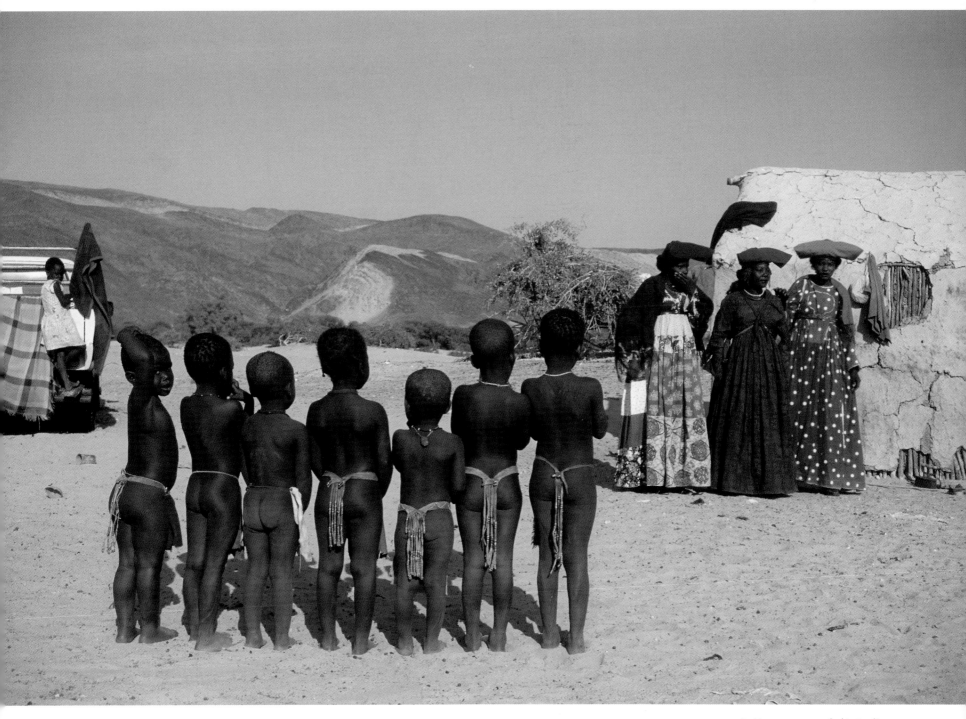

Herero women clad in traditional Victorian-style dresses near Purros, Namibia. (1997)

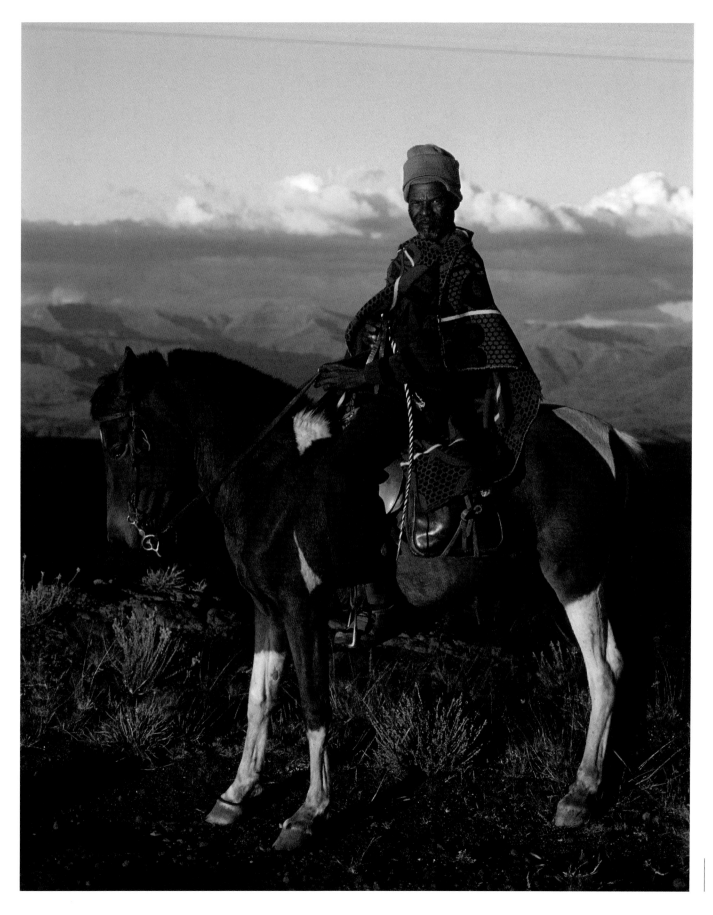

A Basotho horseman on a
pony trek in Lesotho's Thaba
Putsoa Mountains. (1995)

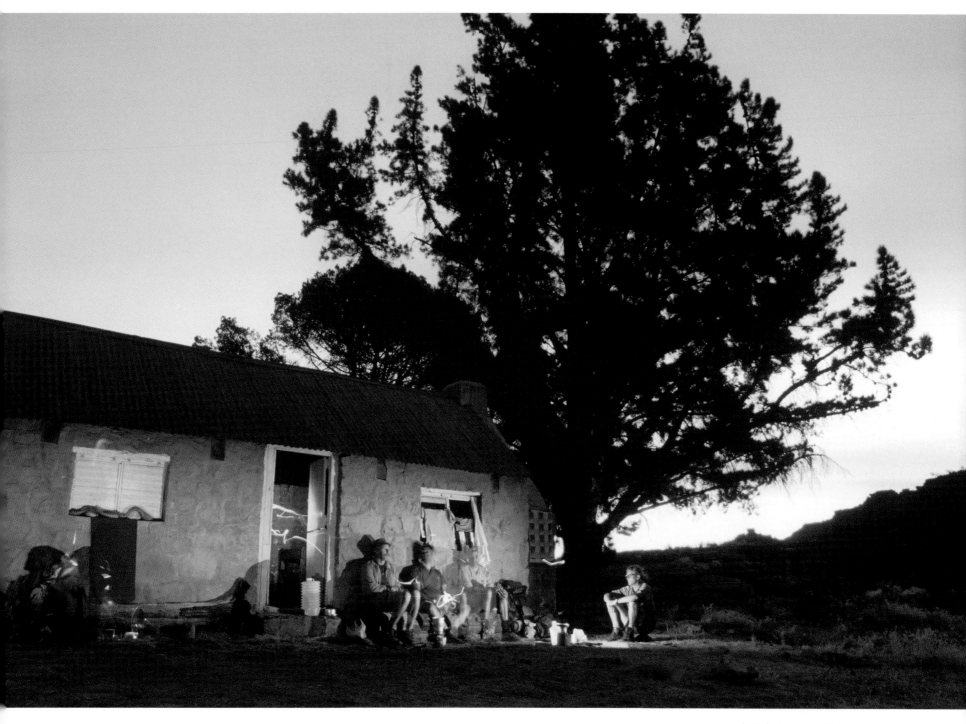

Relaxing round the gas stove at Middelberg Hut. Fires are strictly prohibited in the Cederberg Wilderness Area. (1992)

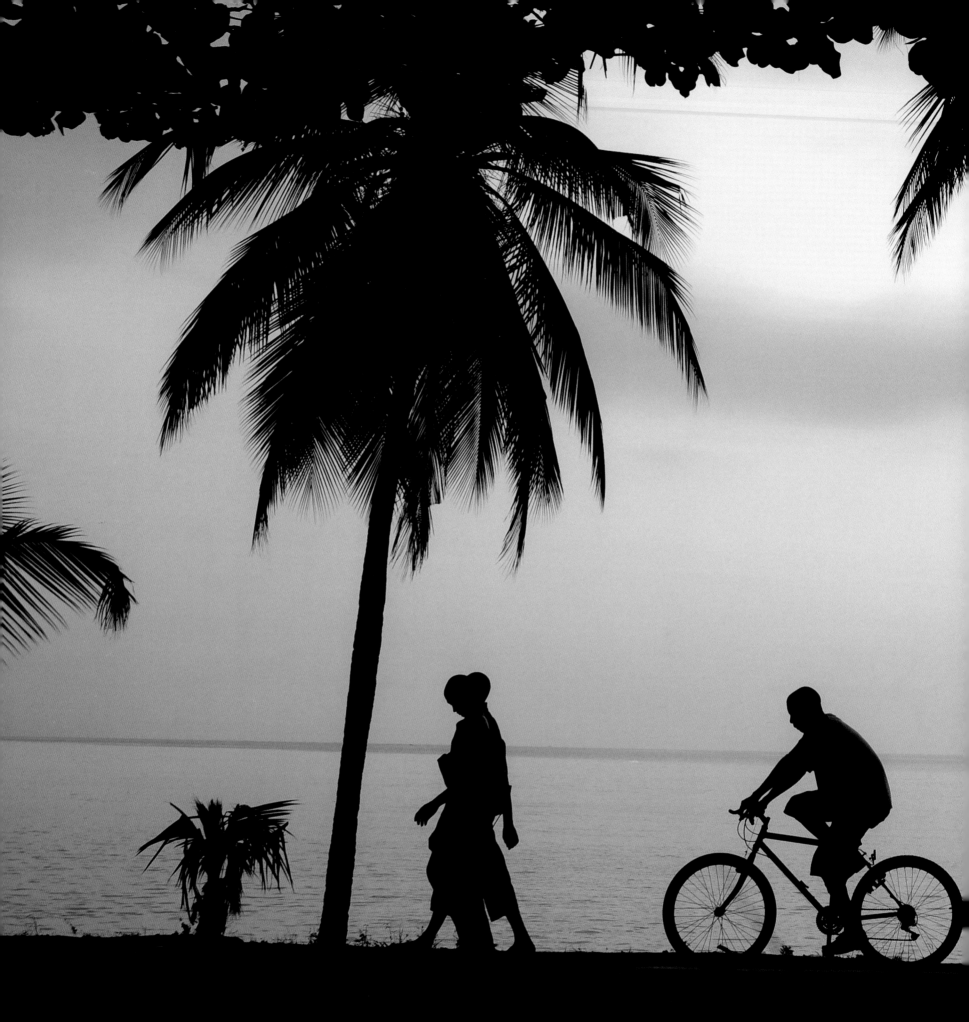

'I was sitting next to a driver who was manoeuvring out of the hotel grounds on the way to São Tomé airport and snapped this shot out of the window,' said Don Pinnock. (2009)

Adventuring

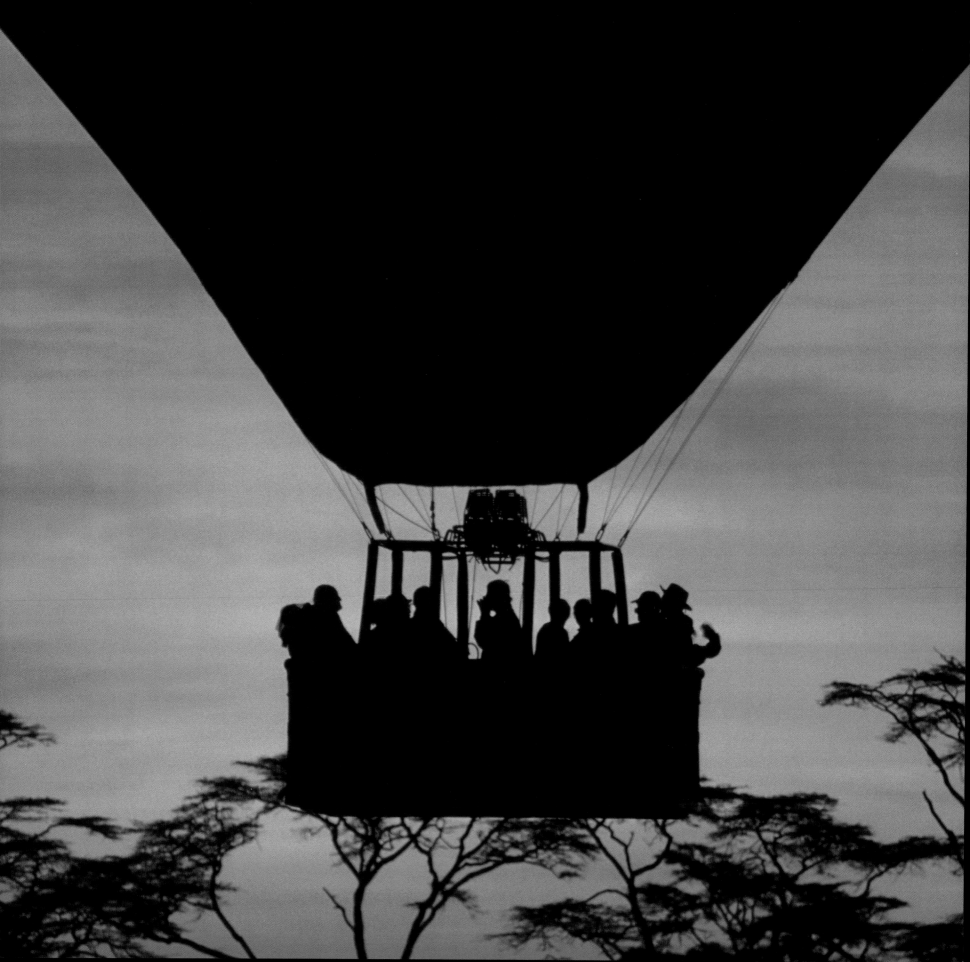

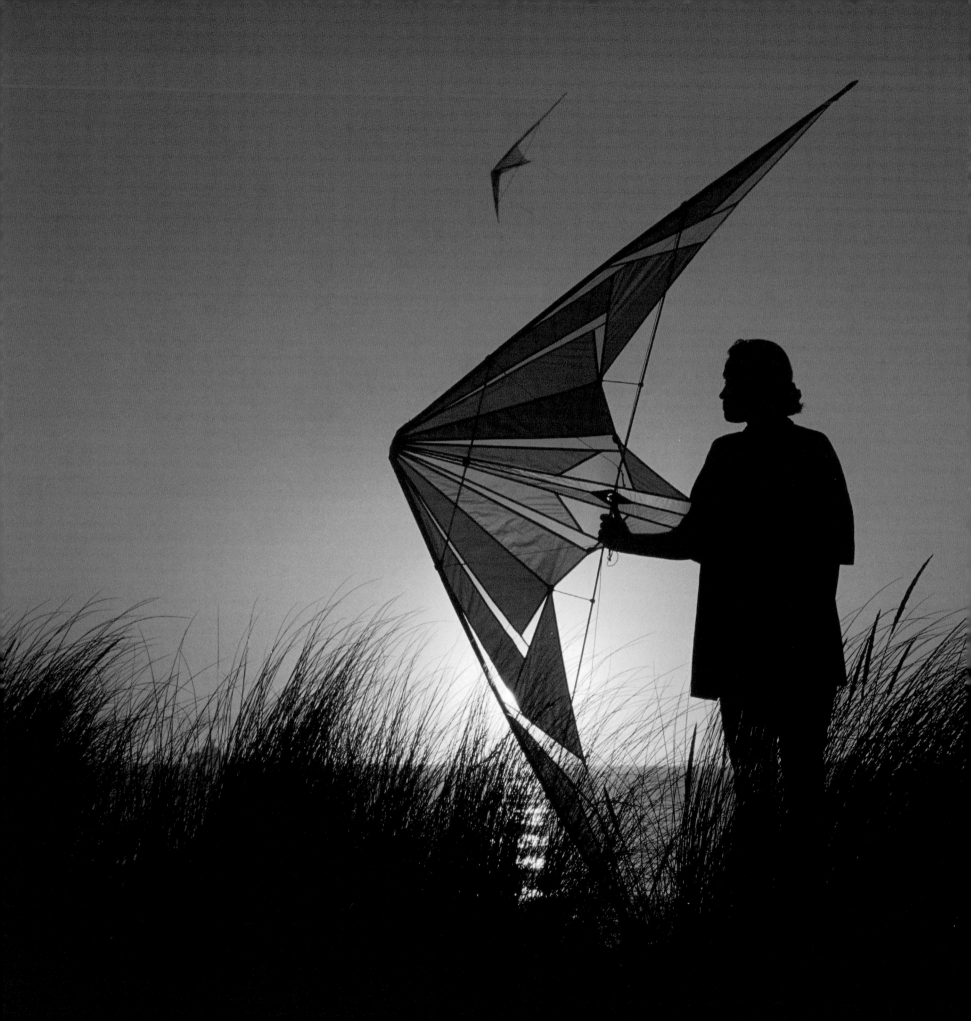

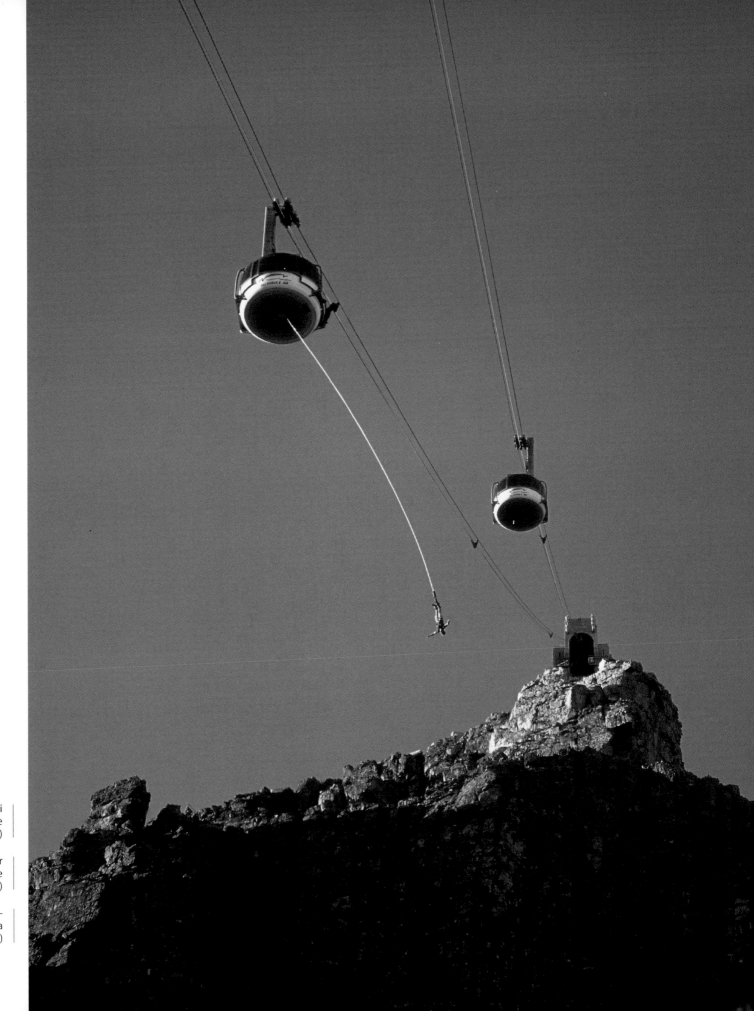

RIGHT: Early morning bungi jumping from the Table Mountain cable car. (2001)

OPPOSITE: Twilight kiter on Dolphin Beach, Cape Town. (1996)

PREVIOUS SPREAD: Ballooning at dawn over the Seronera River in the Serengeti. (1999)

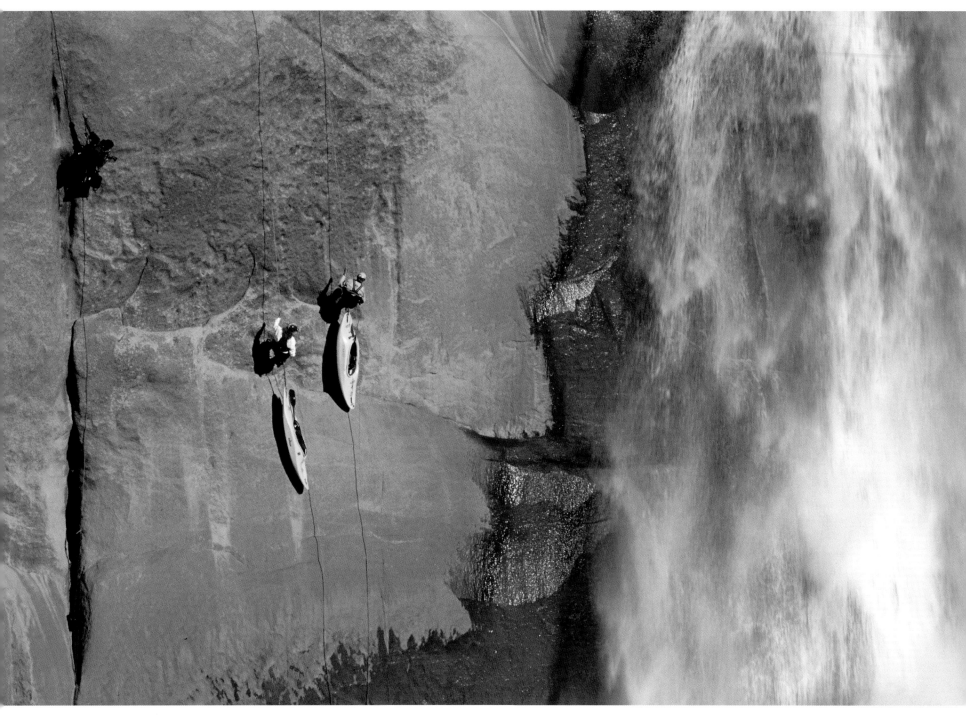

ABOVE: Two daredevils abseil into the Augrabies Gorge for a wild kayak down Orange River rapids. (2002)

OPPOSITE: At Murchison Falls, the White Nile thunders through a narrow gorge, stunning fish and providing easy food for crocodiles. (1996)

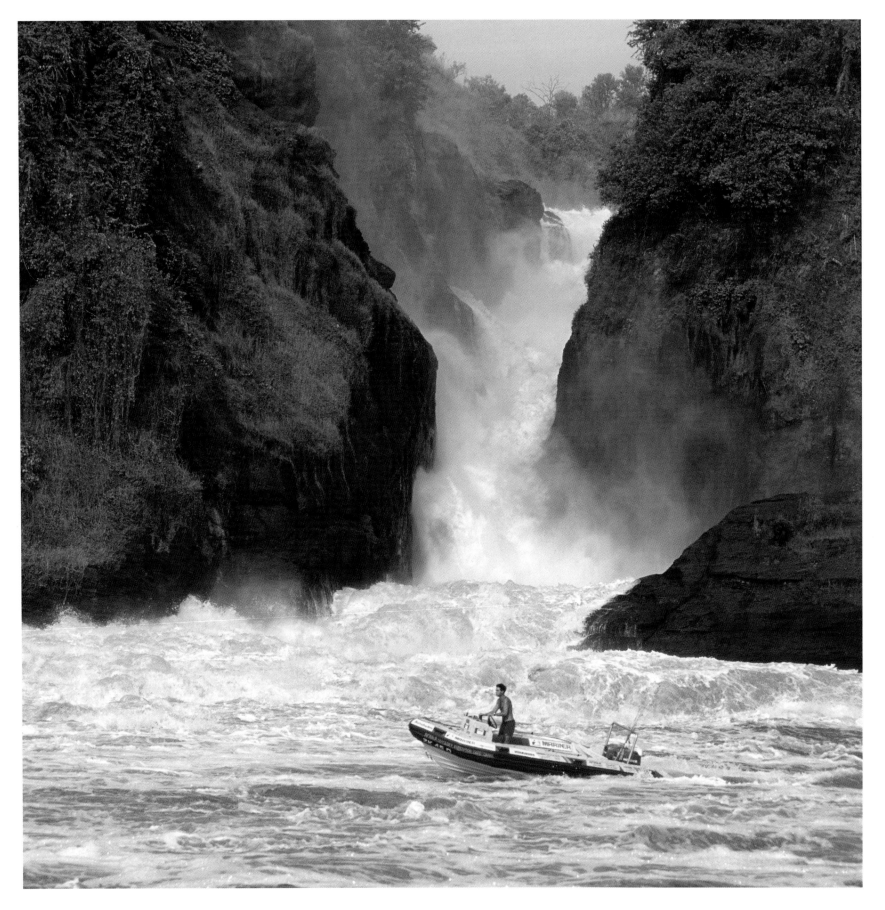

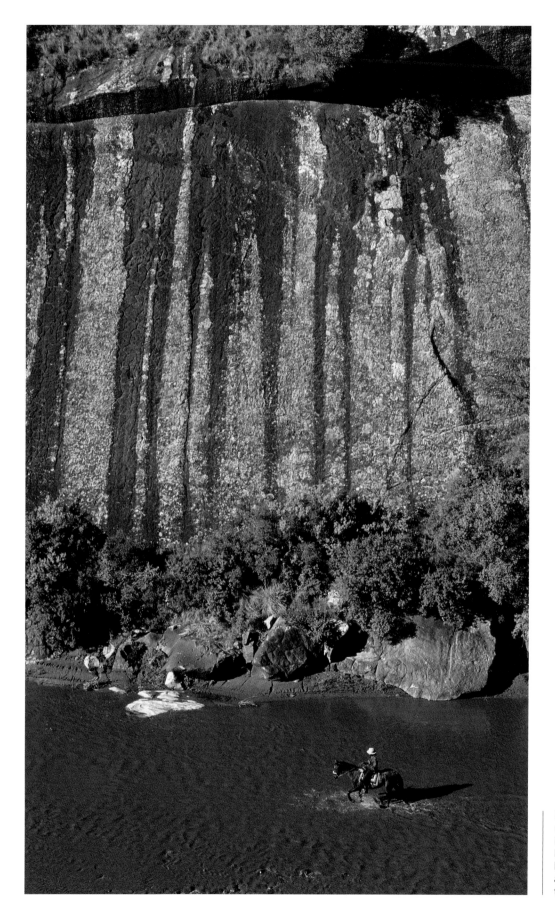

Lesotho's rugged Thaba Putsoa range invites pony trekkers into its spectacular realm. Here the Makhaleng River has sliced through the basalt and exposed layers of tinted sandstone. (1995)

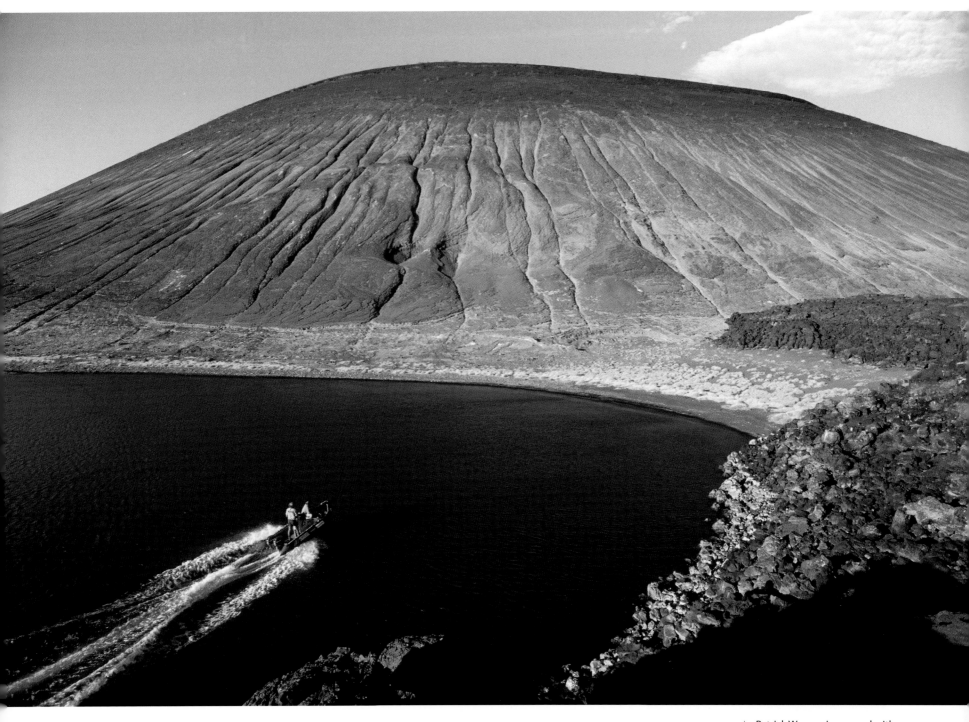

Patrick Wagner journeyed with Kingsley Holgate in the footsteps of Count Teleki, the first European to see Lake Turkana. The volcanic cone of Nabuyatom (Turkana for 'stomach of the elephant') stands like a truncated pyramid on the southernmost shore. Here one of the expedition inflatables arrives to collect members of the team who'd scaled its slopes. (1996)

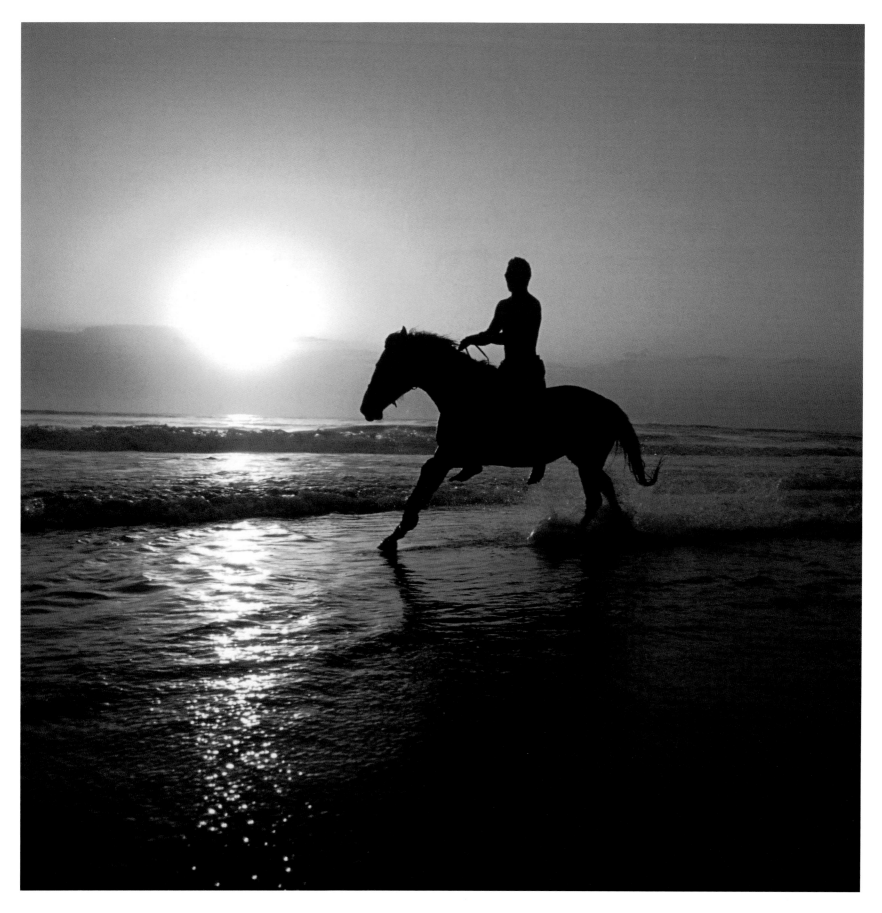

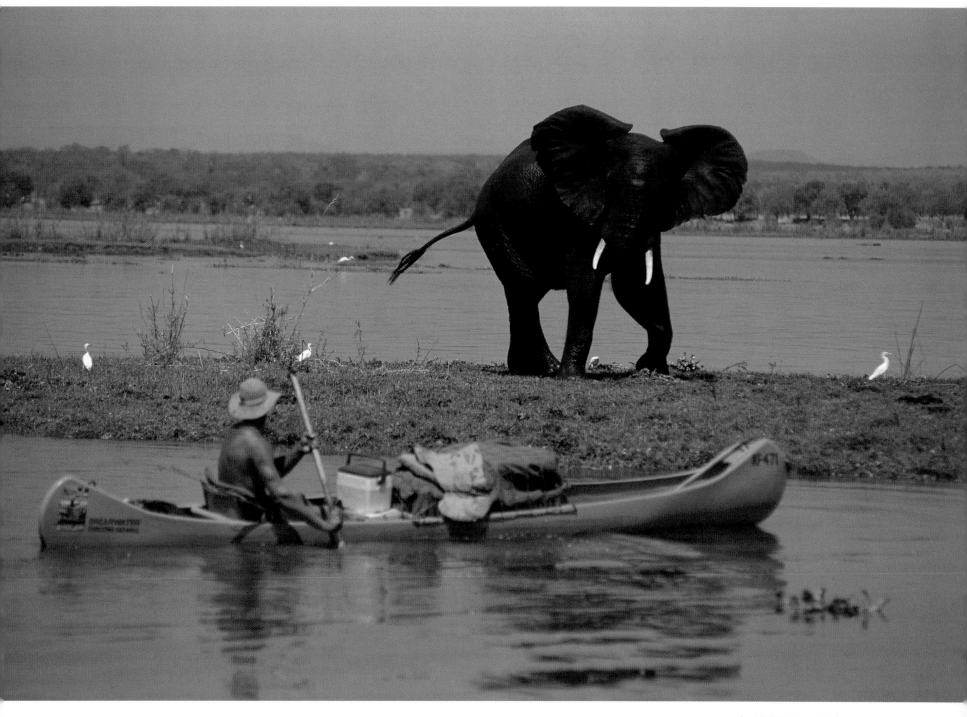

ABOVE: Mana Pools encounter, Zambezi River. (1999)

OPPOSITE: Horse riding on the beach at Ponta Mamoli, southern Mozambique. (2003)

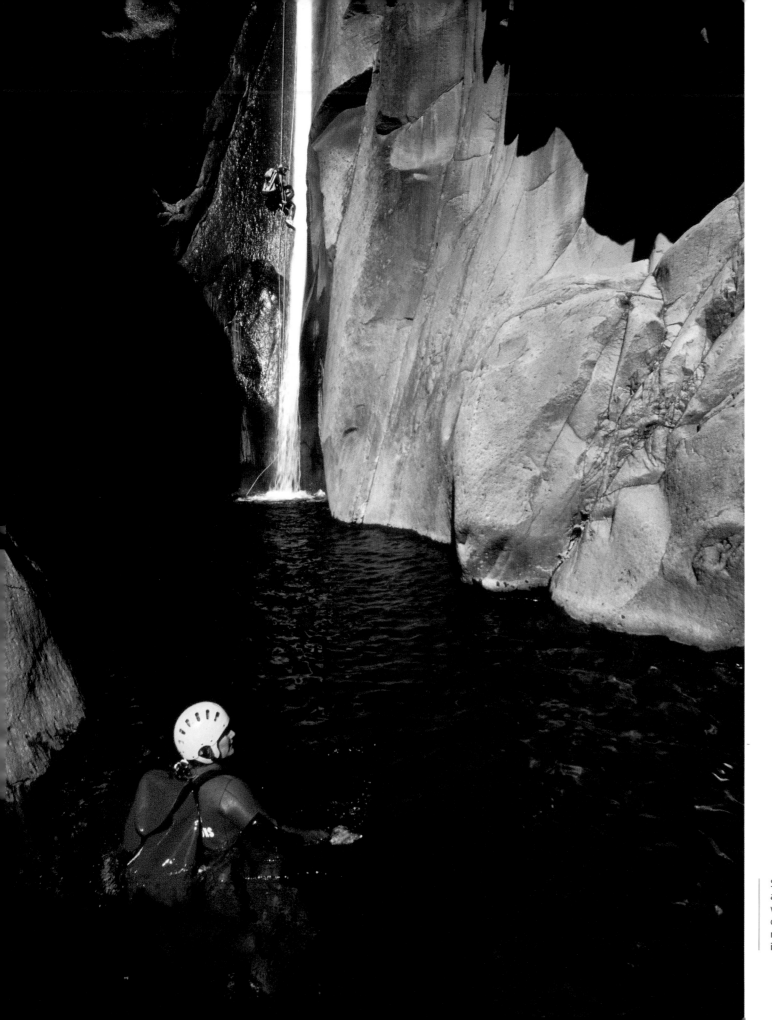

Seldom were the waters of a chilly mountain pool so welcome as at the bottom of the Canyon Fleur Jaunes' most daunting abseil – Réunion Island. (1998)

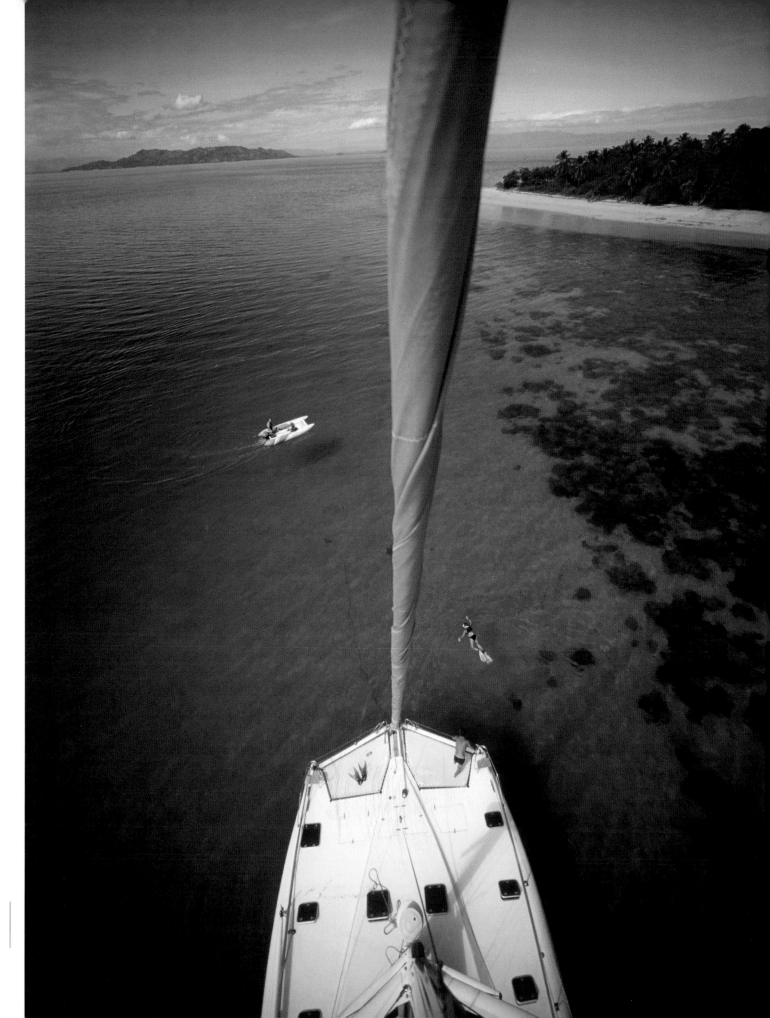

Diving and island-hopping in northwestern Madagascar on the chartered catamaran, *Bossi*. (2000)

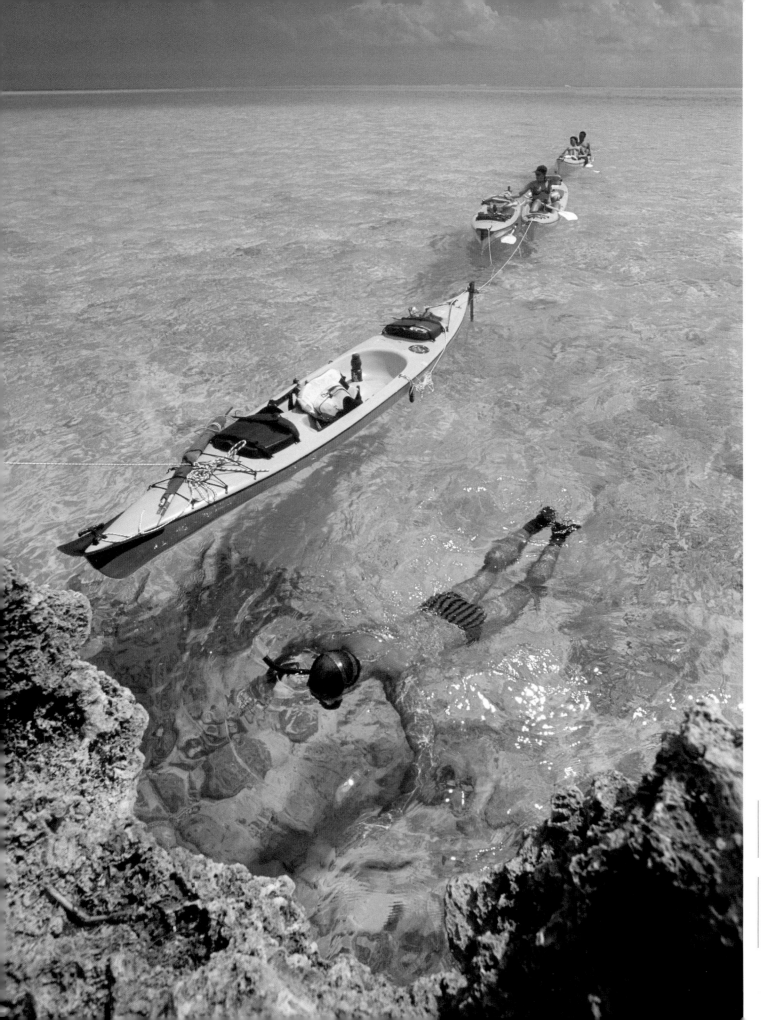

LEFT: Îlot aux Bénitiers looks like a pot plant in the sea. It's probably the most photographed lump of coral on Mauritius. (2001)

OPPOSITE: Anse Lazio Beach on Praslin, Seychelles, adheres perfectly to the tropical island fantasy. This image provided the best-selling cover for that year's Christmas issue. (2001)

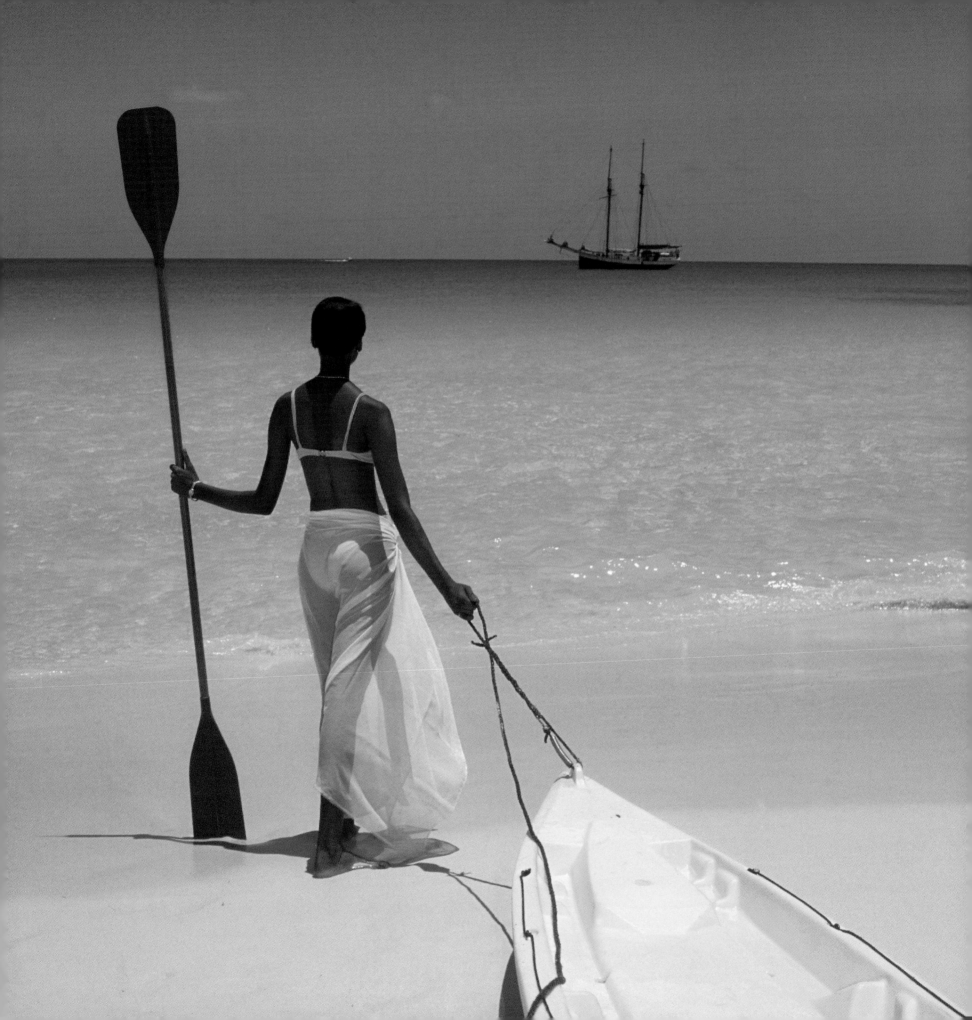

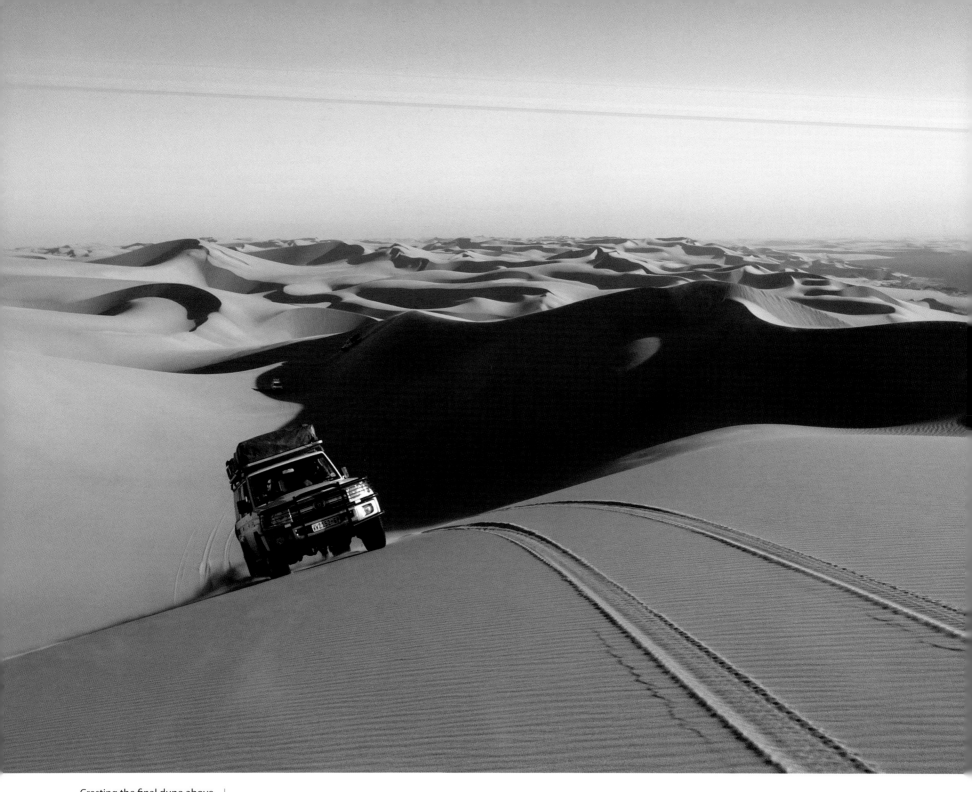

Cresting the final dune above Sandwich Harbour on a six-day drive from Lüderitz through Namibia's trackless Sperrgebiet or 'forbidden zone'. (2009)

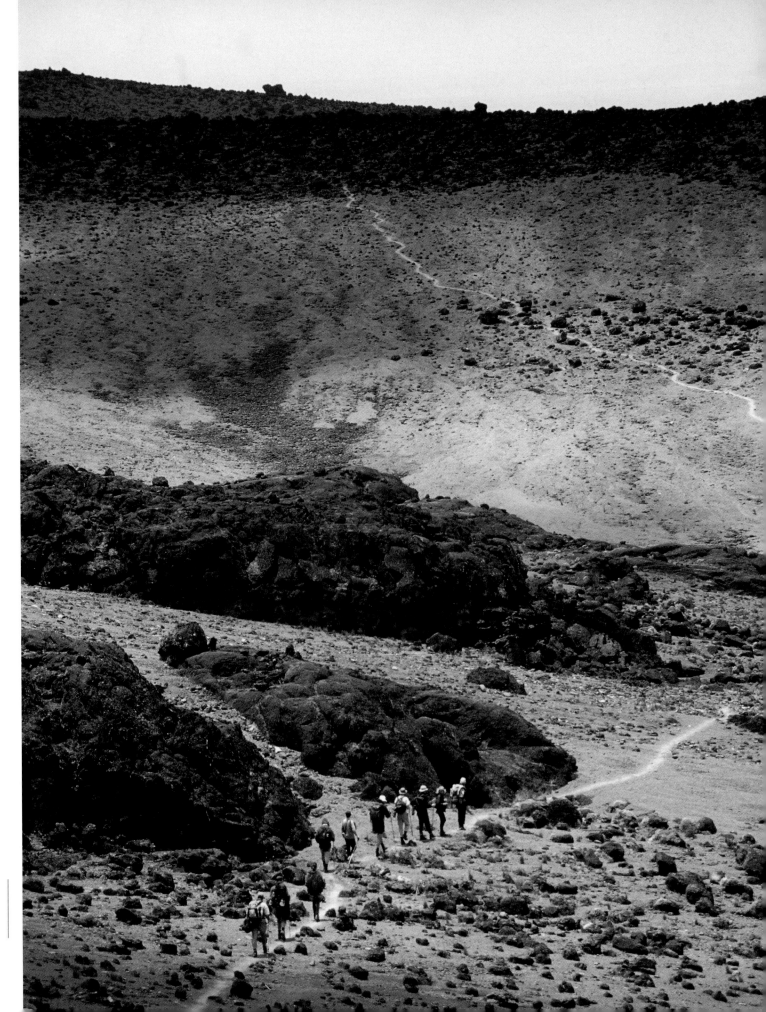

Little grows above 4 000 metres in Kilimanjaro's volcanic rubble. The area looks like a moonscape and the air is gaspingly thin. (1998)

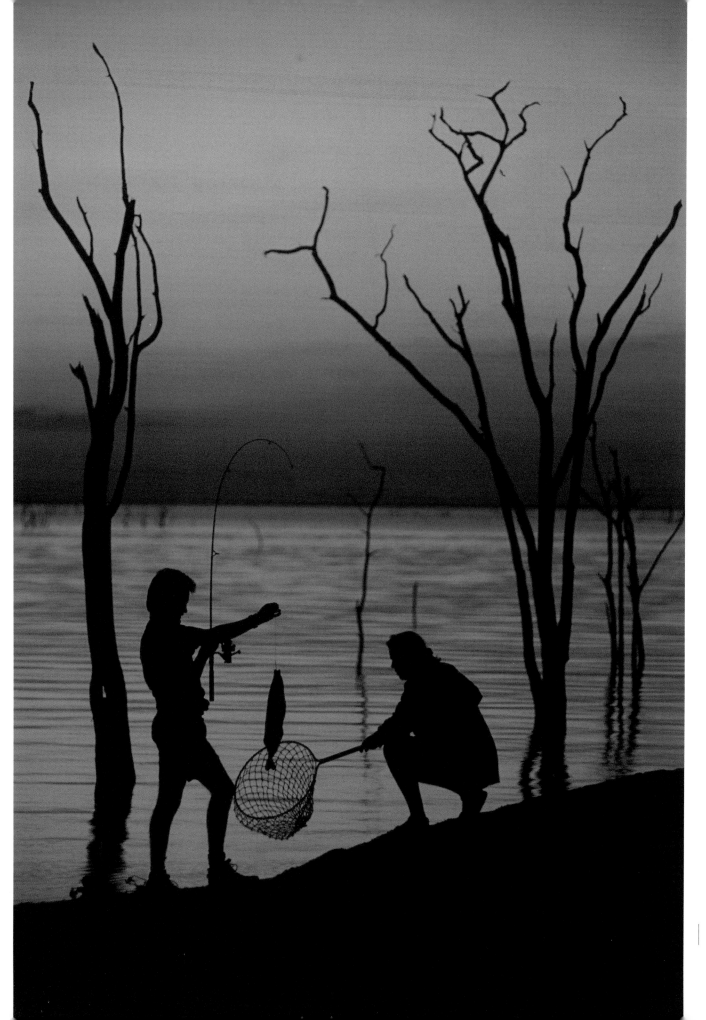

Kariba sunset, Zimbabwe.
(1996)

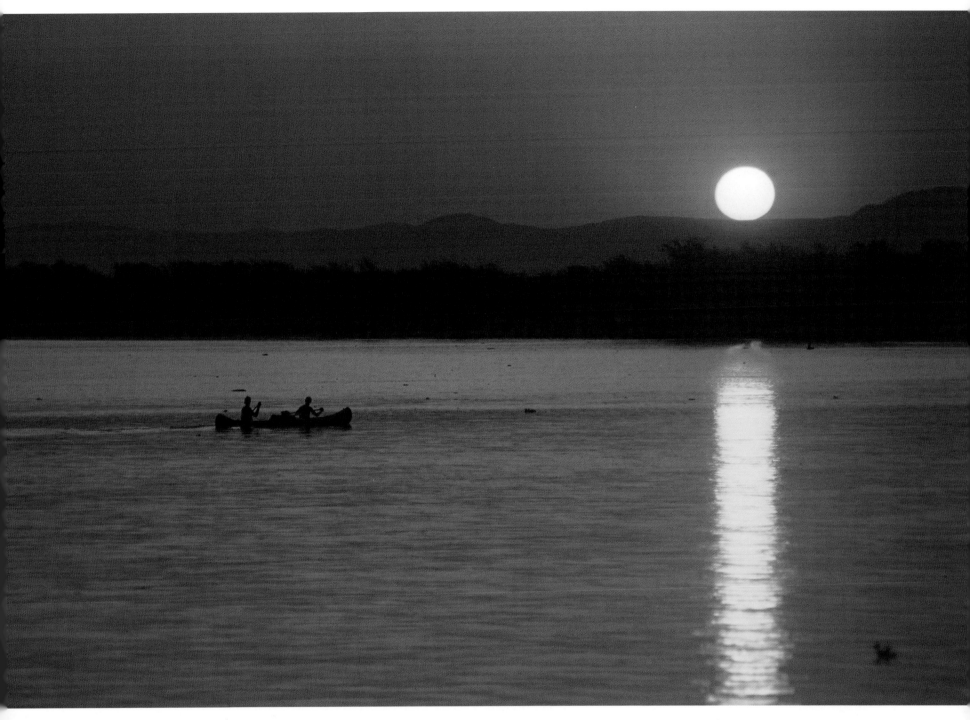

Canoeing on the Zambezi
River downstream from Lake
Kariba, Zimbabwe. (1993)

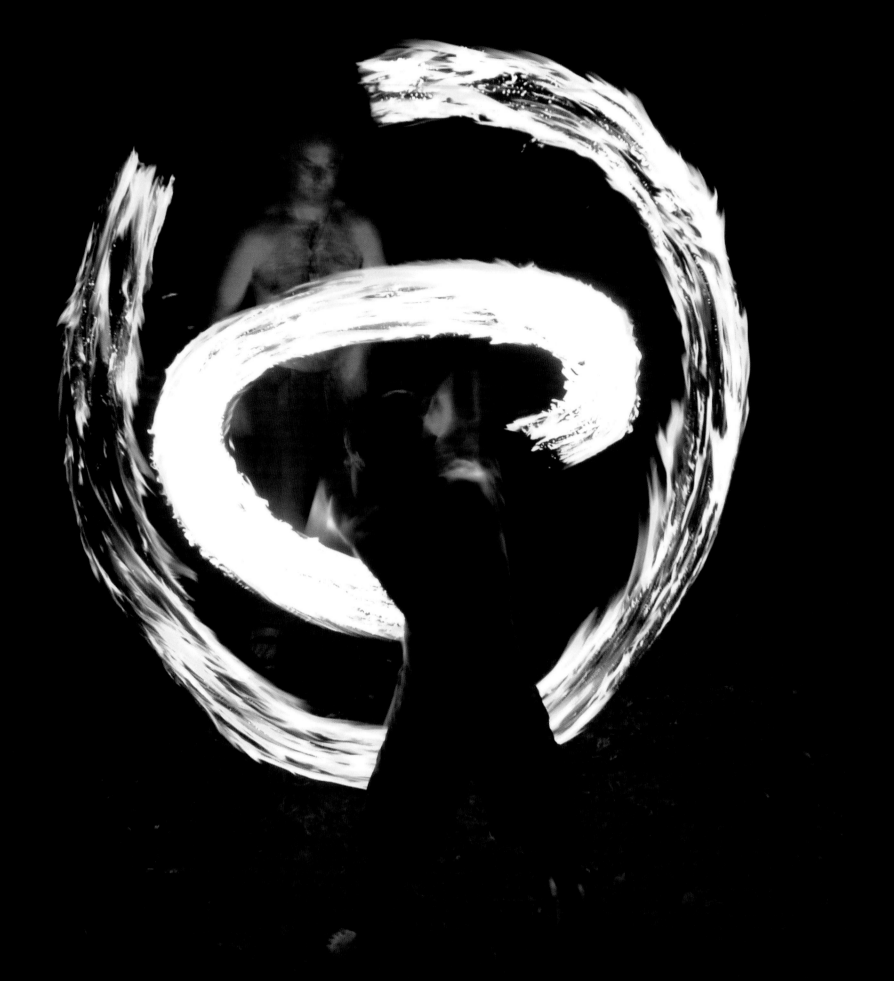

ABOVE: A full moon rises over the viewing point at Mdumbi Beach, a favourite with backpackers on the Wild Coast. (2008)

OPPOSITE: Fire poi on a Port St Johns beach. (2007)

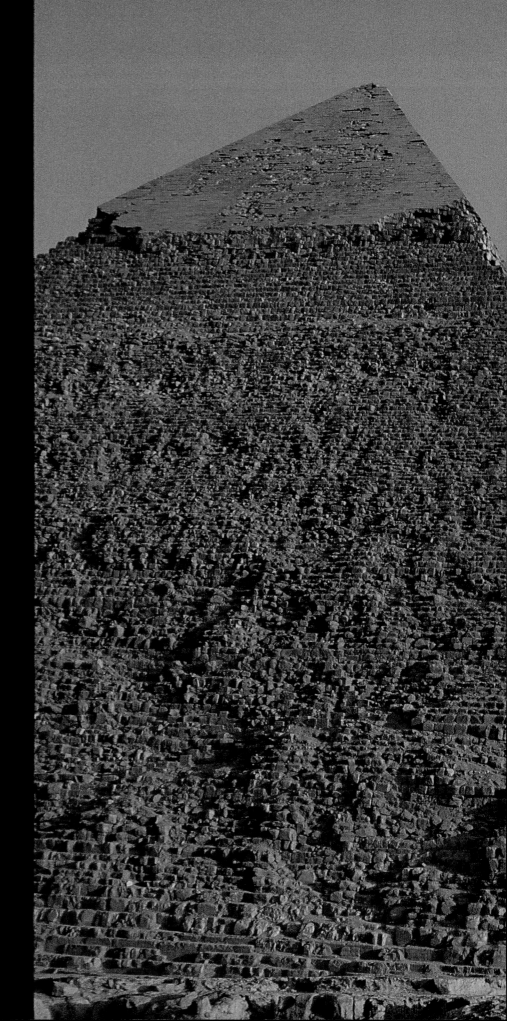

Built
Environments

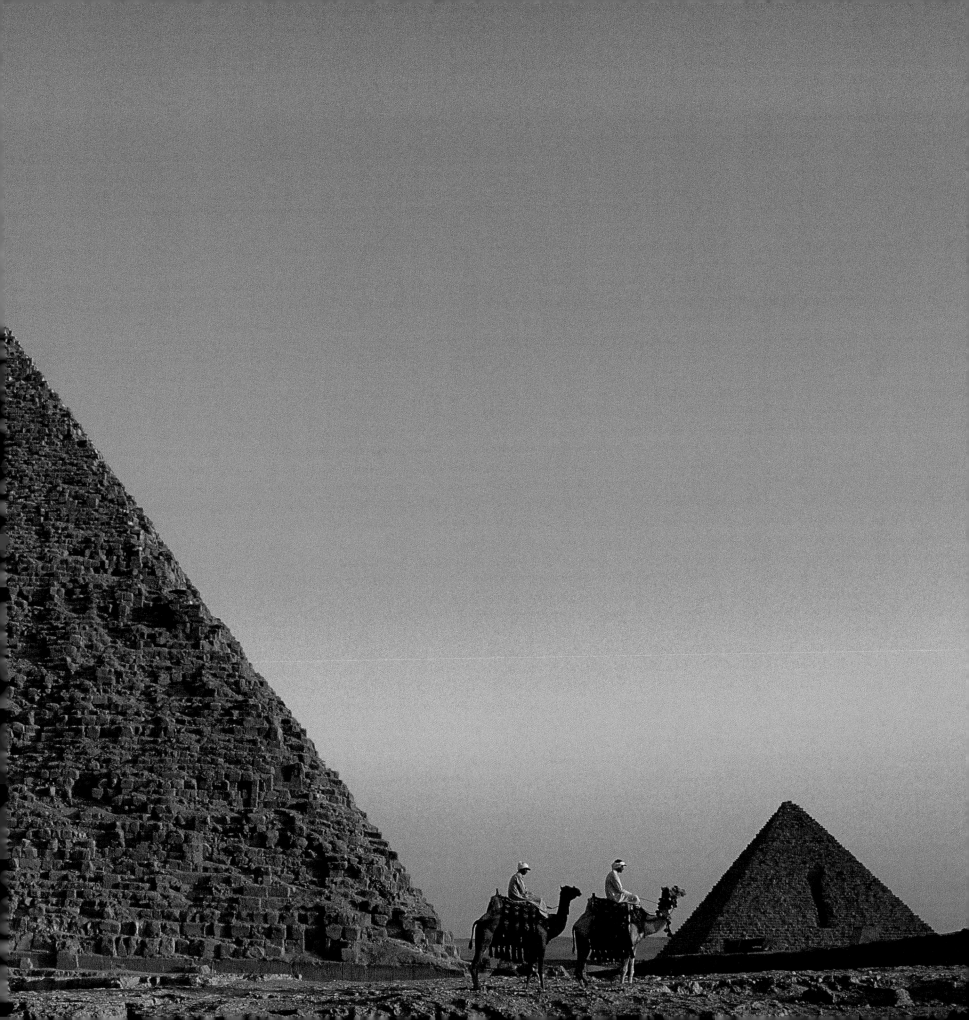

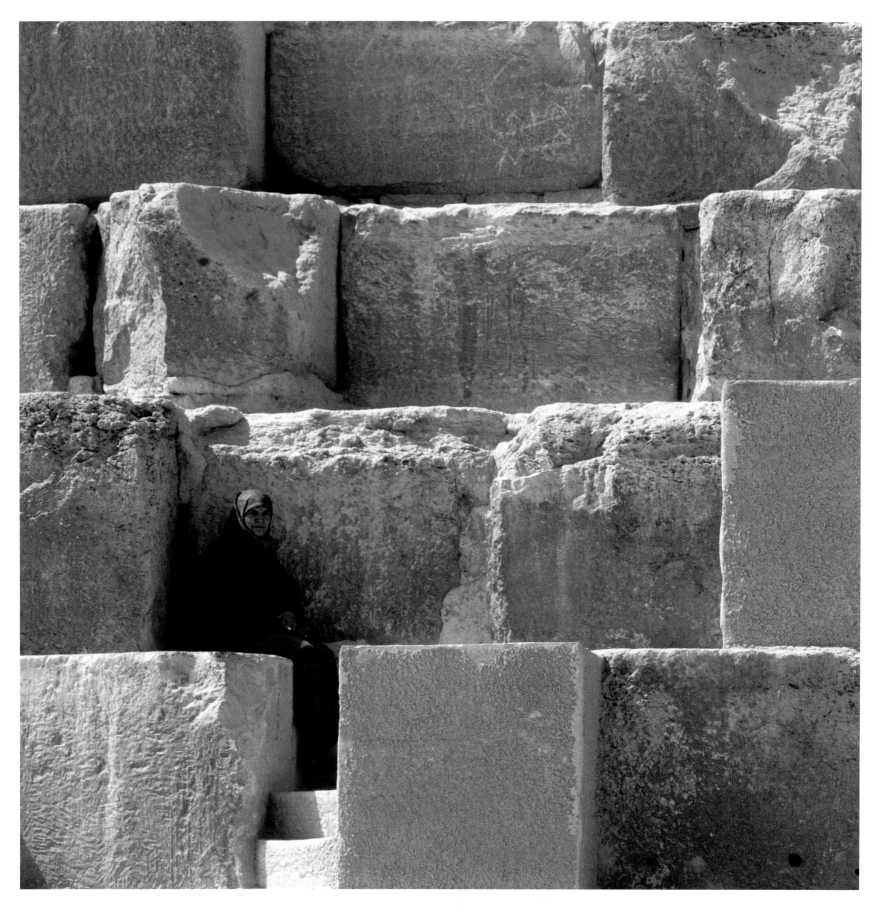

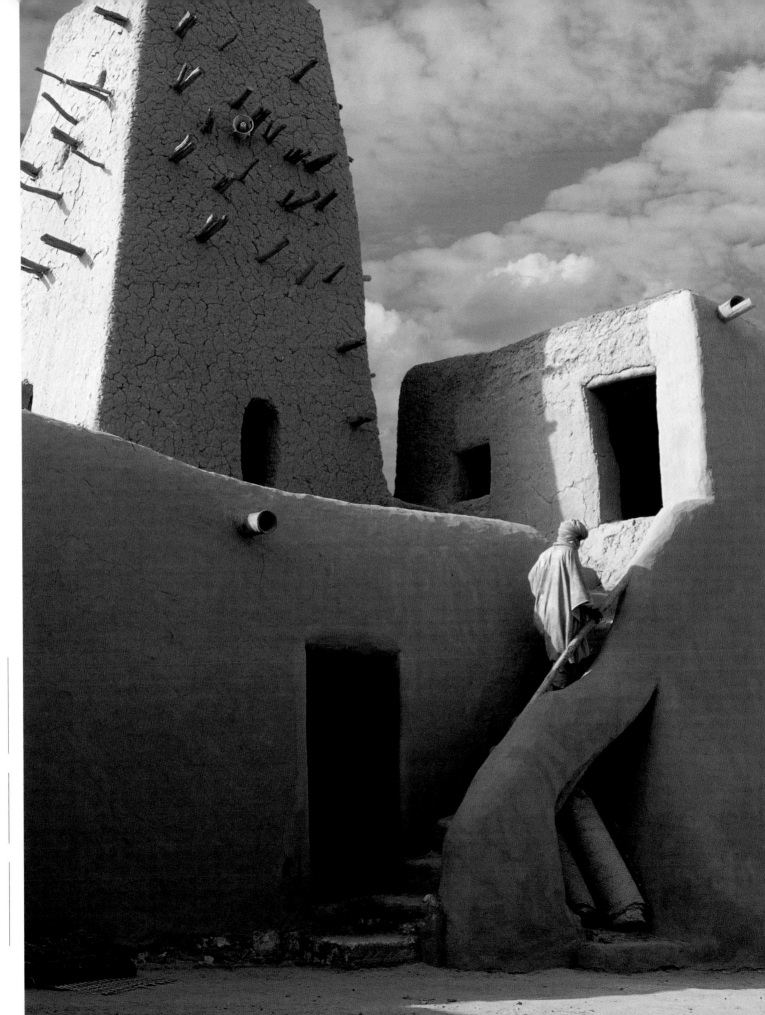

RIGHT: Timbuktu's Djingarey-ber Mosque was built in 1325. The main, colonnaded prayer space can hold well over a thousand worshippers and its thick walls keep the interiors relatively cool in the desert heat. (2007)

OPPOSITE: For centuries people have debated how the pyramids of Giza were built, as the granite blocks from which they're constructed weigh at least a ton each. (2004)

PREVIOUS SPREAD: The Great Pyramid of Cheops at Giza was constructed more than 4500 years ago. Each of its 2,5-million stone blocks was carved and moved by hand. (2006)

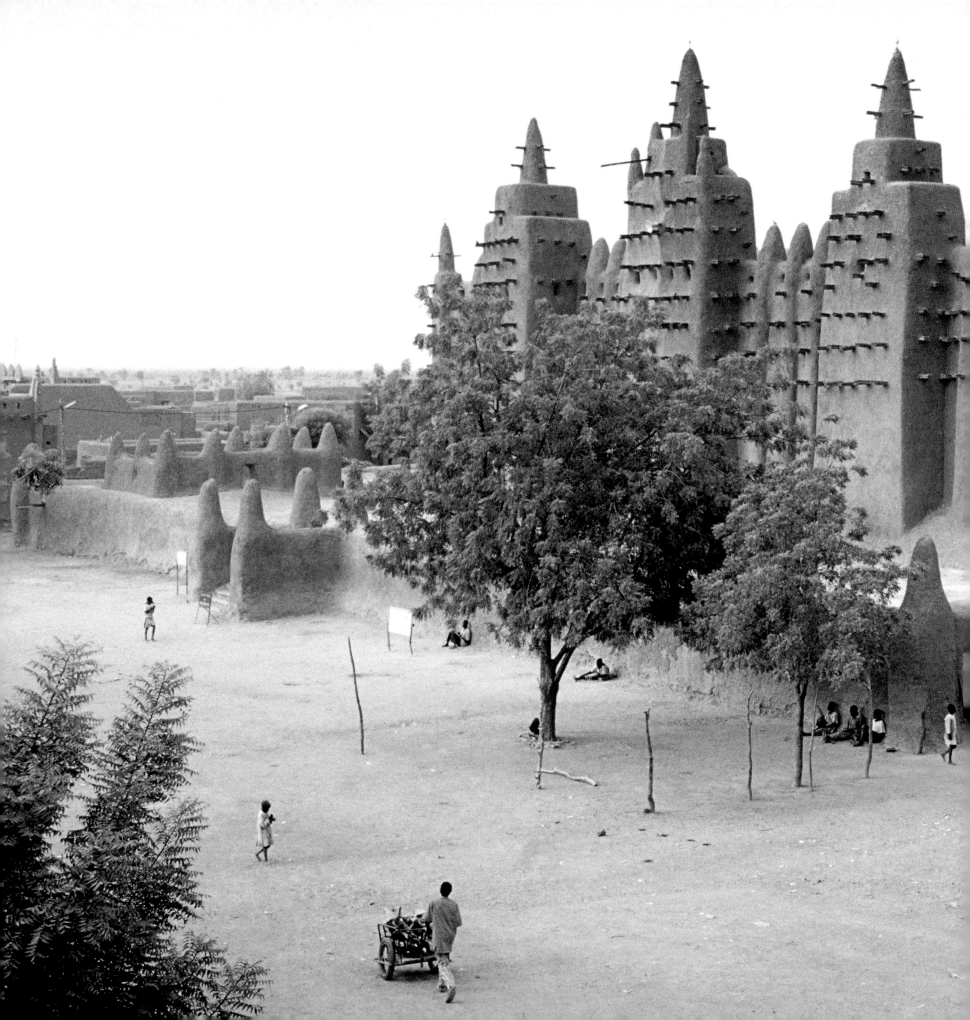

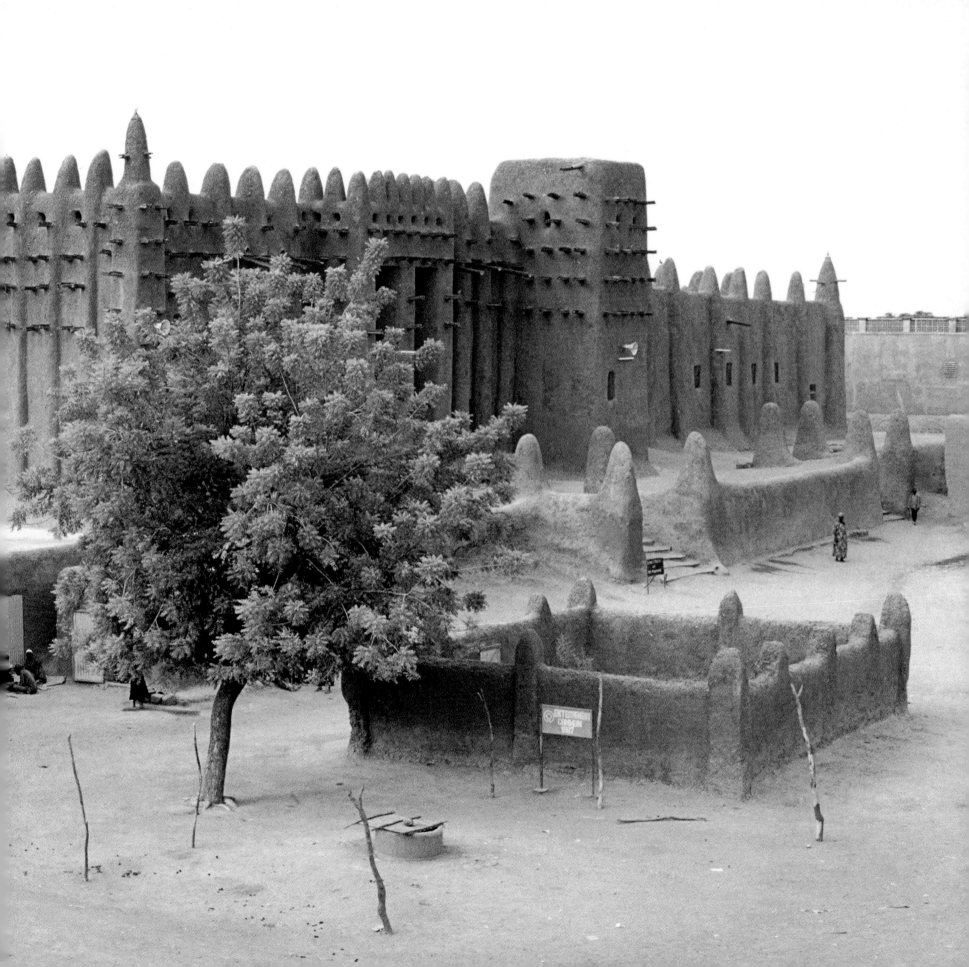

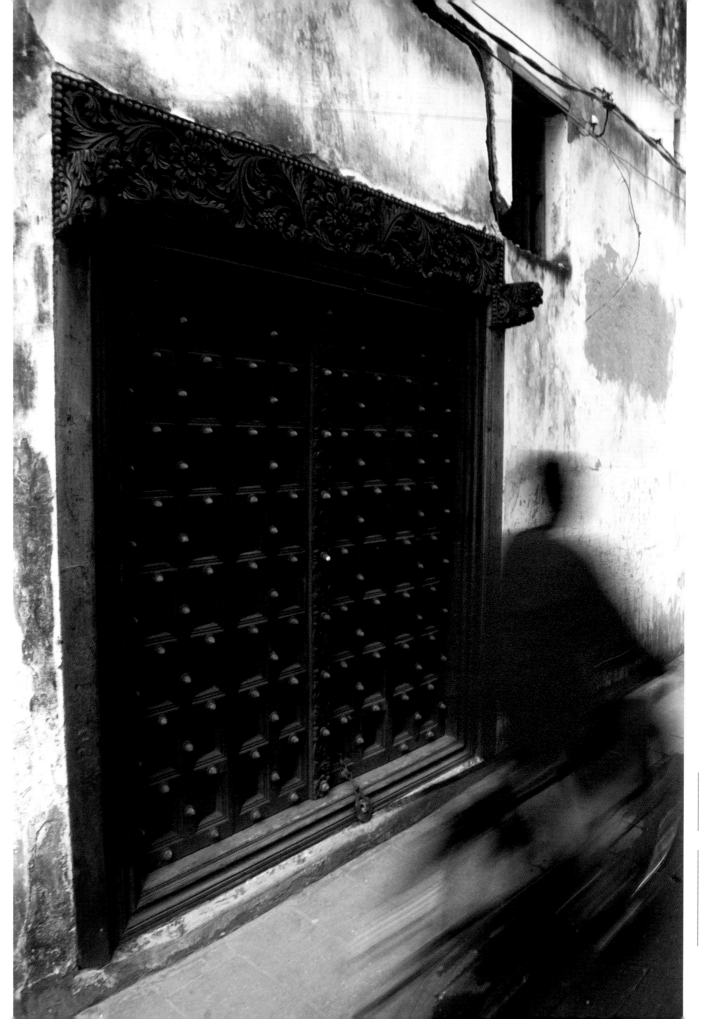

LEFT: Stone Town's old villas are graced with carved doors – just mind the cyclists who tear along the winding alleys. (2003)

PREVIOUS SPREAD: The Sudanic Friday mosque at Djenné, Mali, is one of the continent's architectural wonders. The protruding logs serve both as decoration and scaffolding for elaborate re-plastering ceremonies. (2001)

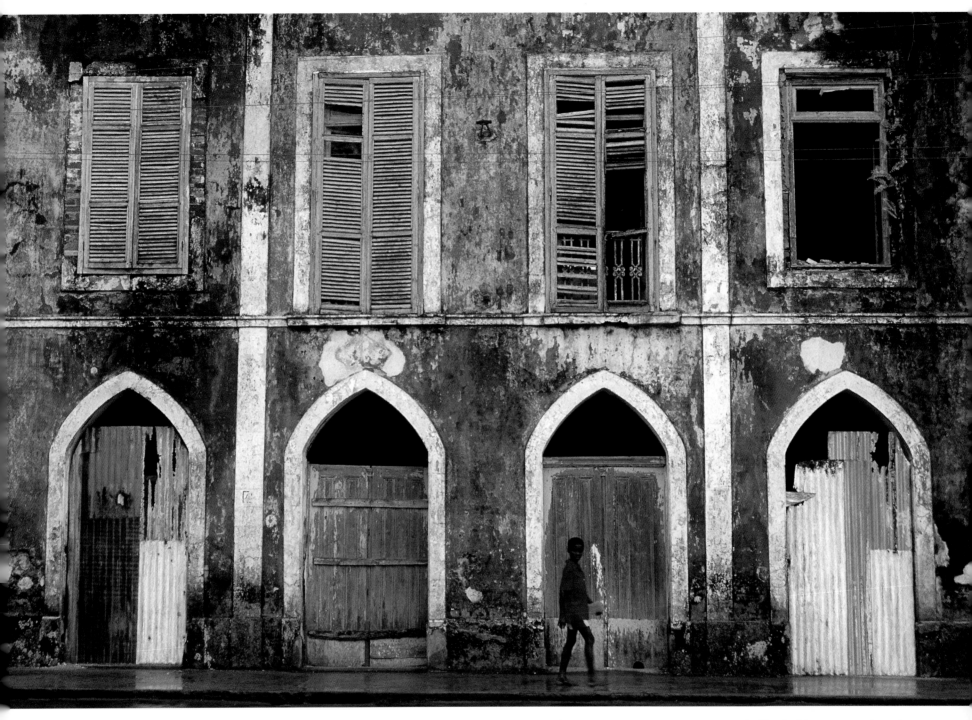

The double-storey mansions of Santo António are run-down reminders of Principé Island's colonial history and provide a weathered backdrop to brightly clad passersby. (1993)

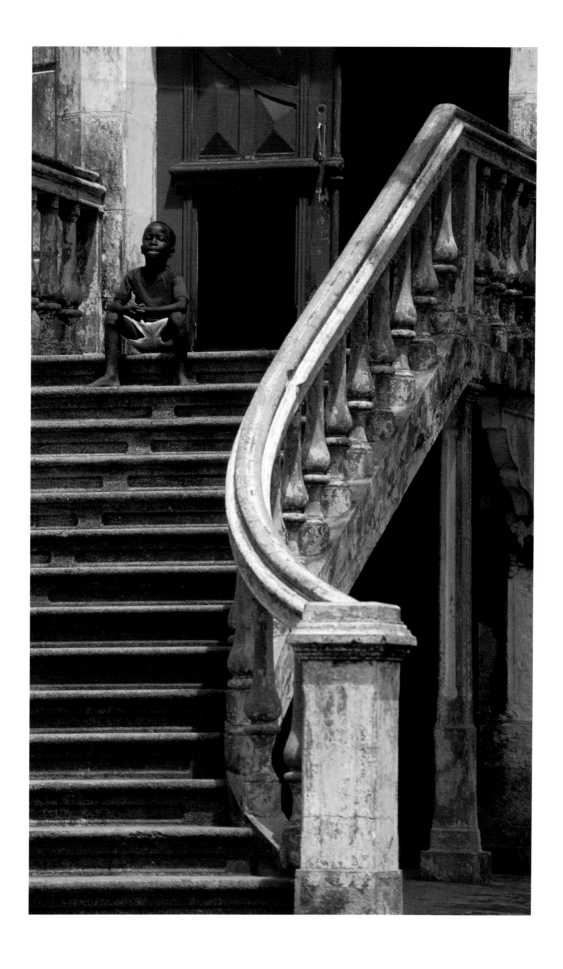

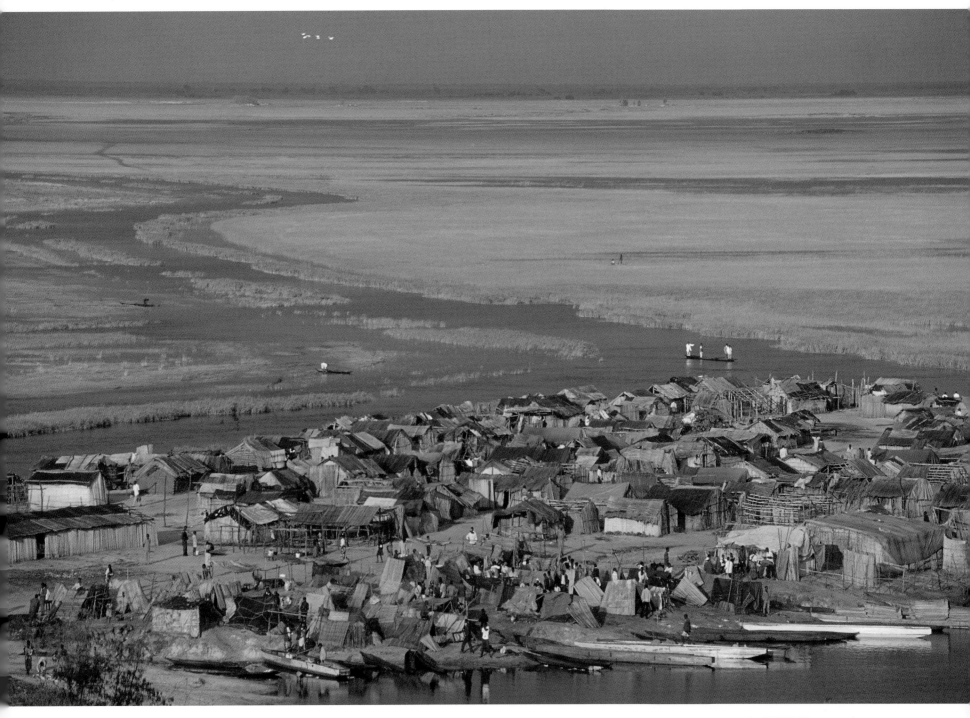

ABOVE: Mongu settlement on the Barotse floodplain in western Zambia during Patrick Wagner's journey down the Zambezi River with adventurer Kingsley Holgate. (1993)

OPPOSITE: Crumbling mansions on São Tomé Island are the old bones of the Portuguese Empire and hark back to the heydays of cacao and sugar farming. (2002)

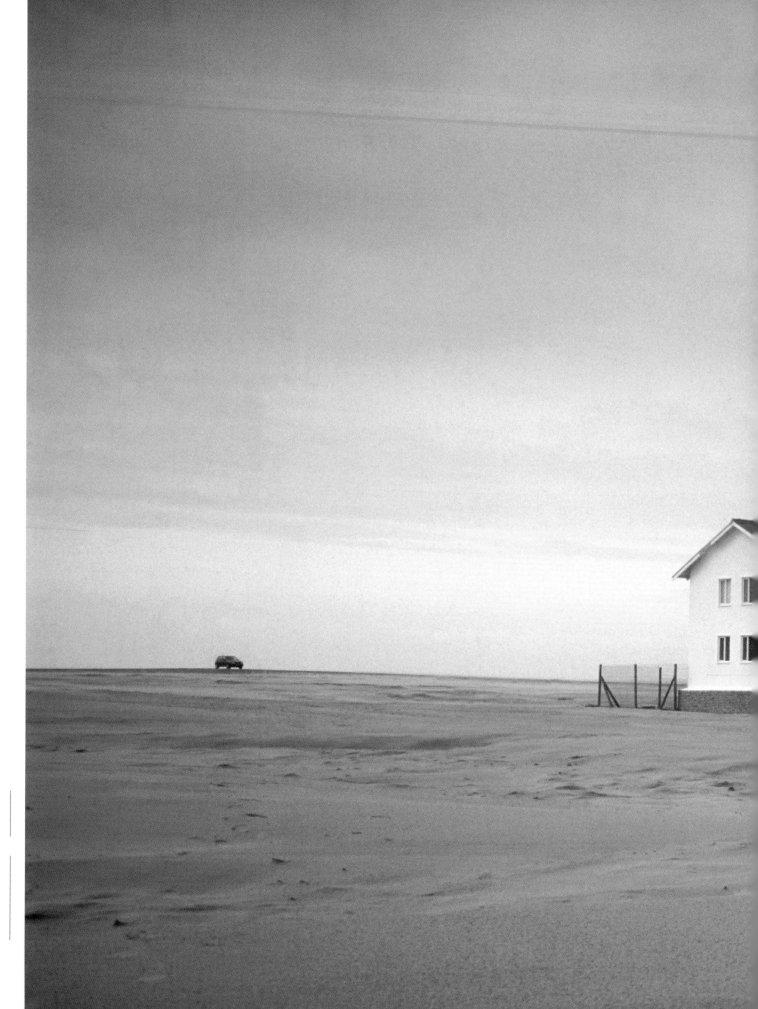

RIGHT: Sand dunes build up through wind action round the lighthouse at Cape Recife, Port Elizabeth. (1999)

FOLLOWING SPREAD: One of the characteristics of long exposures in urban environments is the blurred and streaky effect of car lights, captured here during a Cape Town dusk. (1992)

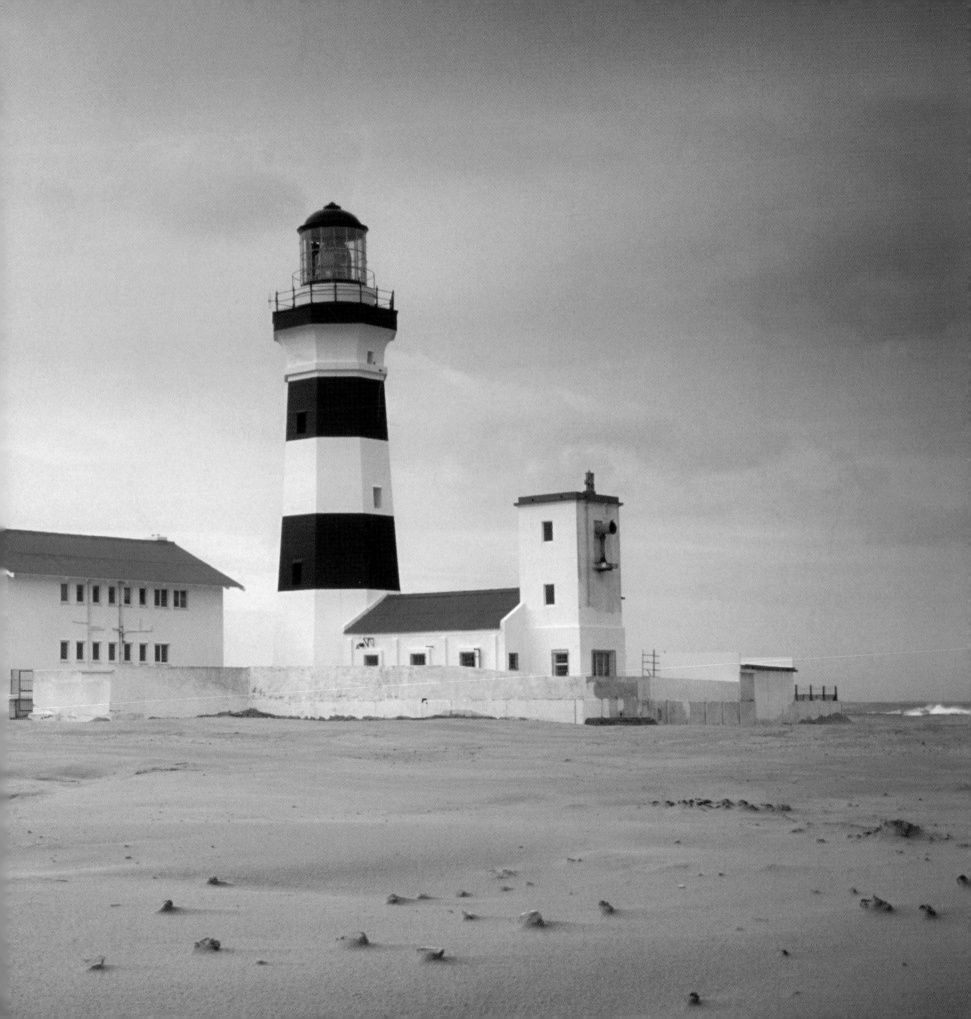

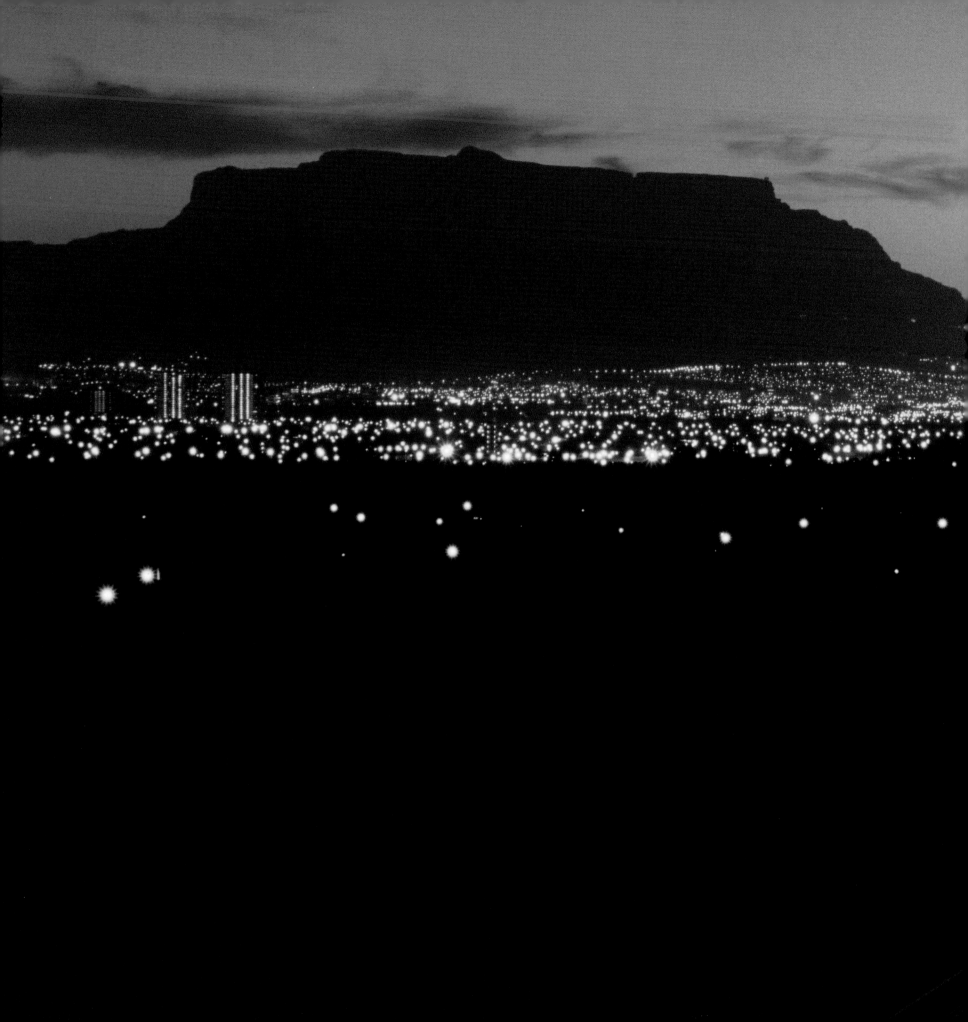

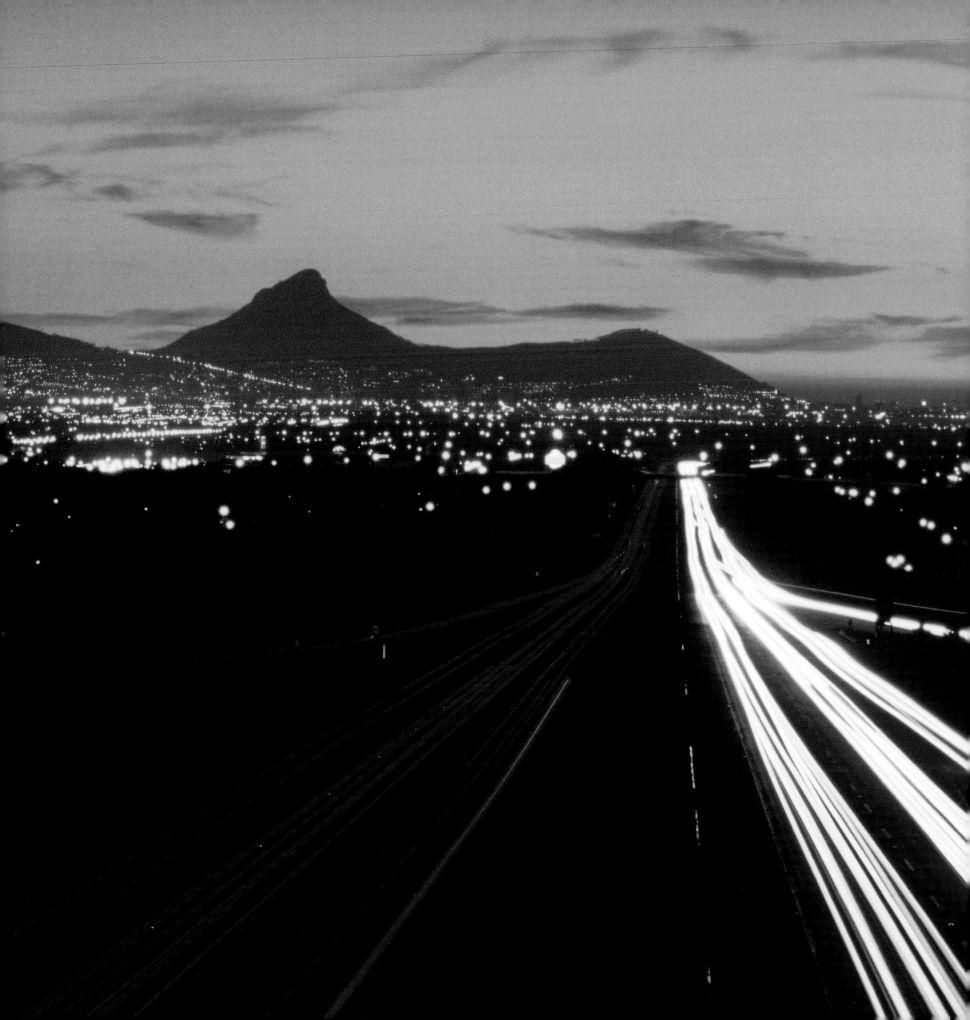

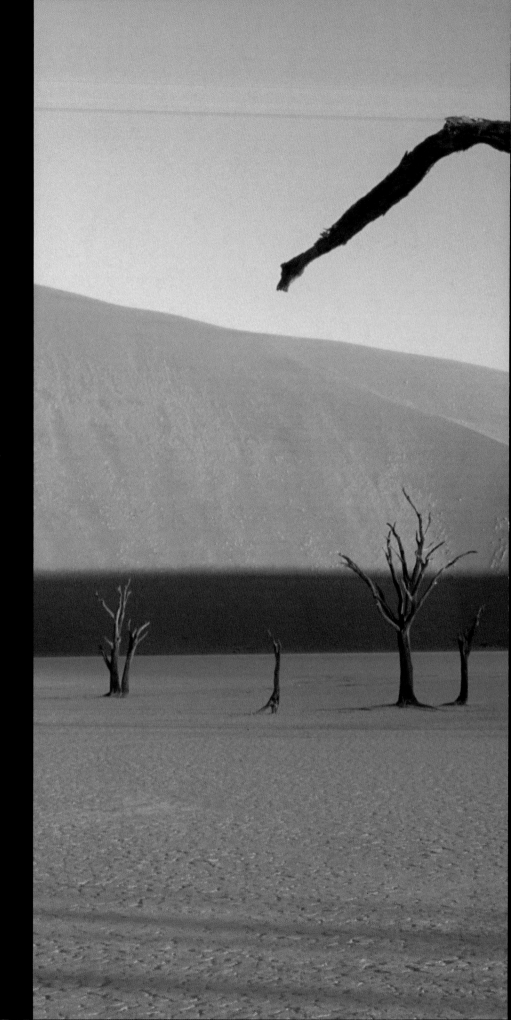

Land Shapes

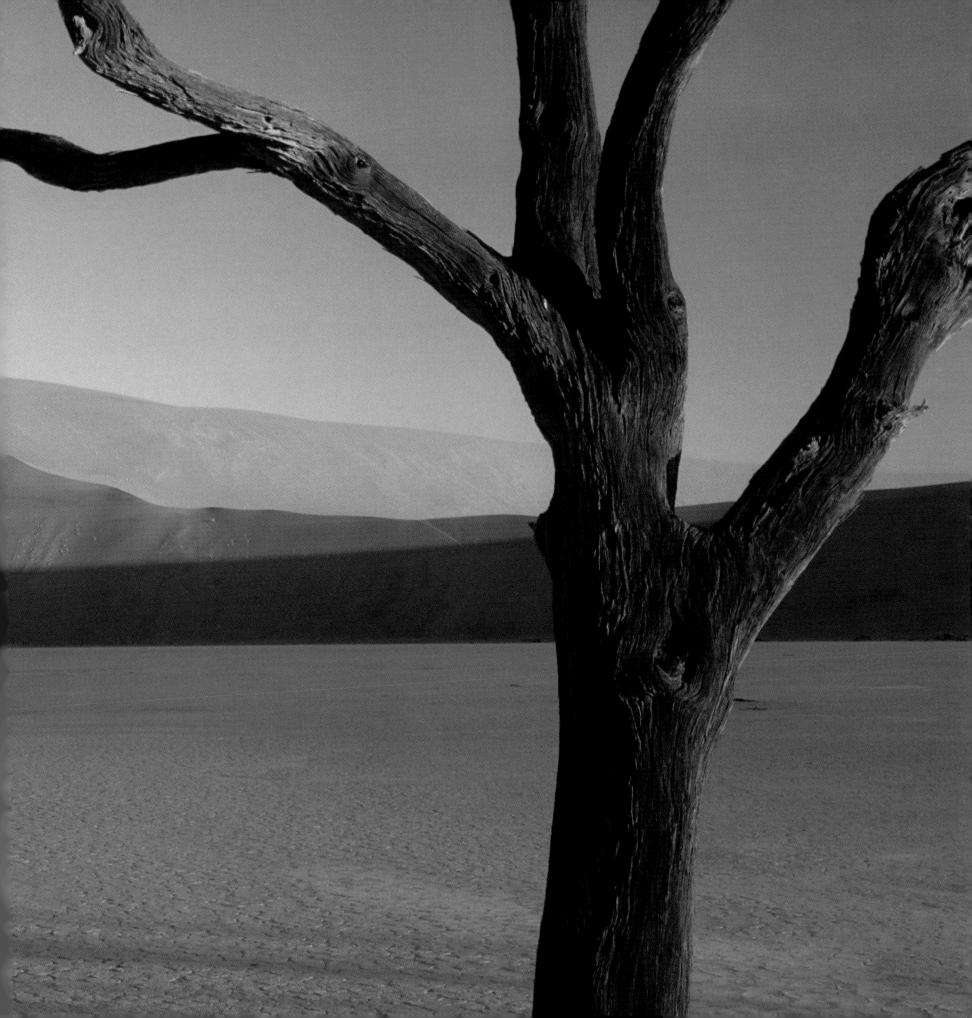

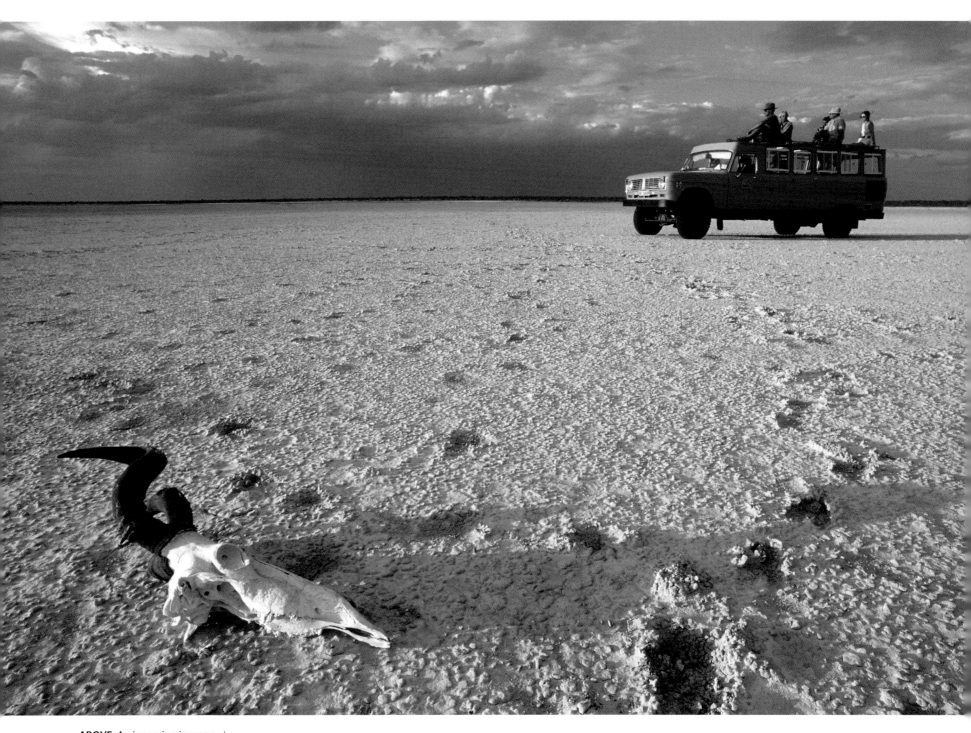

ABOVE: A pioneering journey into the central Kalahari with legendary guide Izak Barnard. (1995)

PREVIOUS SPREAD: Dead Vlei skeletons, Sossusvlei. (2003)

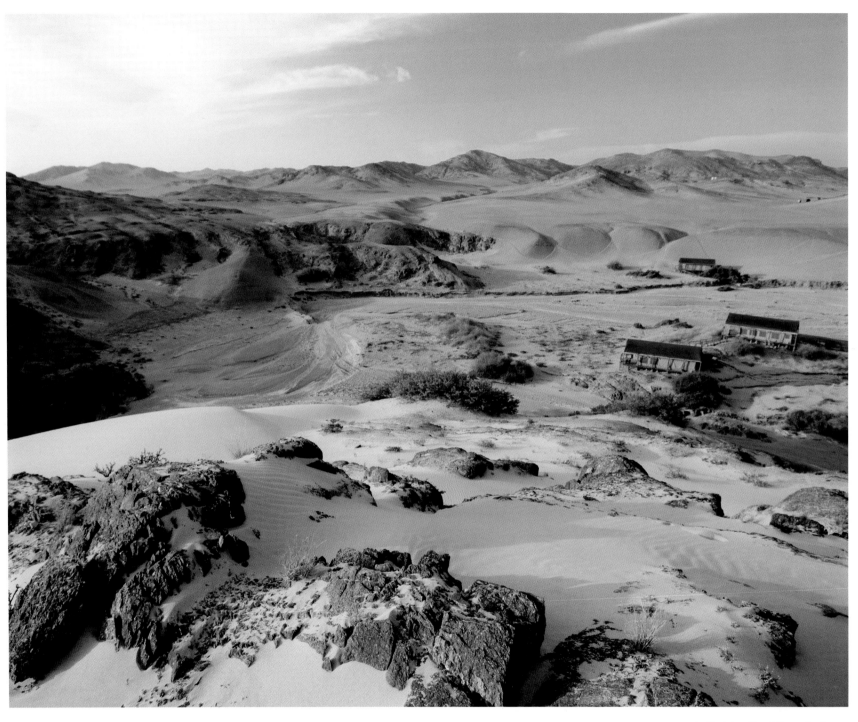

Skeleton Coast Camp lies in the dry bed of the Khumib River, a haunting spot frequented by jackals and brown hyenas. (2009)

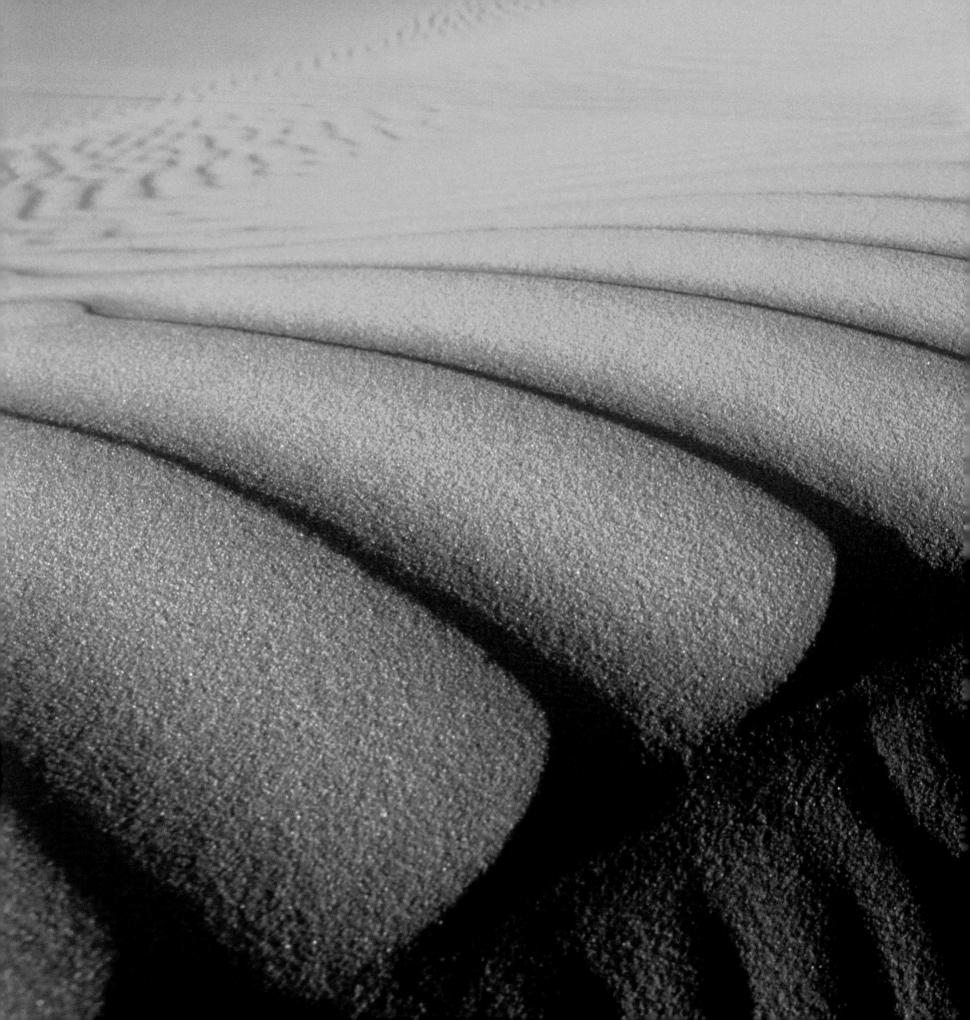

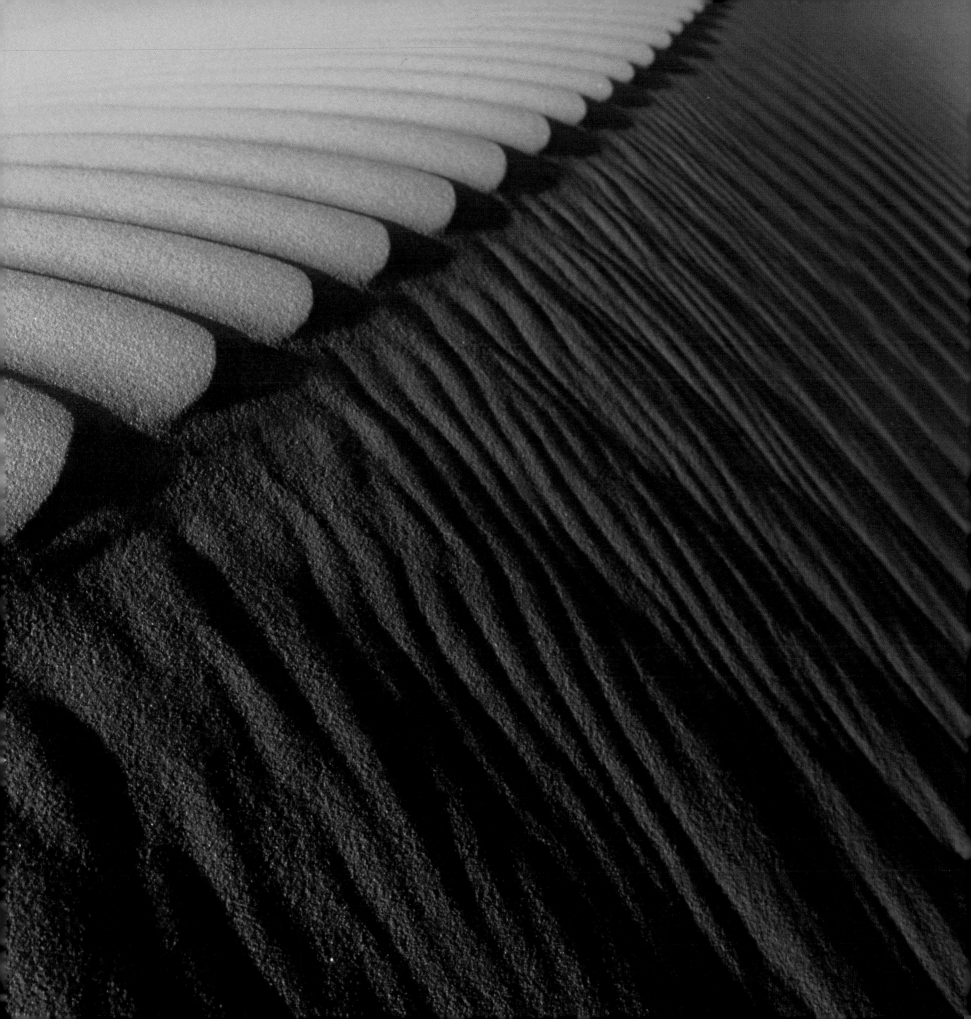

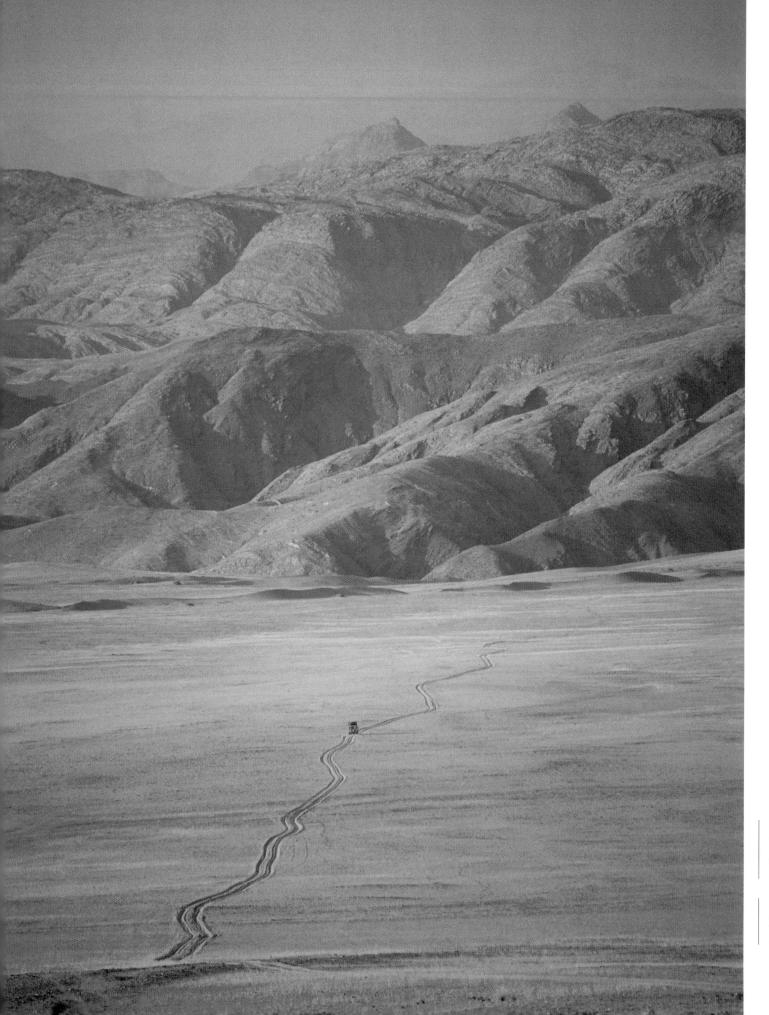

LEFT: A Land Rover follows a sandy track through Hartmann Valley towards the Kunene River, northern Namibia. (1991)

PREVIOUS SPREAD: Shifting sand ergs near the Berber town of Nalut, central Libya. (2000)

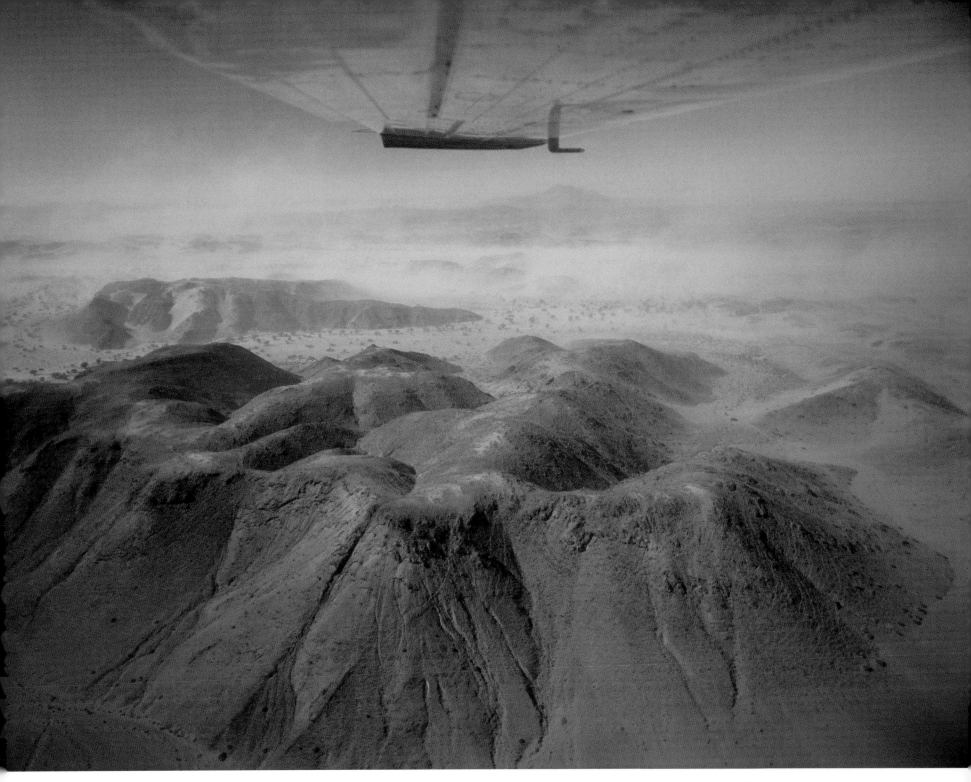

Coming in to land on a make-
shift strip in Damaraland,
northern Namibia. (2005)

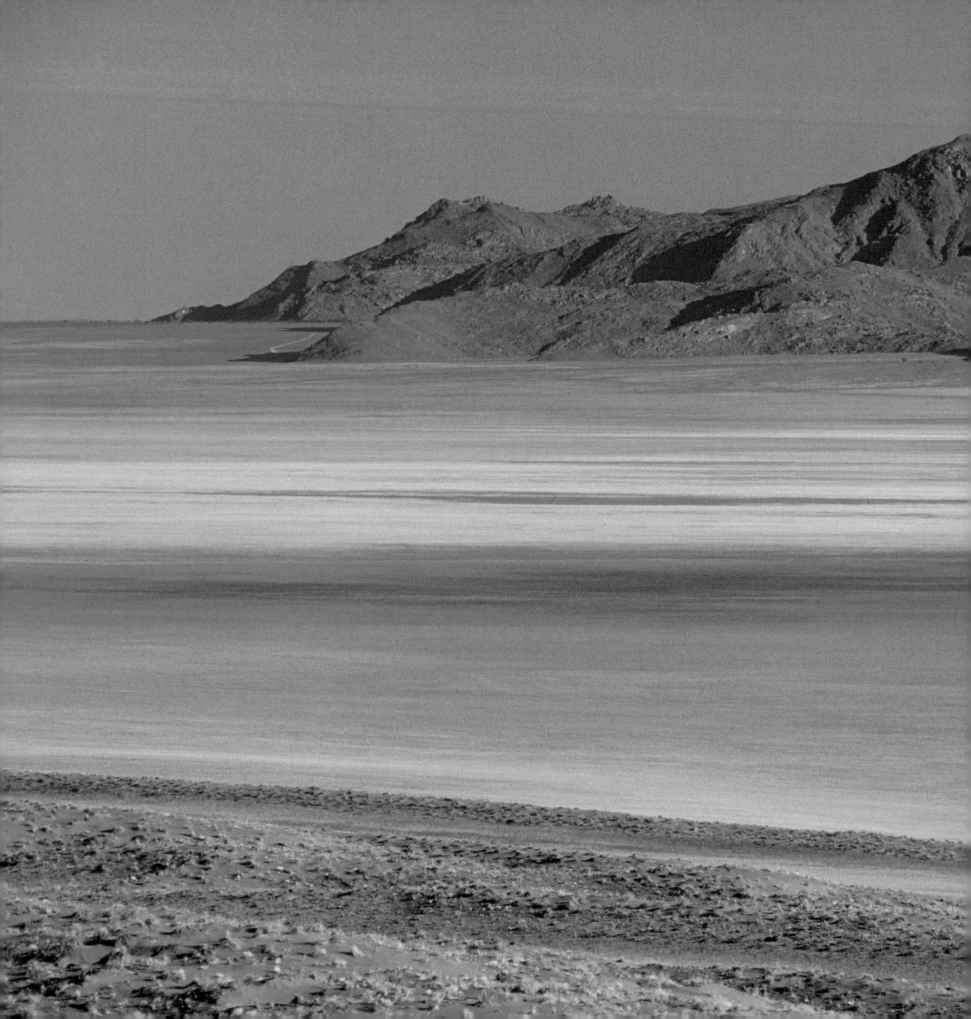

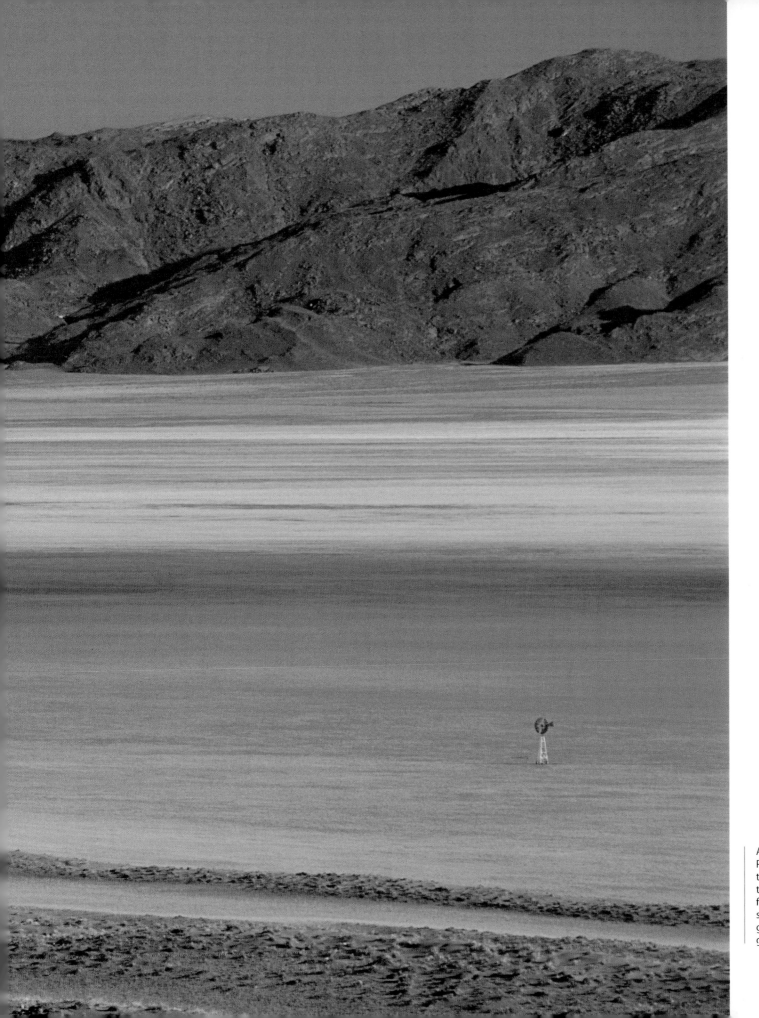

After good summer rains, Patrick Wagner headed north to photograph a Namib Desert transformed. This is the view from Gunsbewys farm, the streaks of colour created by germinating flowers and grasses. (1996)

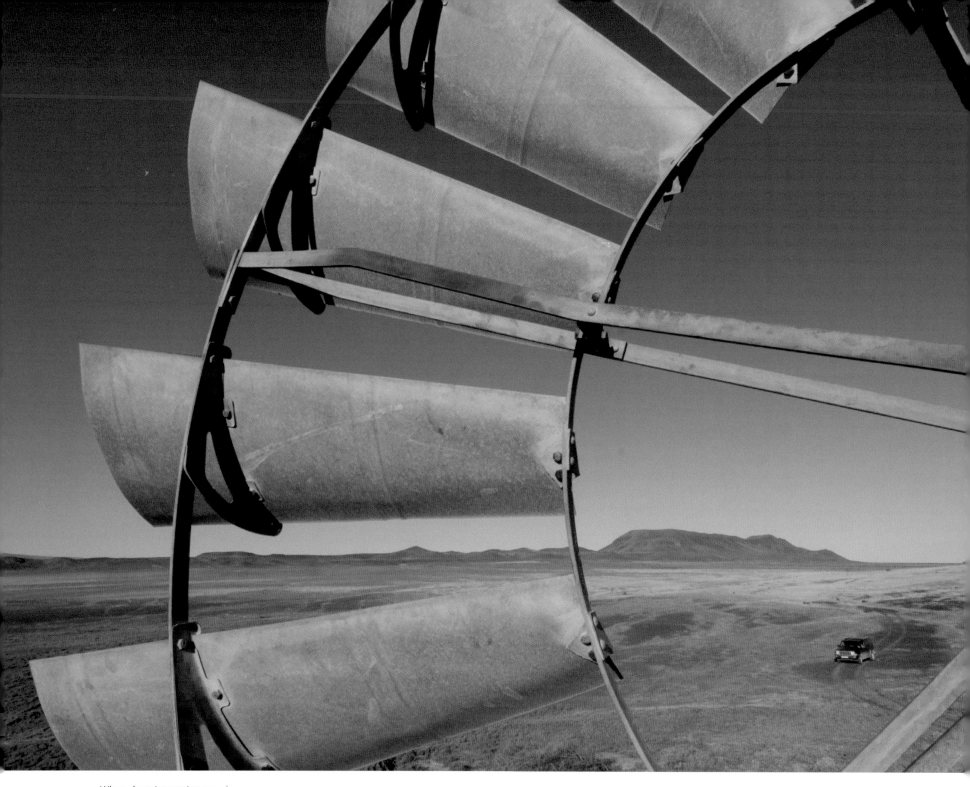

When the winter rains are good, the dusty earth turns to carpets of flowers in the Tankwa Karoo National Park. (2007)

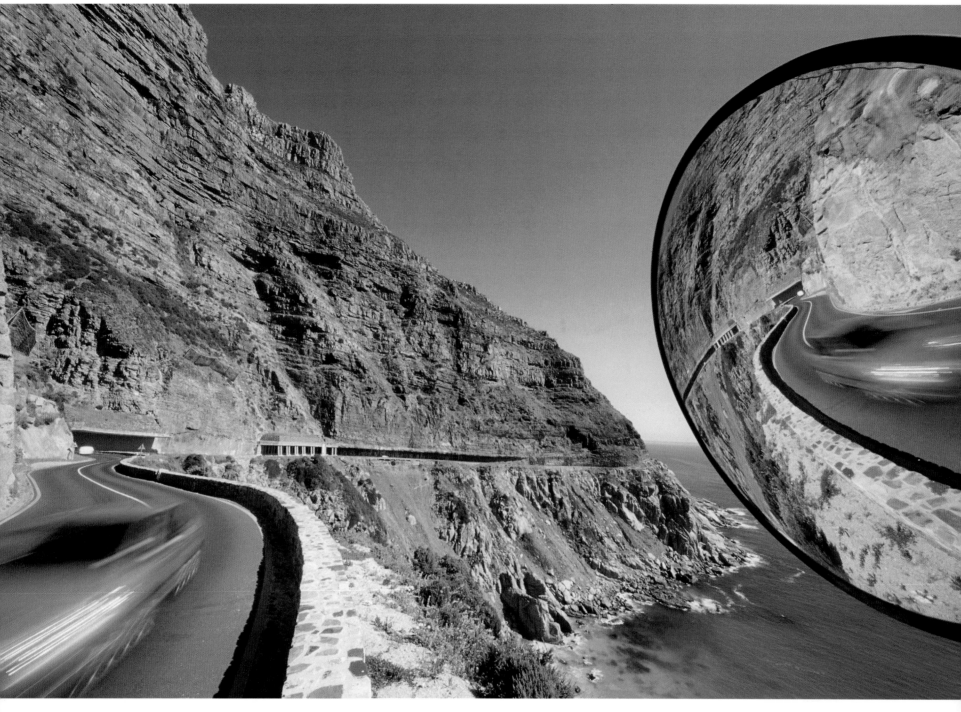

ABOVE: Chapman's Peak Drive, Cape Peninsula. (2006)

FOLLOWING SPREAD: Cosmos is a weed introduced to Southern Africa from South America during the Anglo-Boer War. In autumn in the Lesotho highlands, it carpets fallow land with spectacular blooms of pink, white and purple. (1996)

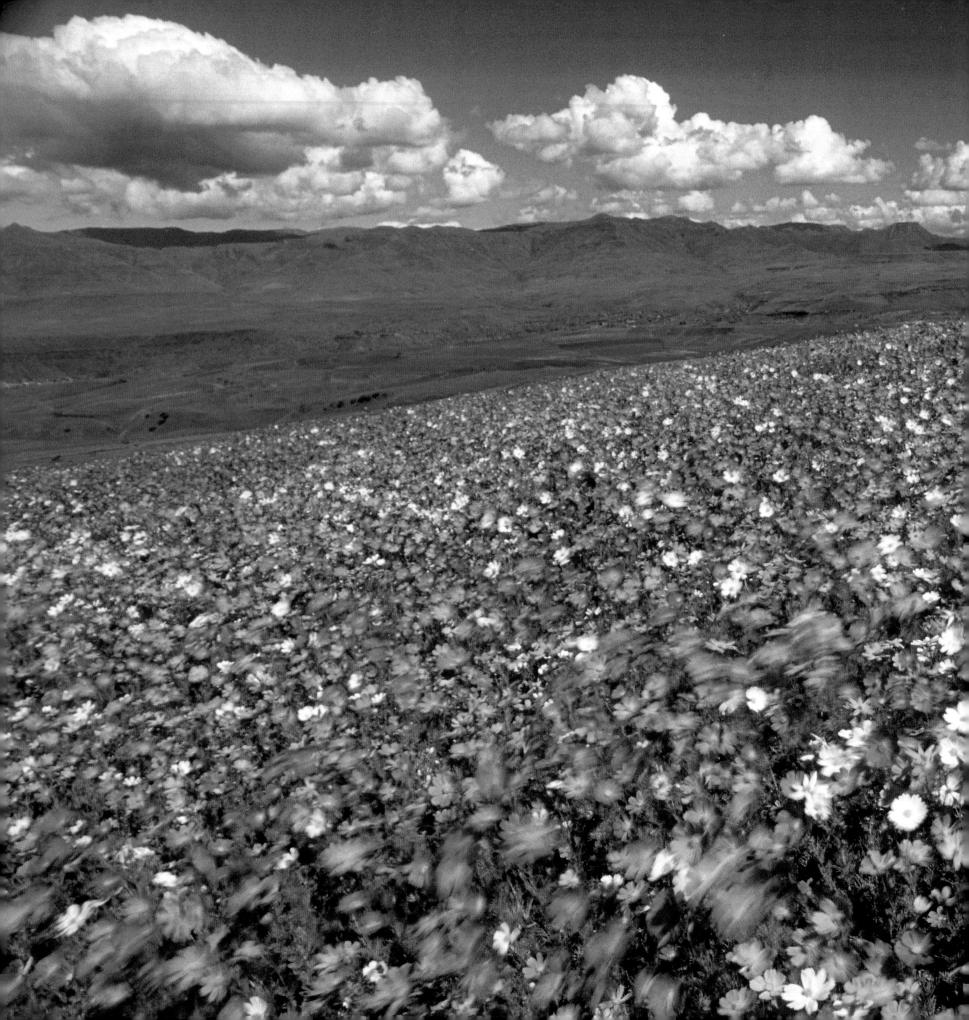

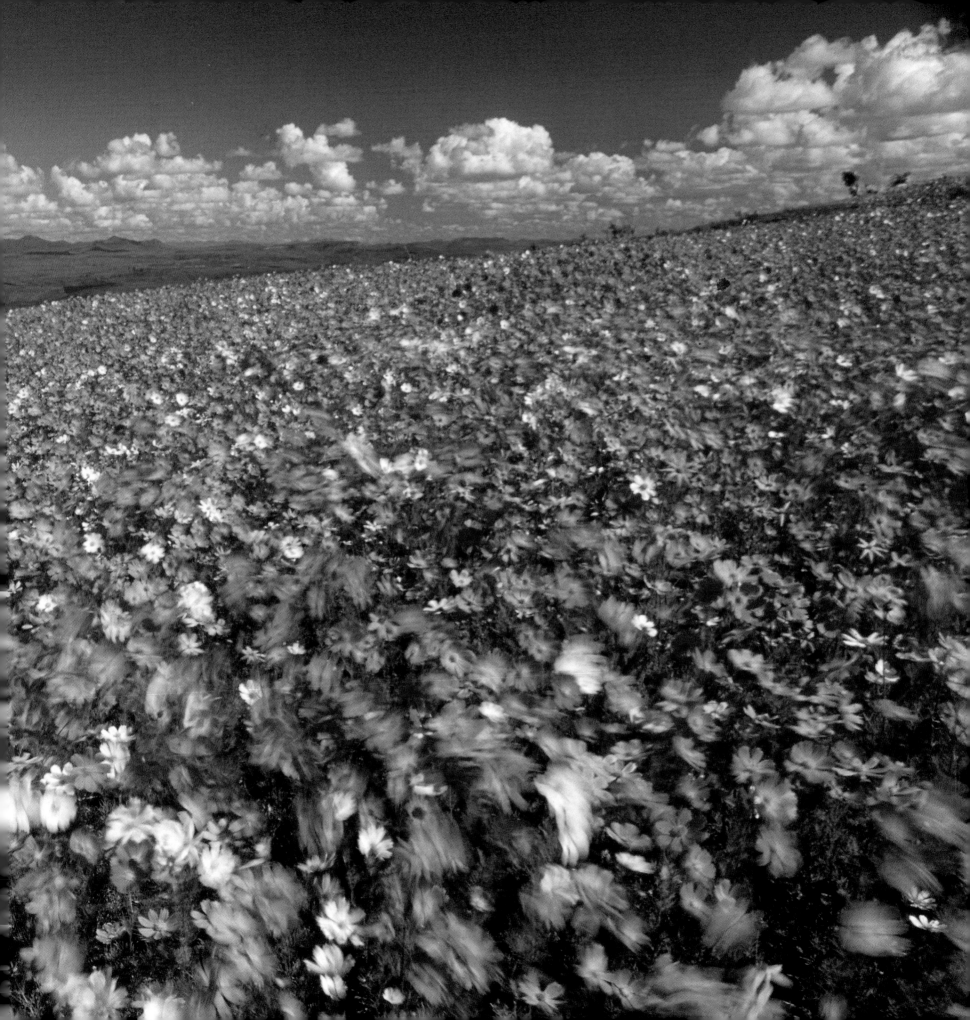

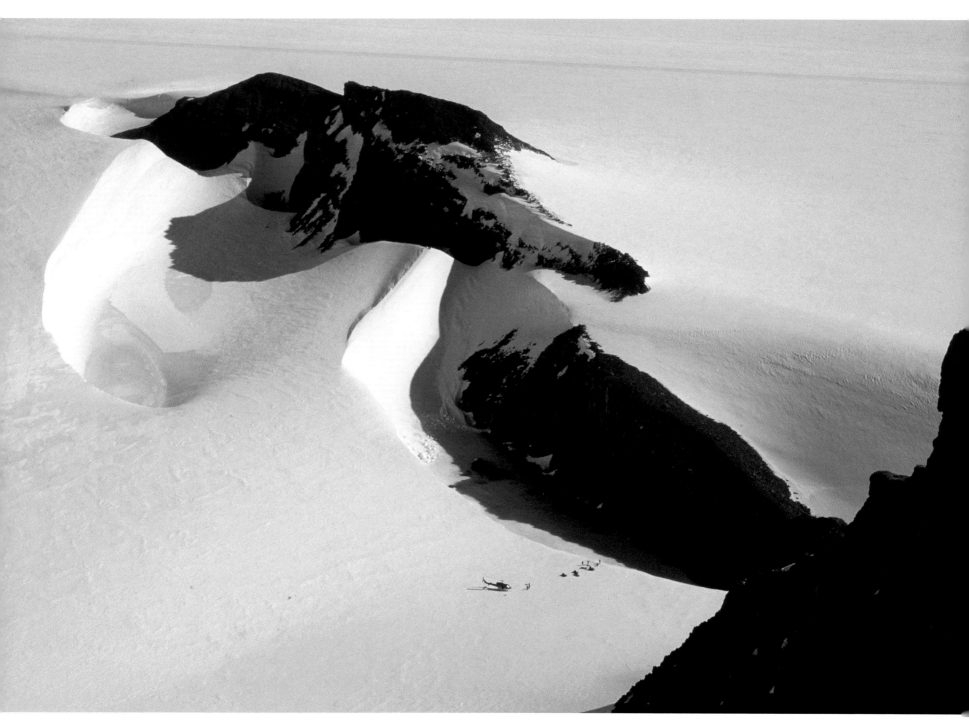

A braai at the base of a nunatak during Don Pinnock's two-month stay in Antarctica. (2005)

OPPOSITE: This image of Kibo Crater was taken during a *Getaway* ascent of Kilimanjaro's less-used Machame Route. (1998)

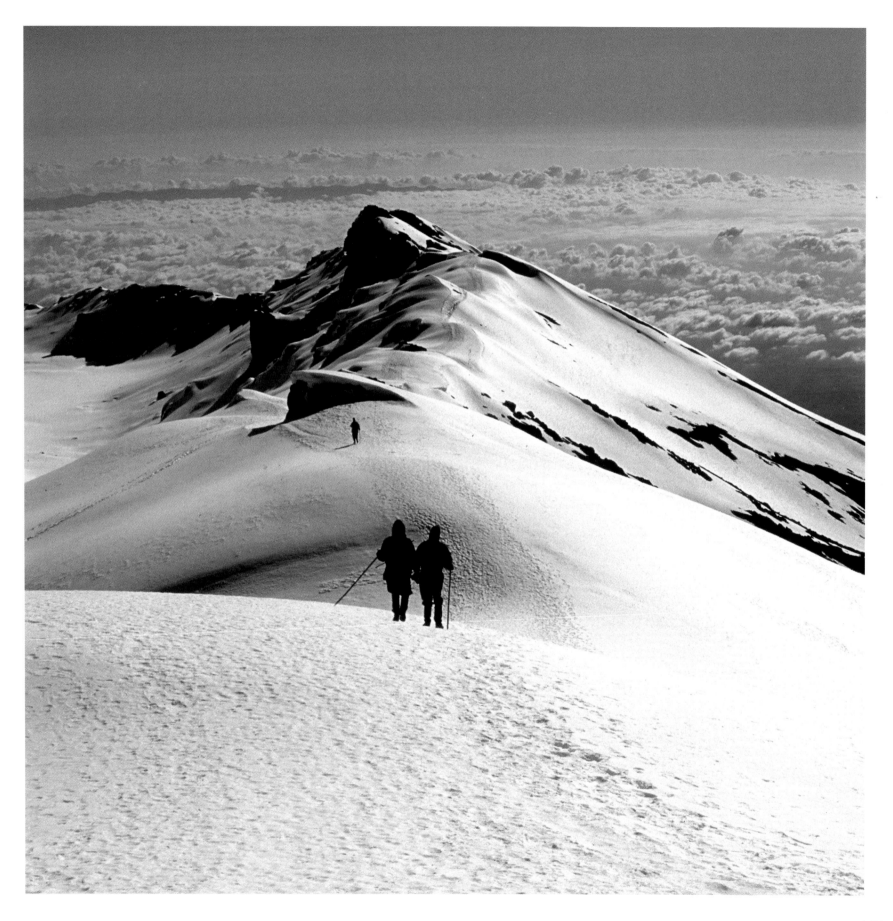

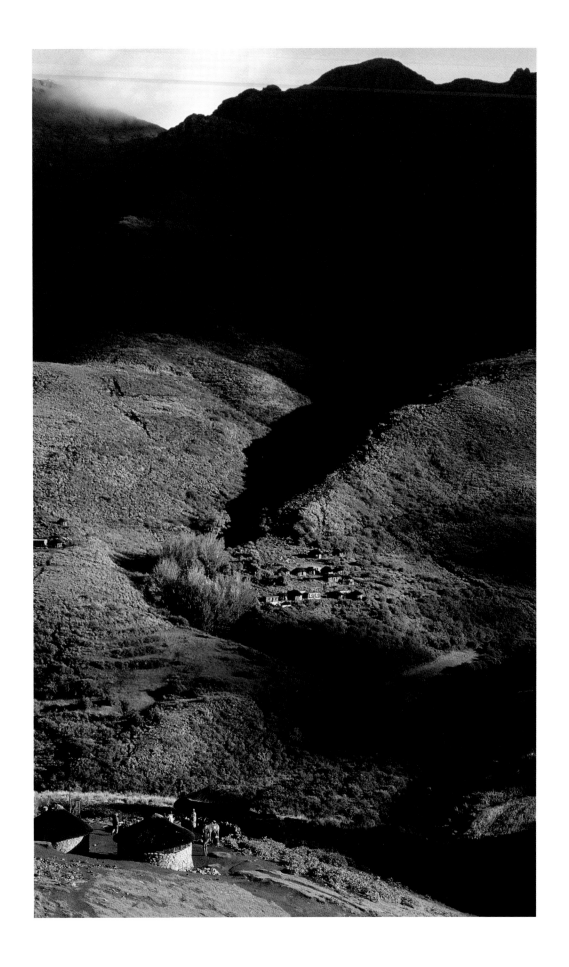

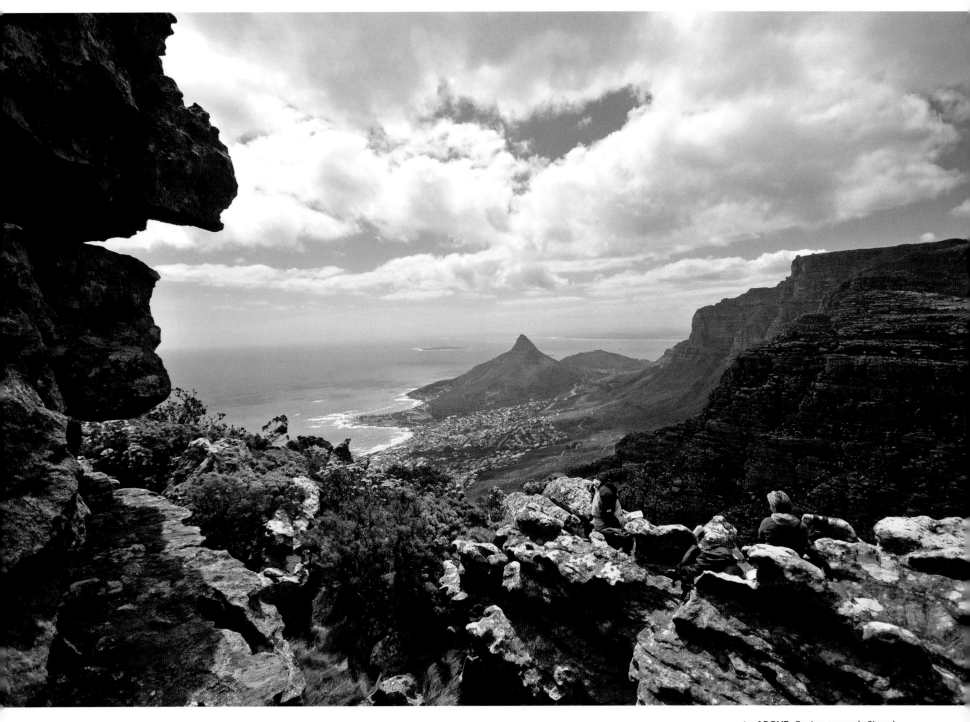

ABOVE: Gazing towards Signal Hill from Tranquillity Cracks, you feel as though you've come upon a secret hideaway above the Mother City. (2008)

OPPOSITE: Accommodation on pony treks from Malealea is provided in traditional Basotho settlements, such as this one in the heart of the Thaba Putsoa range. (1995)

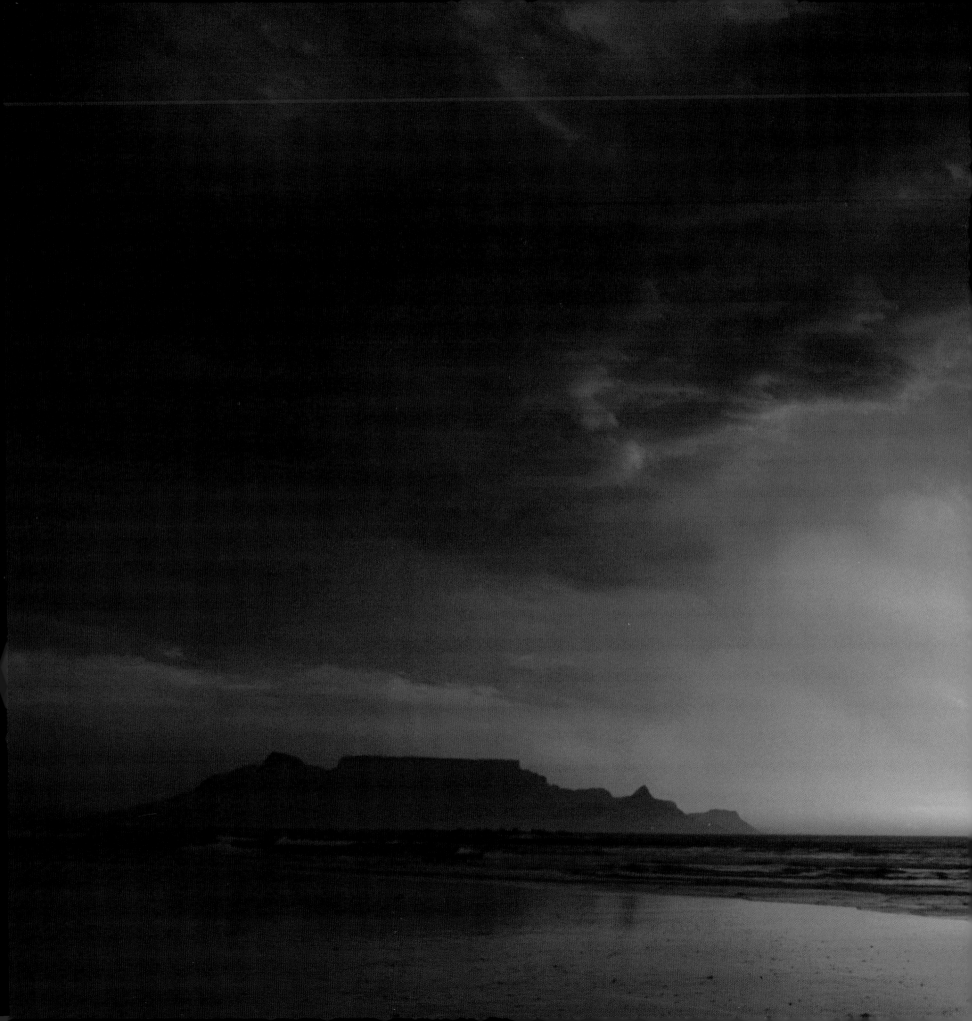

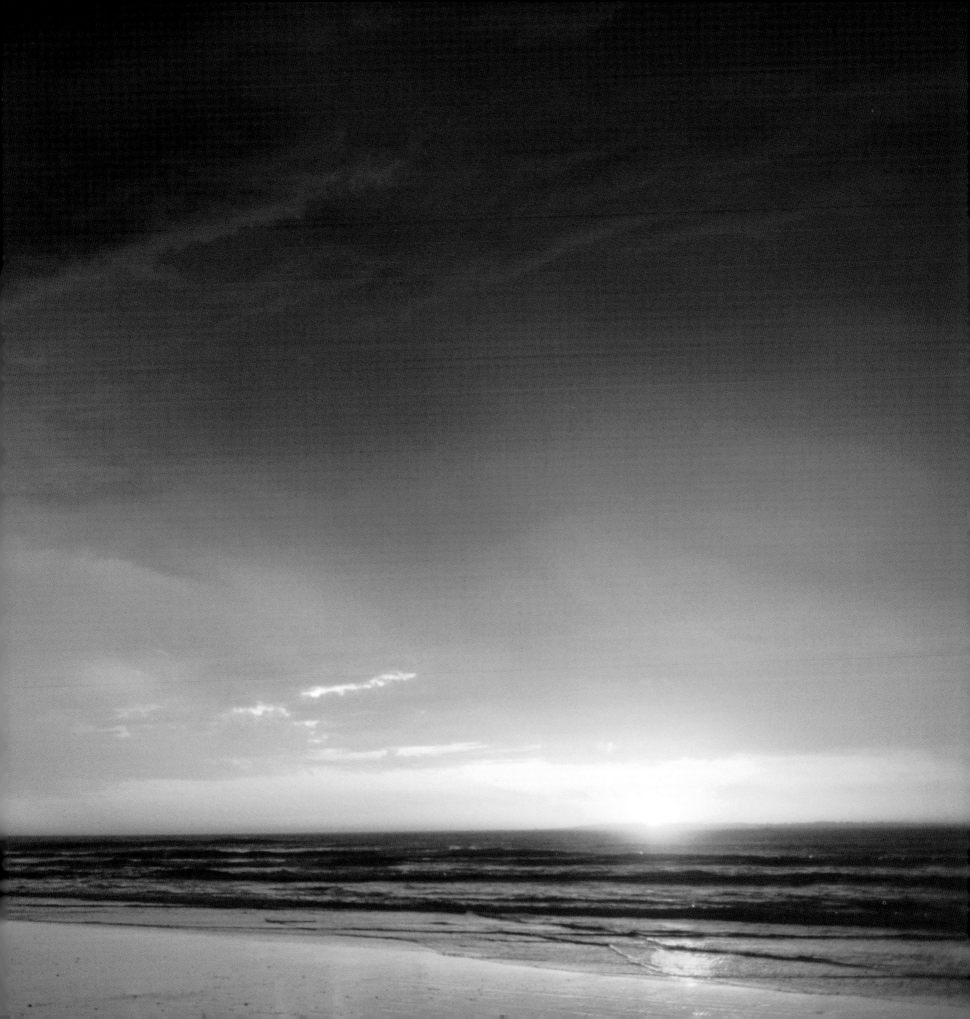

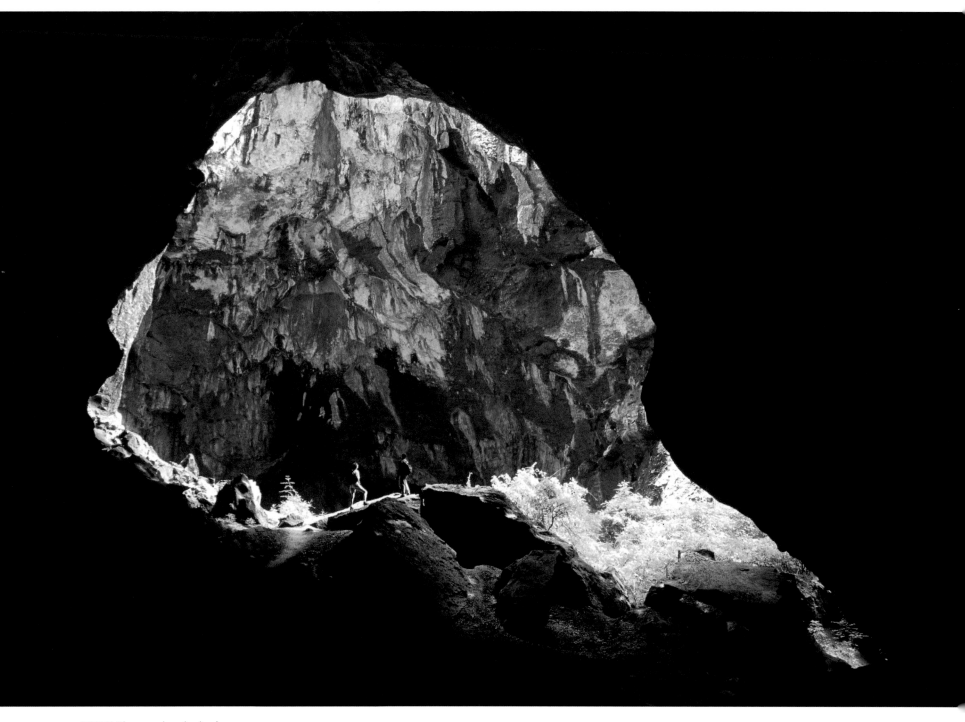

ABOVE: There are hundreds of kilometres of underground rivers in Akarana Mountain, northern Madagascar. In places the roof has fallen in, offering sanctuary to pockets of wild forest. (2001)

PREVIOUS SPREAD: Beautiful cliché: Table Mountain sunset seen from Blouberg during a freakish summer thunderstorm. (2007)

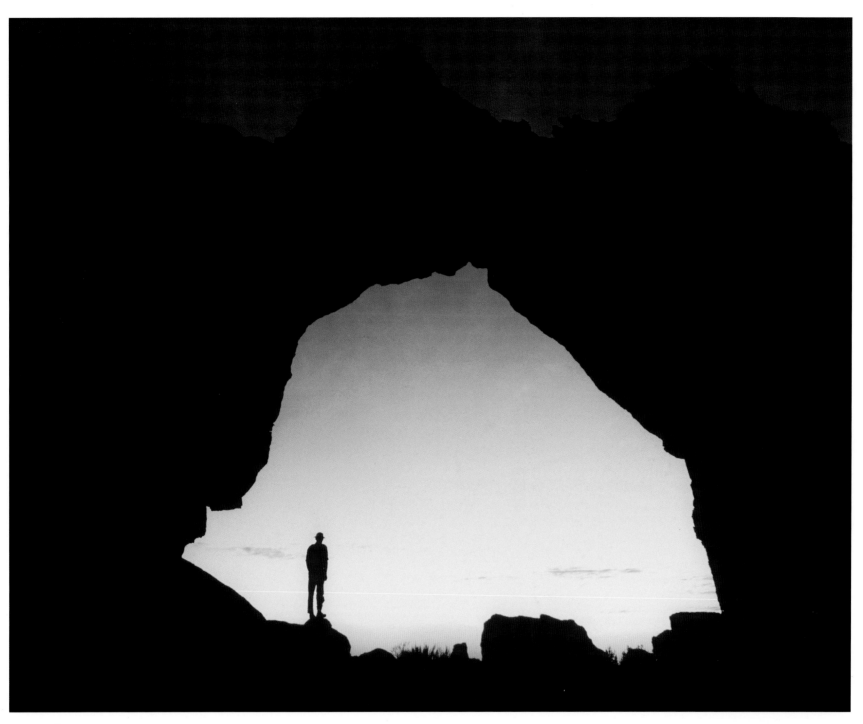

First light at the Wolfberg Arch,
central Cederberg. (1992)

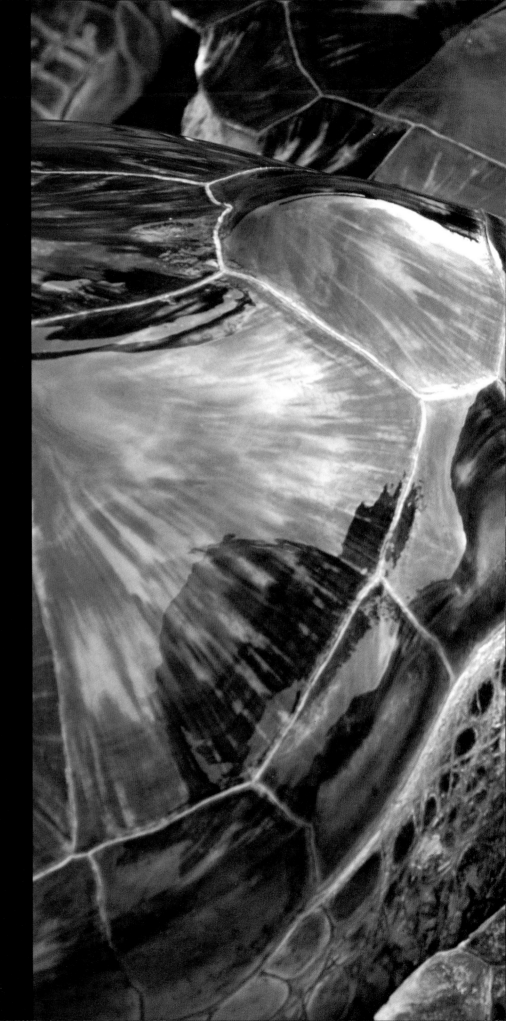

Creatures of the Wild

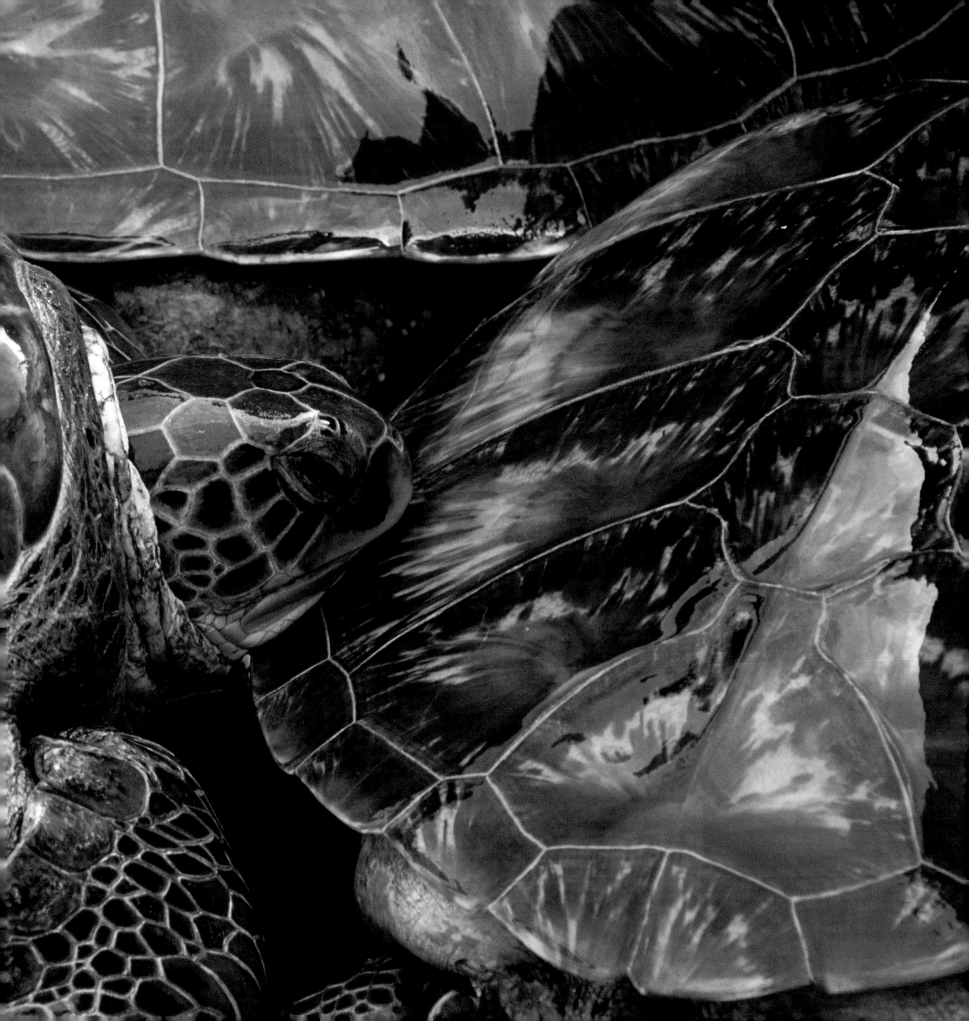

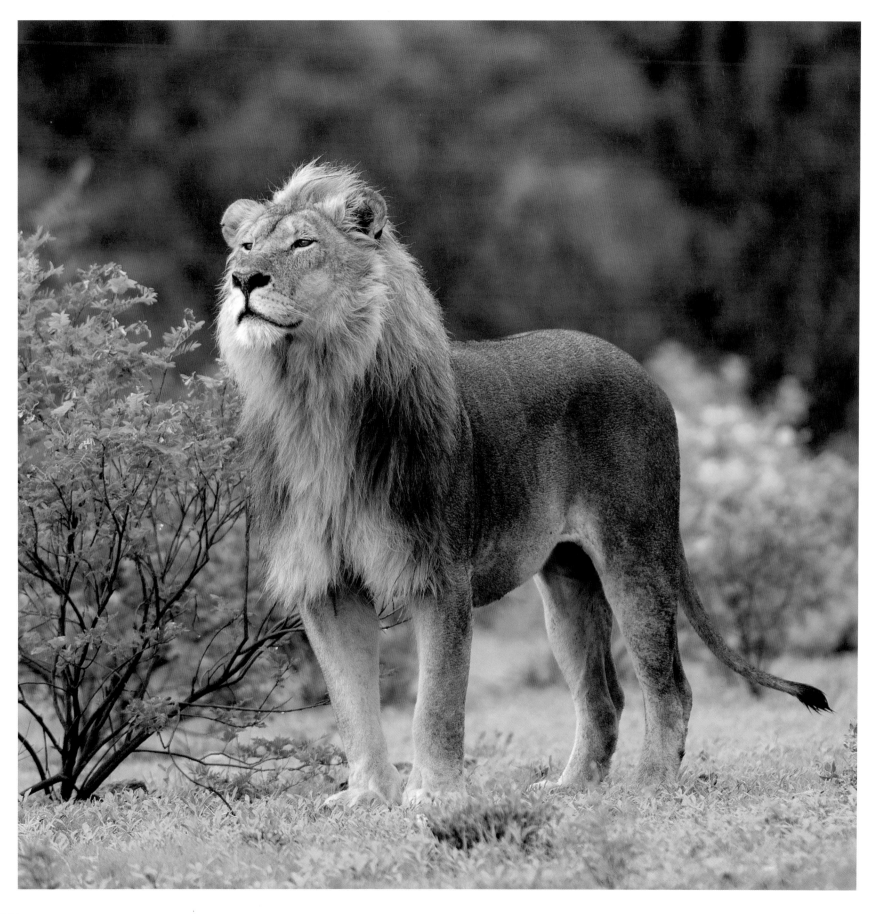

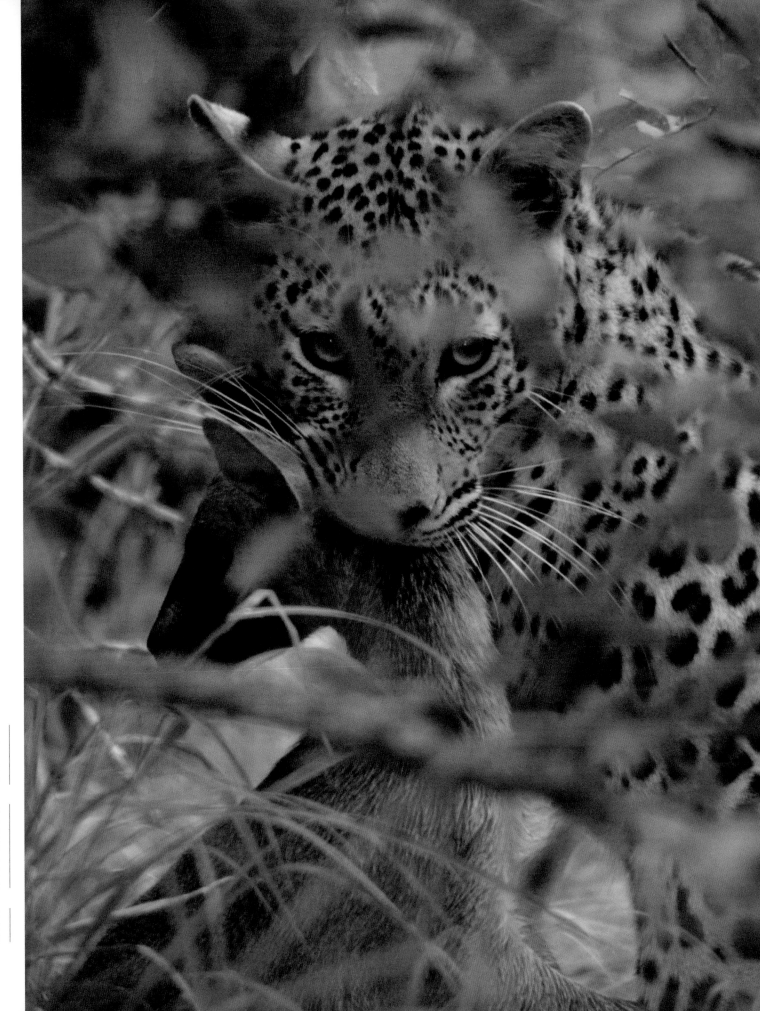

RIGHT: This image of a leopard killing a duiker was shot while Patrick Wagner was still a game ranger at Sabi Sabi Game Reserve. (1998)

OPPOSITE: Lions in arid areas are known to roam huge territories. In Etosha National Park, studies have revealed evidence of nomadic movement between the Kunene and Etosha populations. (2008)

PREVIOUS SPREAD: Green turtle abstract, Réunion Island. (1996)

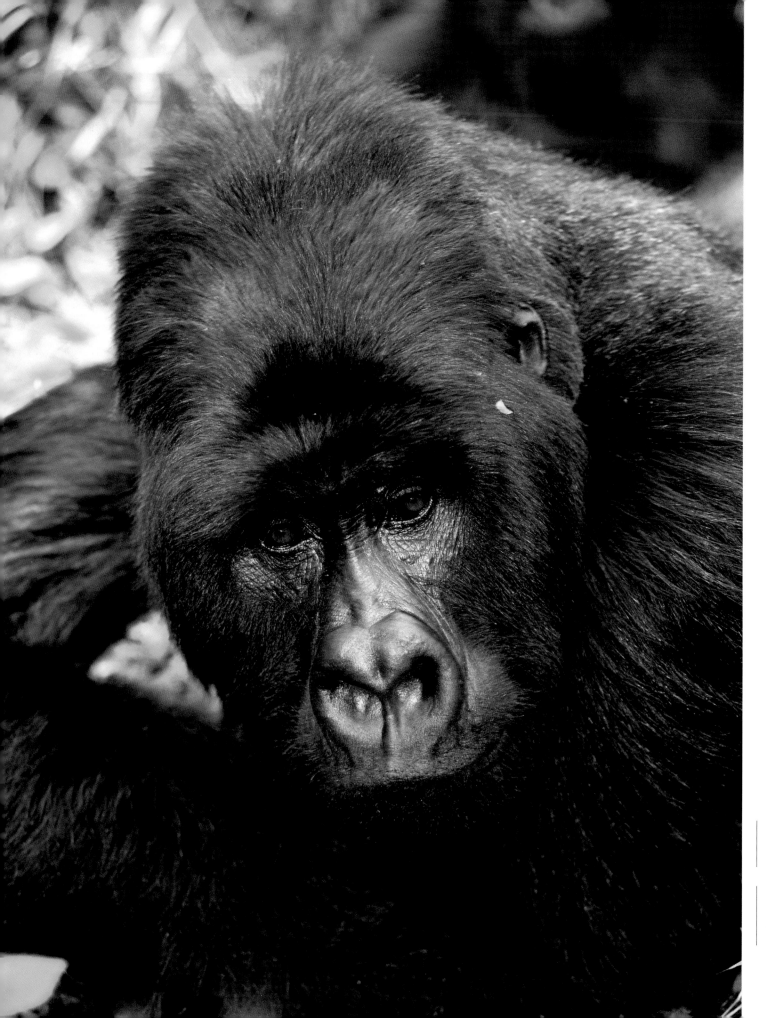

LEFT: Oscar, the silverback gorilla, Virunga Mountains, Democratic Republic of Congo. (1994)

OPPOSITE: Golden crowned lemurs are rare in the rest of Madagascar, but they're plentiful in Ankara Park in the north of the island. (2001)

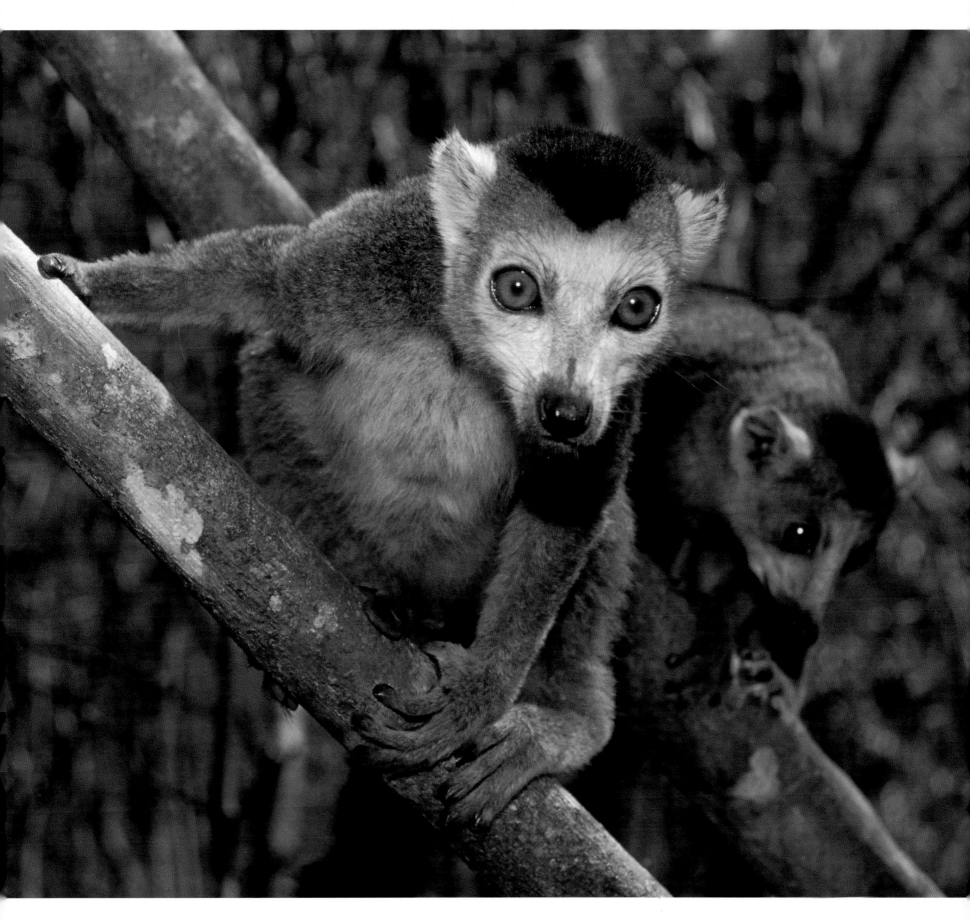

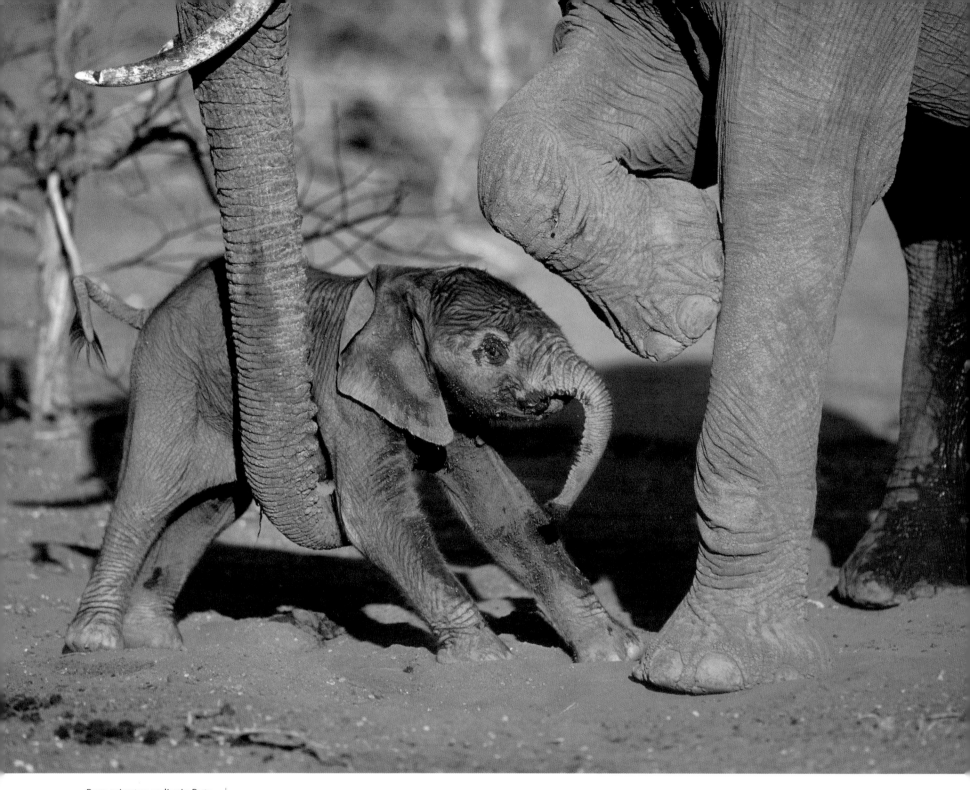

Born minutes earlier in Bots-
wana's Tuli Block, this calf
needed a helping trunk from
mother to stay upright. (2006)

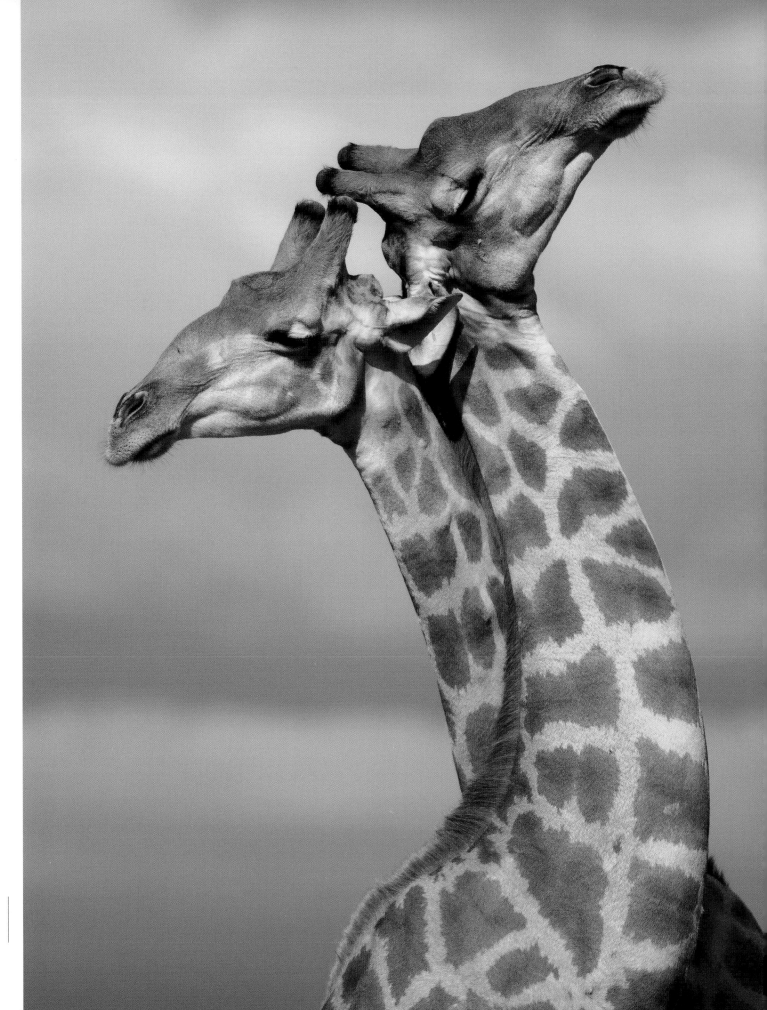

Giraffes 'necking' in Etosha National Park. This soft rubbing action is very different to sparring. (2008)

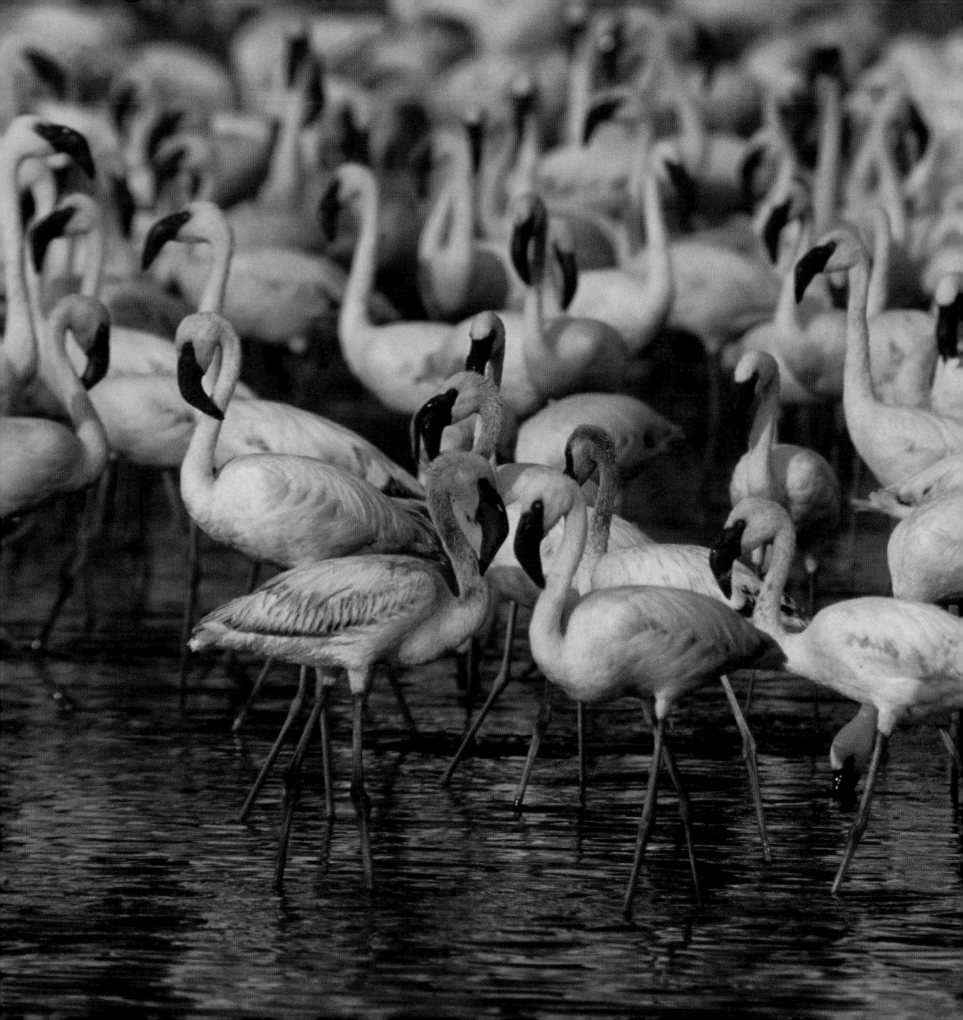

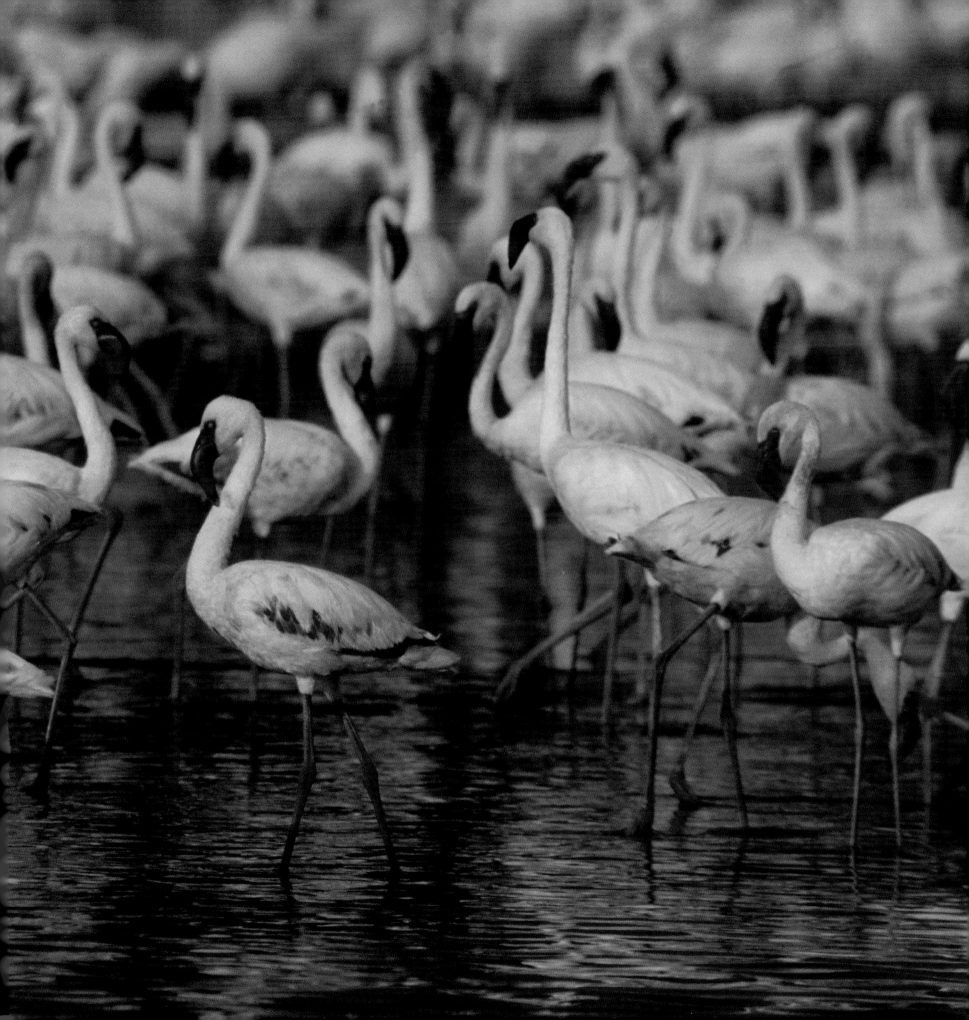

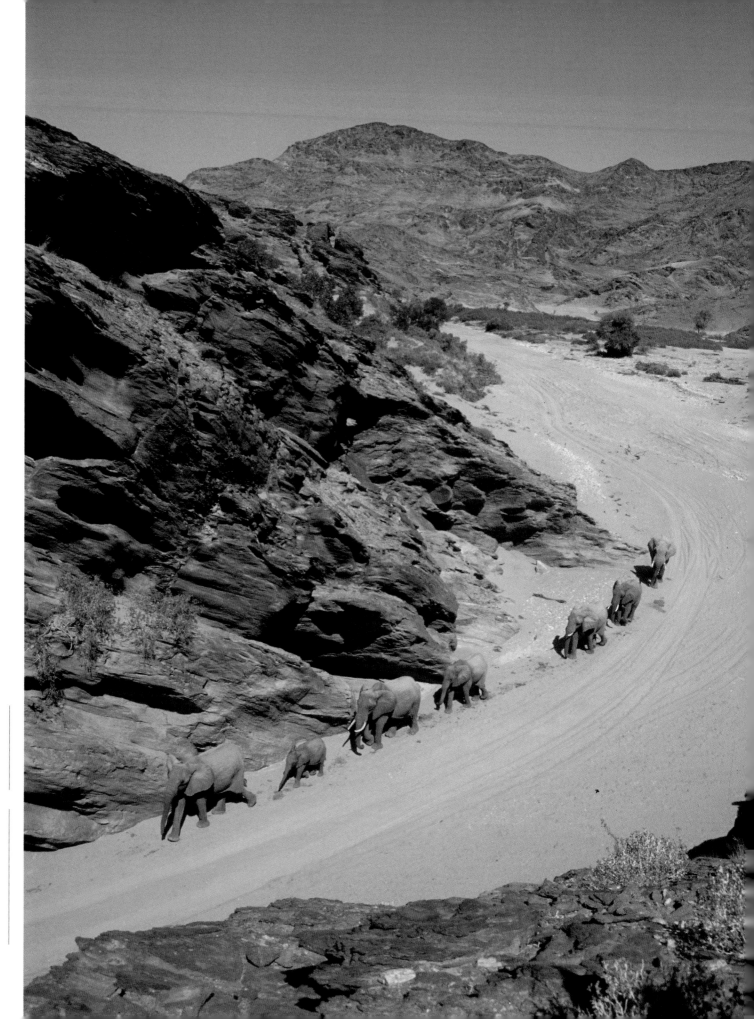

RIGHT: The dry Hoanib River in Kaokoveld is a highway for desert animals. Thirsty for the water of a nearby oasis, a breeding herd of elephants files through a narrow gap near Dubis. (1997)

PREVIOUS SPREAD: *Getaway* joined adventurer Kingsley Holgate following in the footsteps of 19th century Austrian explorer Count Samuel Teleki von Szek down the Great Rift Valley. The massing of nearly two million flamingos at Lake Bogoria was a photographic highlight of that journey. (1996)

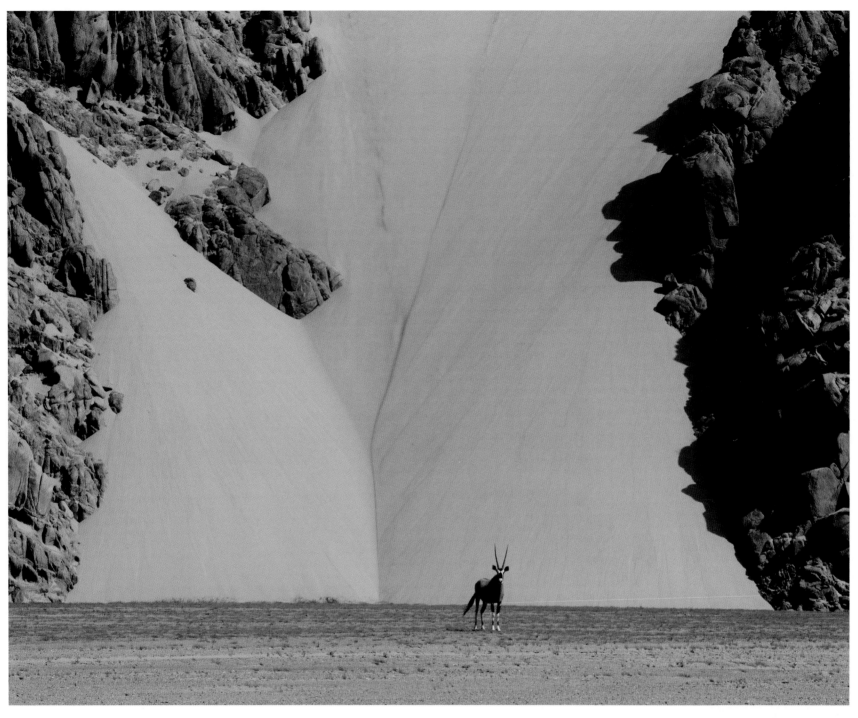

Approaching the sea along the Hoarusib River in Namibia's Kaokoveld, the dunes grow to enormous proportions and animals seek what little verdure and water the dry bed can provide. (2009)

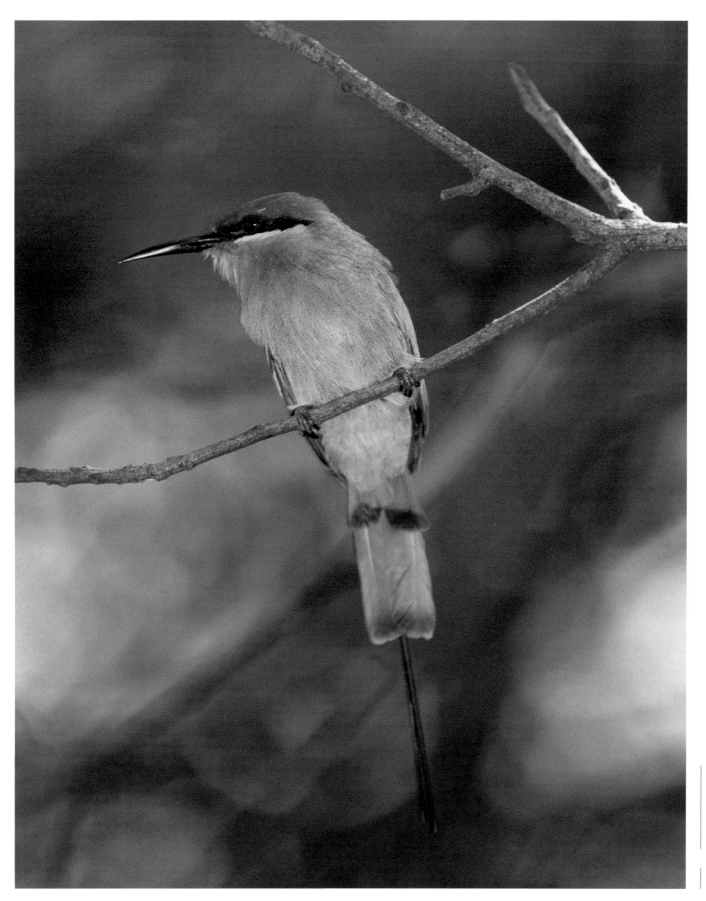

LEFT: This Böhm's bee-eater in Liwonde National Park, Malawi, launched itself from its perch to catch insects with a loud snap of its beak, then returned and beat them on the branch before devouring them. (2002)

OPPOSITE: Adélie penguins are Antarctica's comics. (2005)

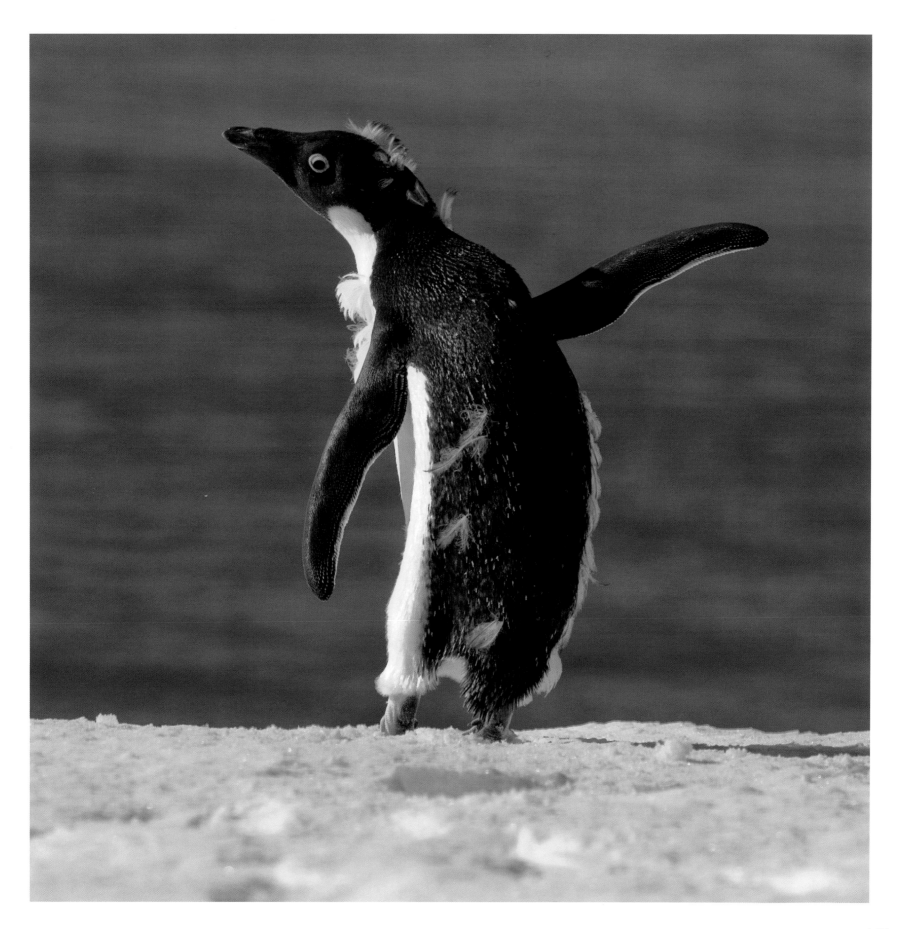

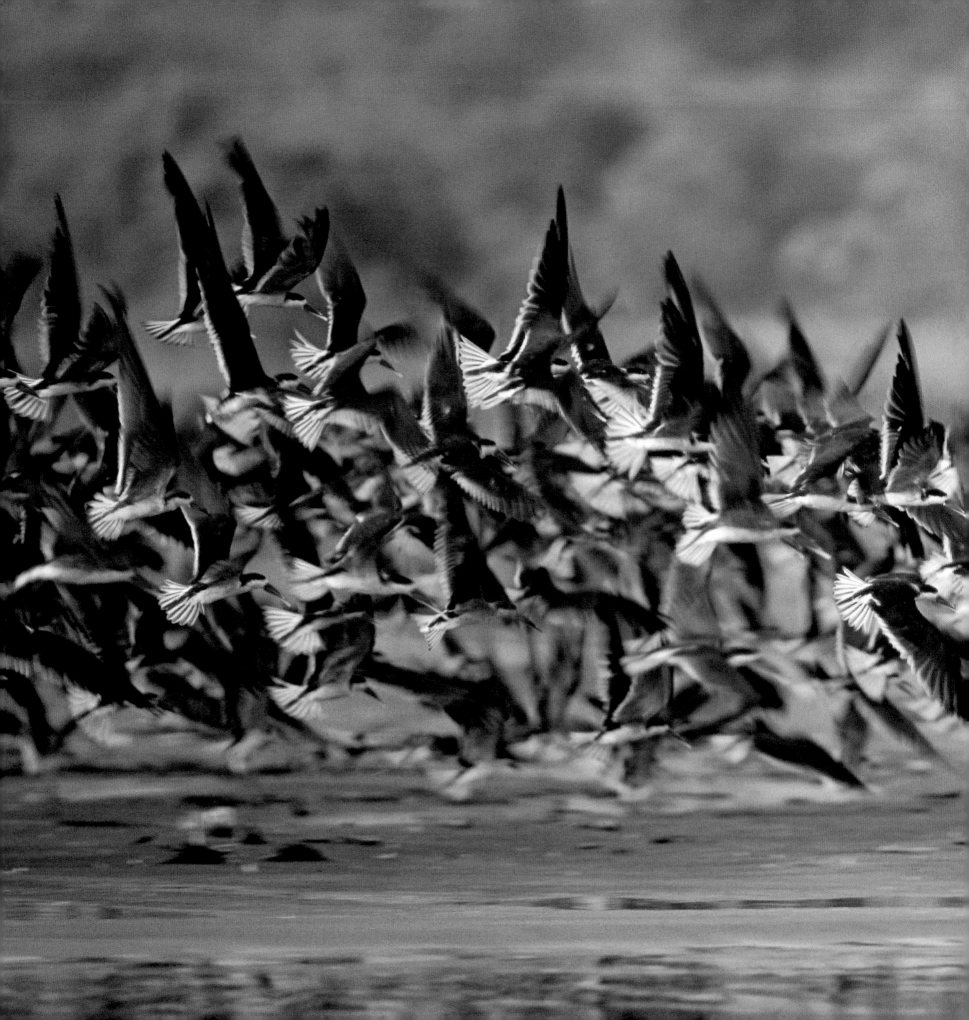

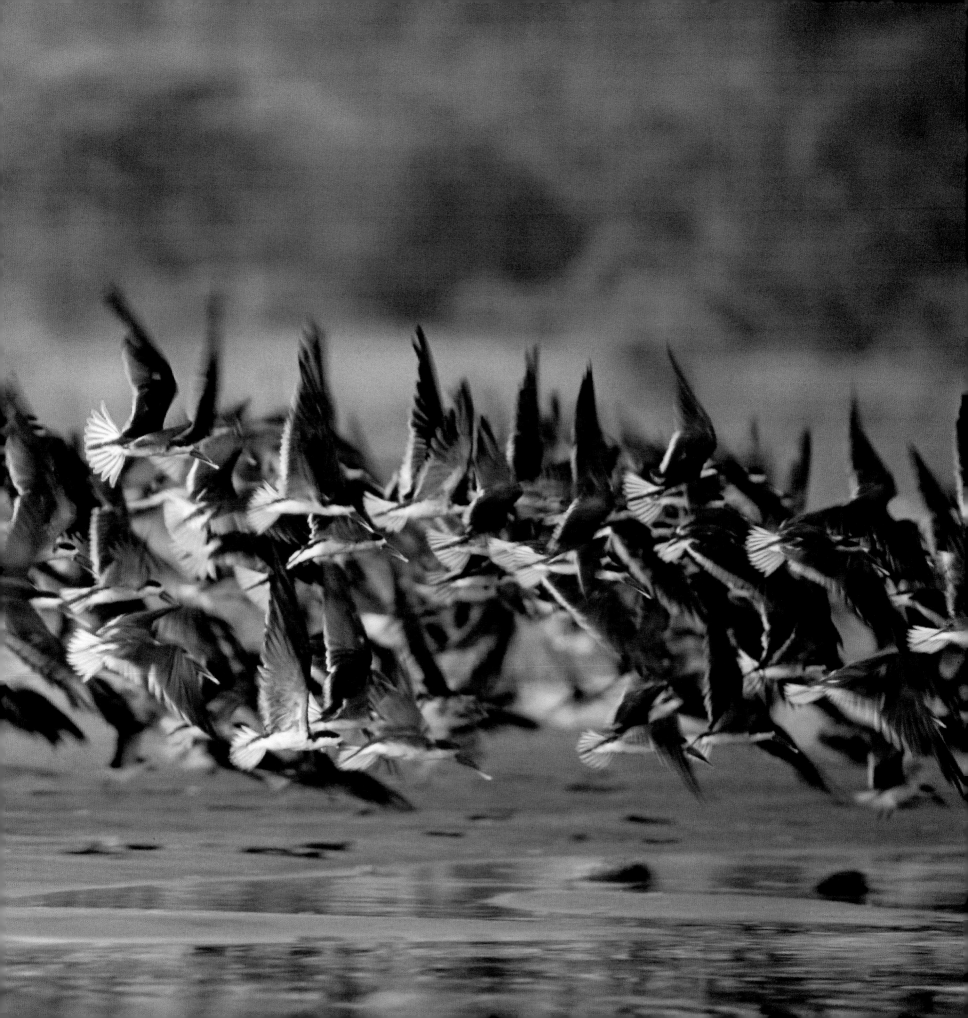

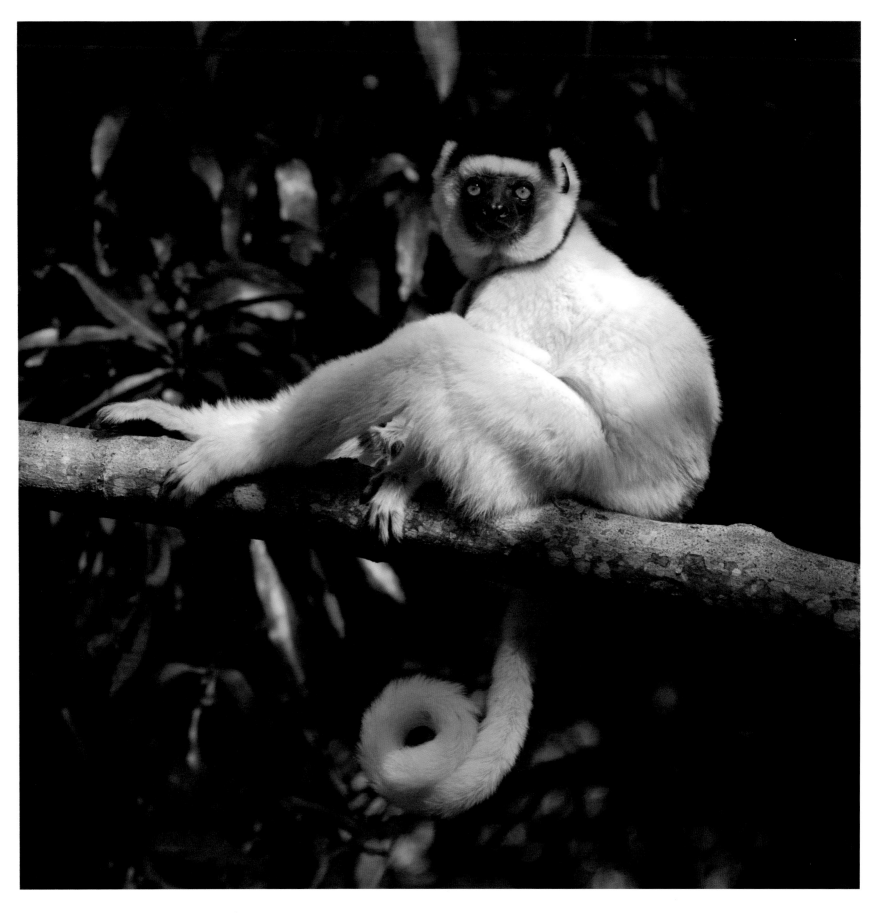

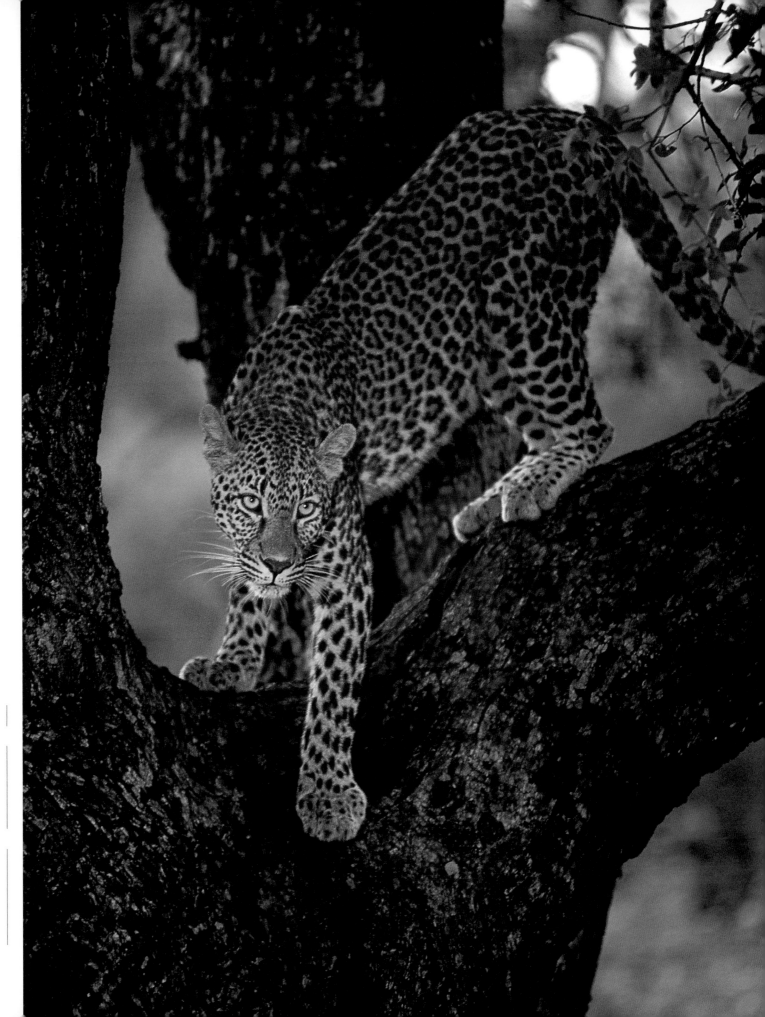

RIGHT: A young Kruger Park leopard at dawn. (2007)

OPPOSITE: Verreaux's sifakas are part of Madagascar's indri family. Unlike tree-bound indris, they frequently hop along the ground on two feet, earning the name 'the dancing lemurs'. (2008)

PREVIOUS SPREAD: Flying low and fast, often at night, and with an elongated lower beak cleaving the water is a smart way to catch fish. Flocks of African skimmers patrol the waters at Murchison Falls National Park, Uganda. (1996)

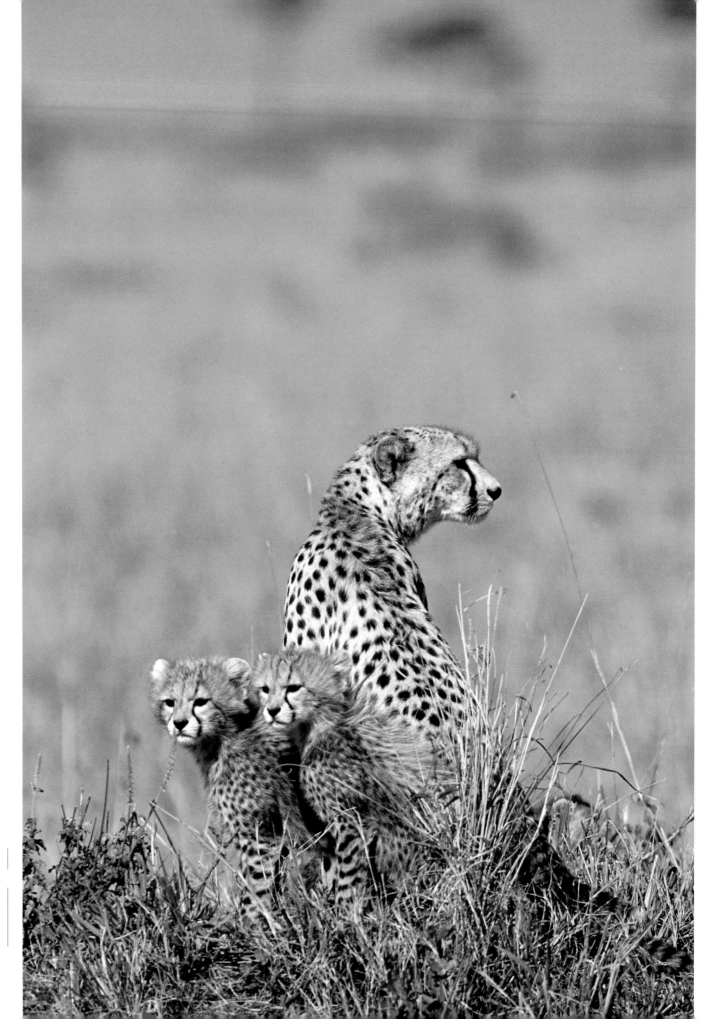

RIGHT: Cheetah and cubs in the Masai Mara, Kenya. (2003)

OPPOSITE: This herd of springbok enjoyed the boundless food the summer rains of 2001 provided for the Kalahari's creatures. (2001)

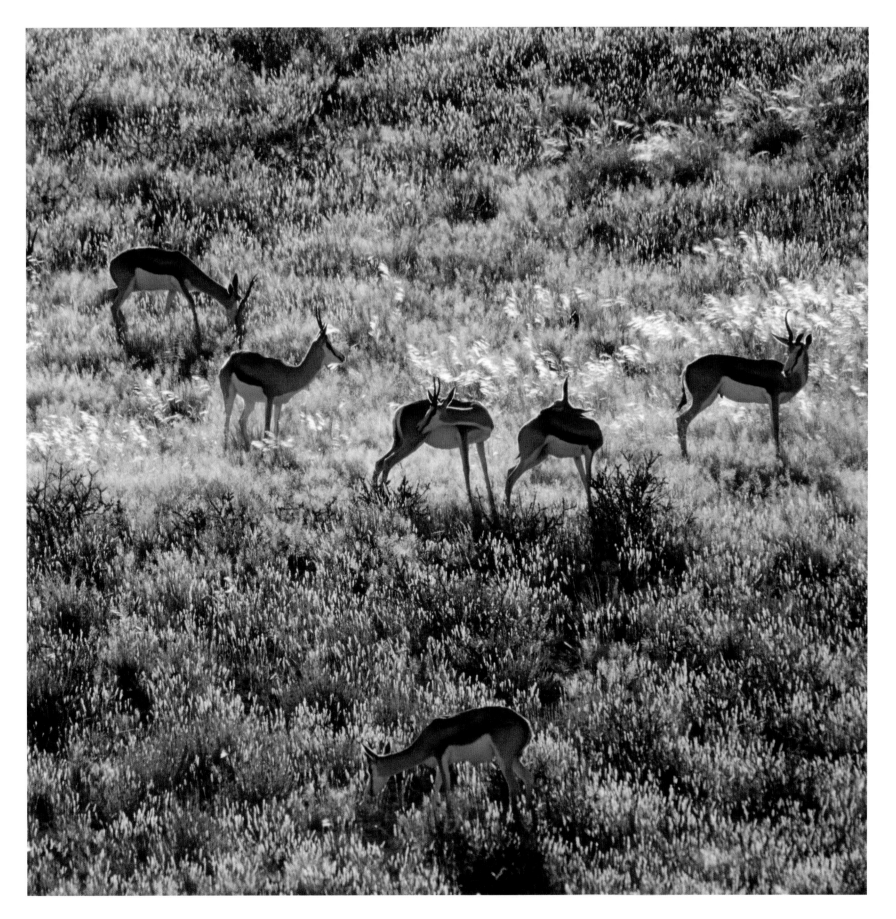

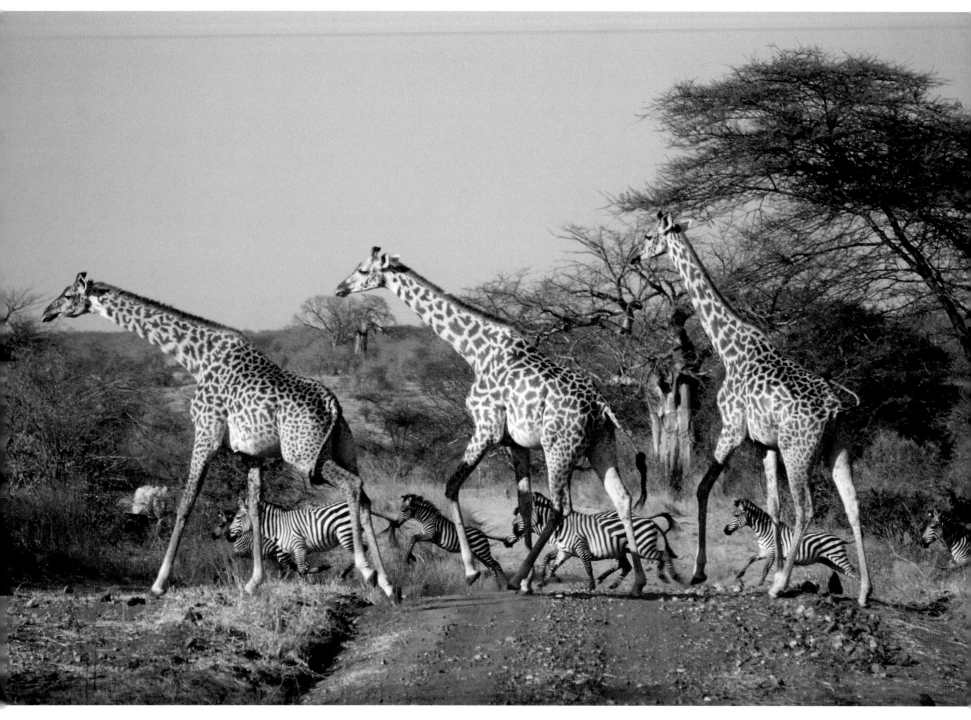

ABOVE: Giraffe-and-zebra crossing, Ruaha National Park, Tanzania. (1997)

OPPOSITE: A leopard climbs a baobab to devour its zebra kill in Ruaha National Park. (1997)

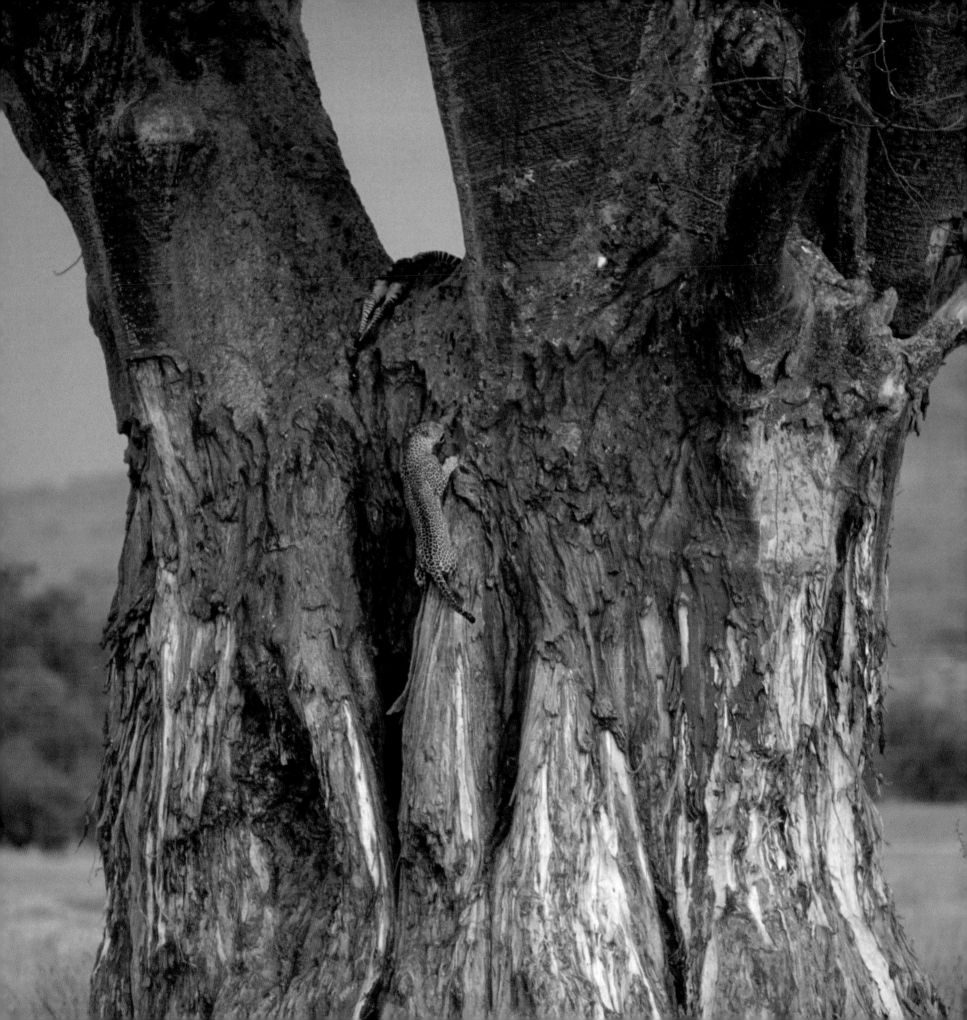

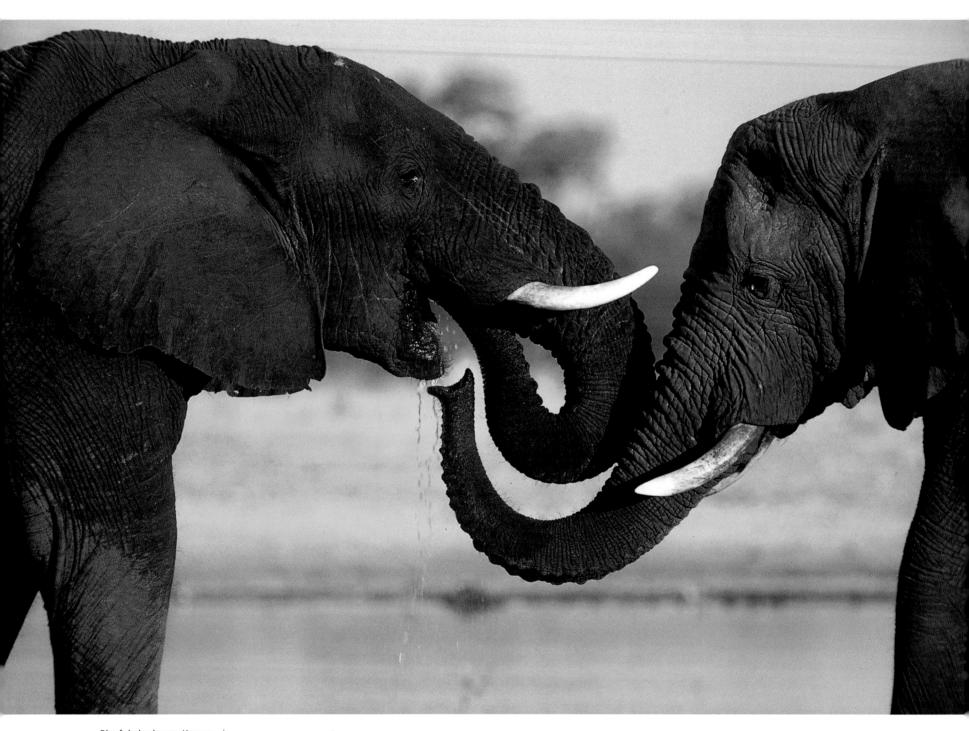

Playful elephants, Kruger
National Park. (2007)

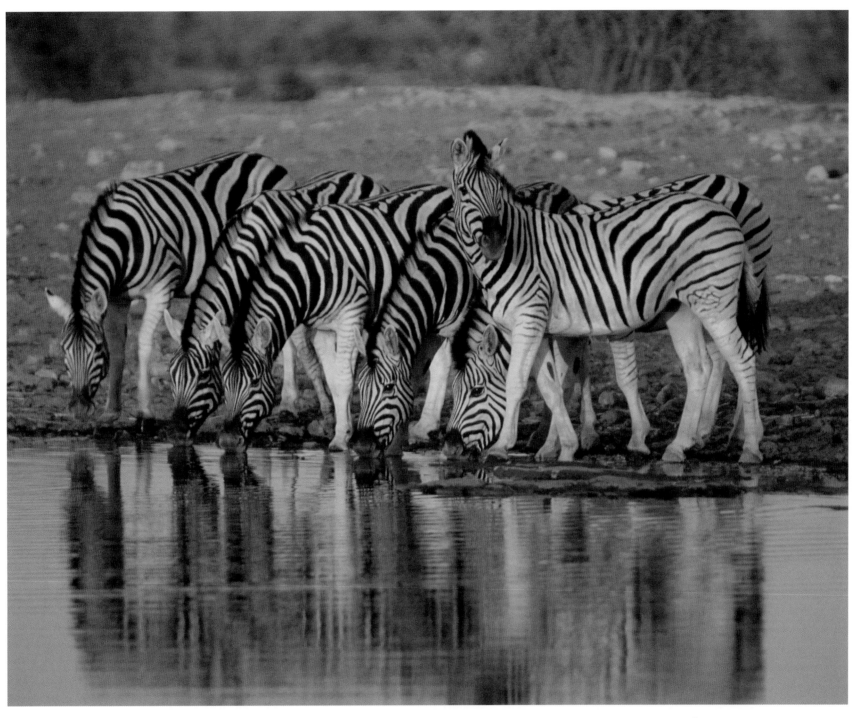

A waterhole sunset in Etosha
National Park, Namibia. (2005)

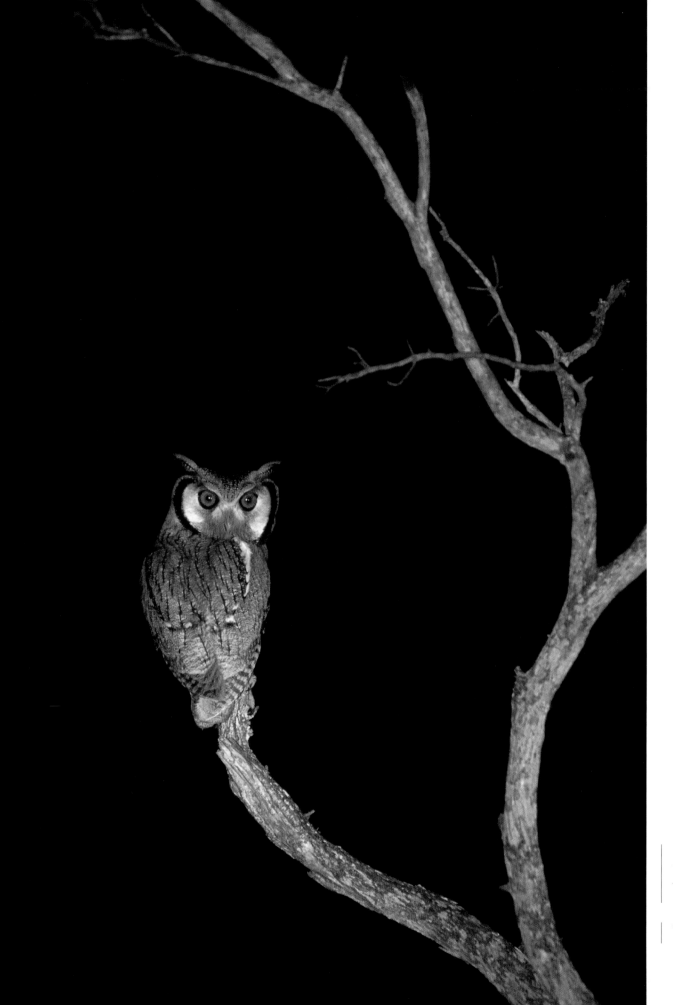

LEFT: A white-faced owl sizes up guests in a Land Rover near Dyason's Camp in Thornybush Nature Reserve, Mpumalanga. (1997)

OPPOSITE: Wildebeest on the rise, MalaMala. (2004)

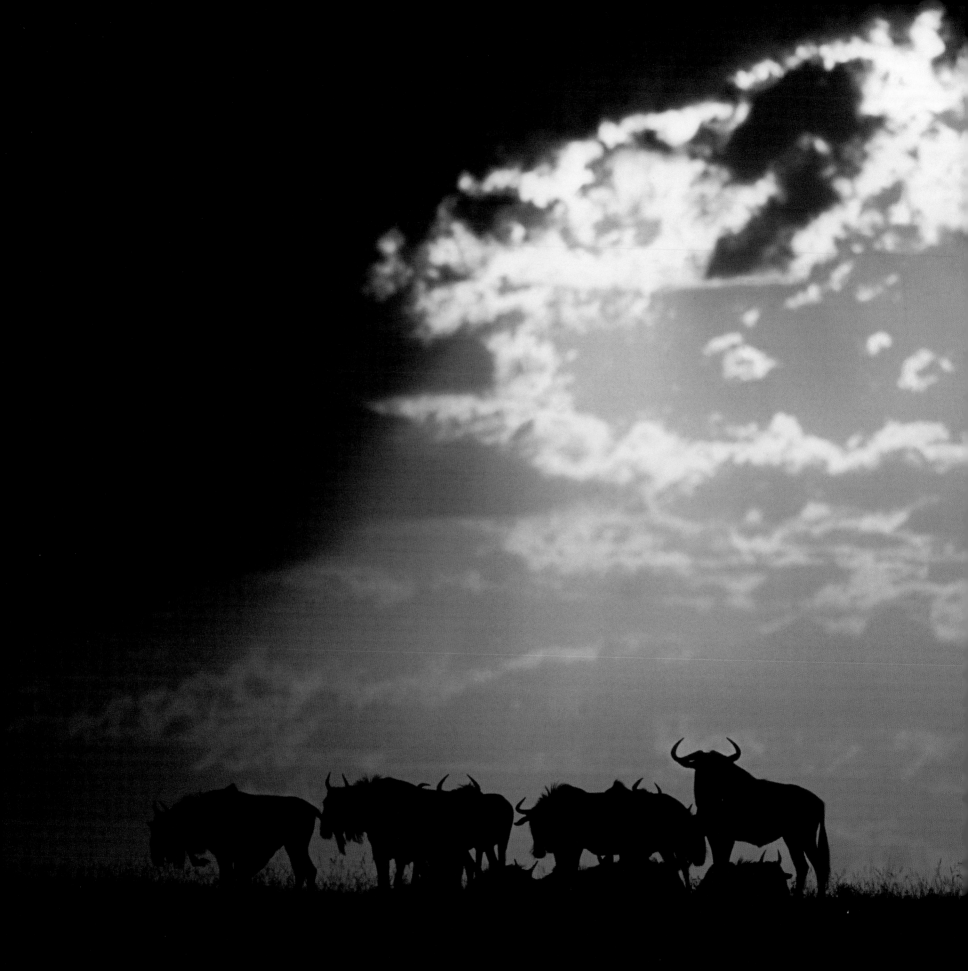

Waterways

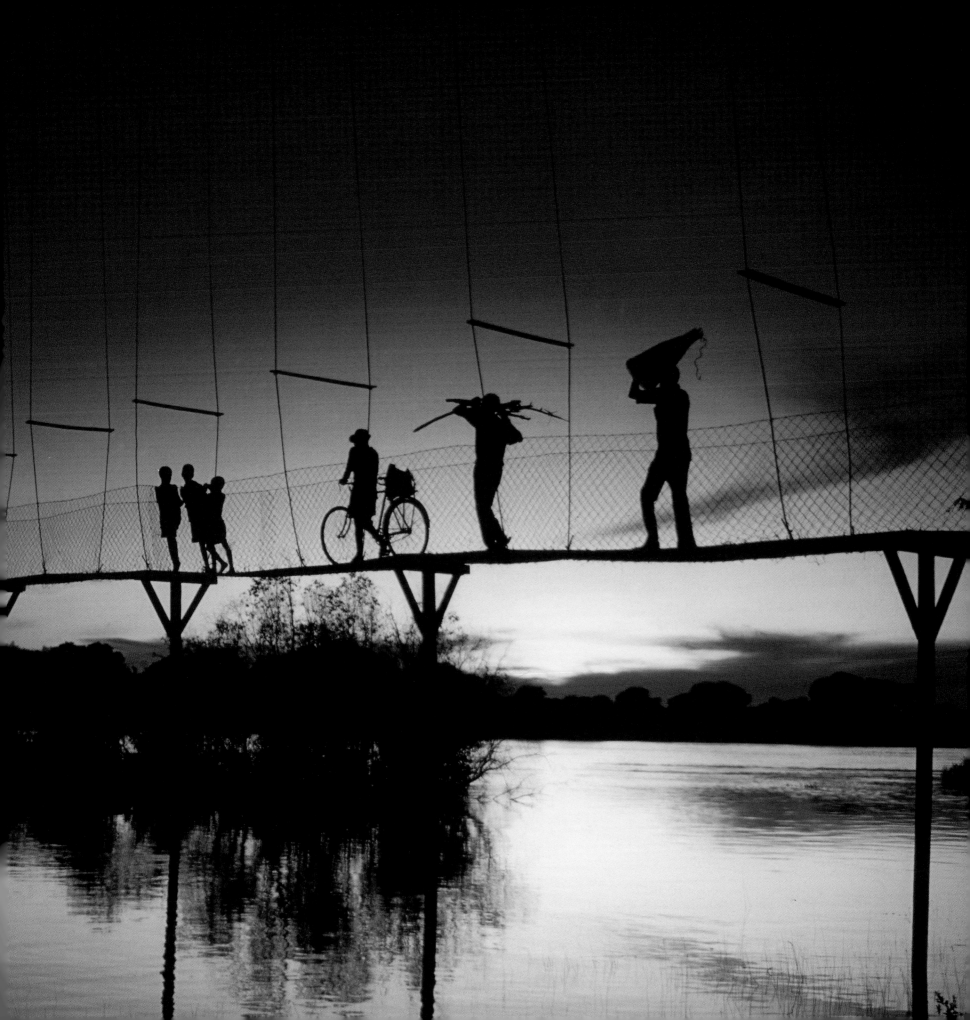

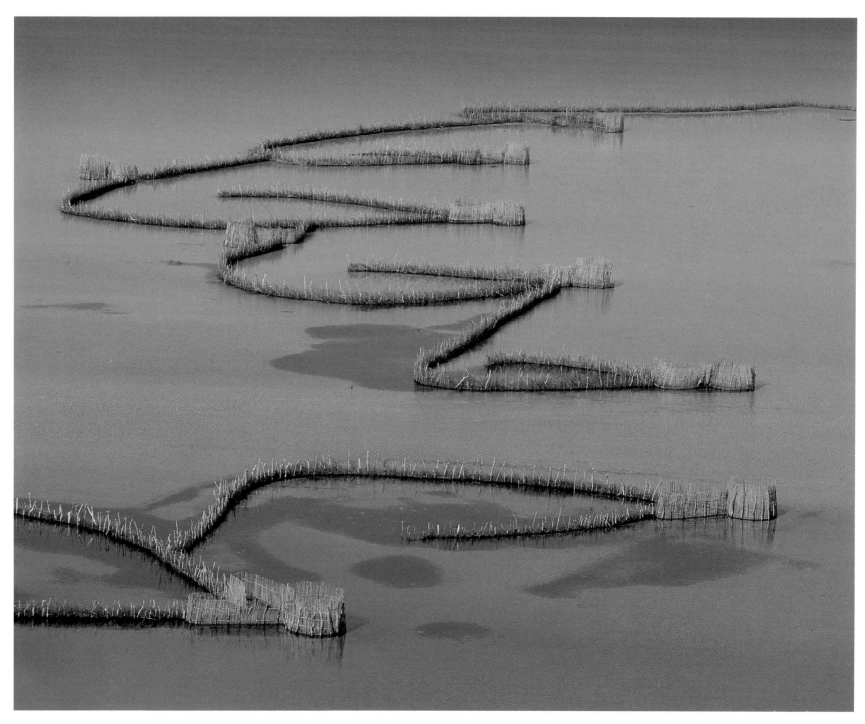

ABOVE: For hundreds of years, local communities have set elaborate fish traps in the Kosi Bay estuary. (2008)

PREVIOUS SPREAD: This suspension bridge over the upper Zambezi at Chinyingi mission station is a landmark of western Zambia. (1993)

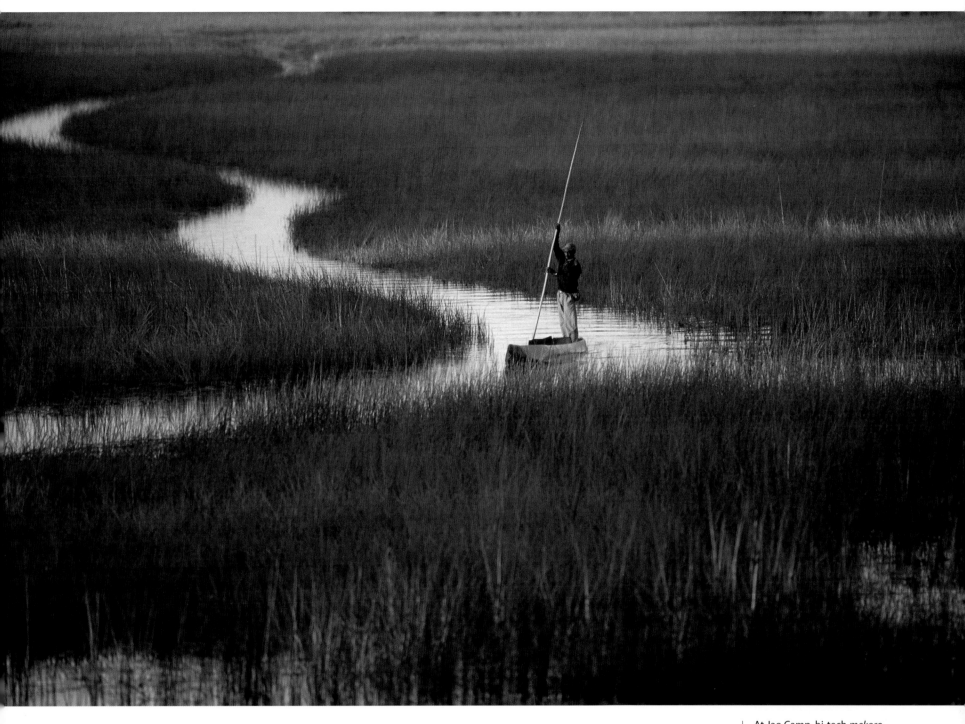

At Jao Camp, hi-tech *mekoro* made from plastic rather than hardwood help to save the fragile Okavango environment. (2000)

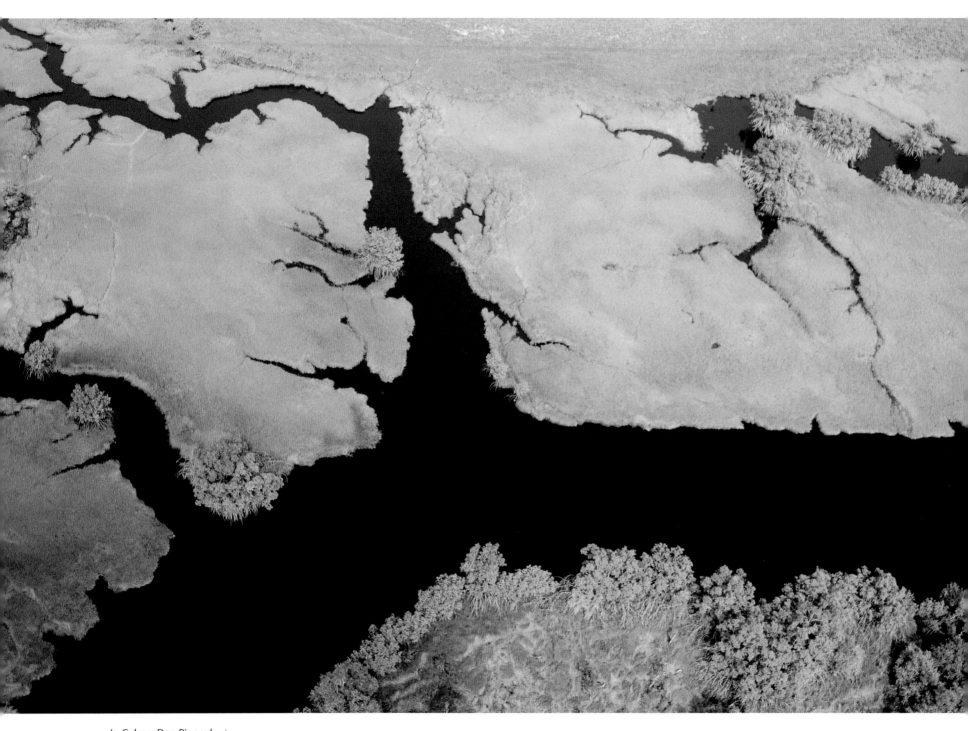

In Gabon, Don Pinnock boarded a Pilates bush-hopper to shoot the rain forests, mangroves and lagoons of Loango Park from the air. (2009)

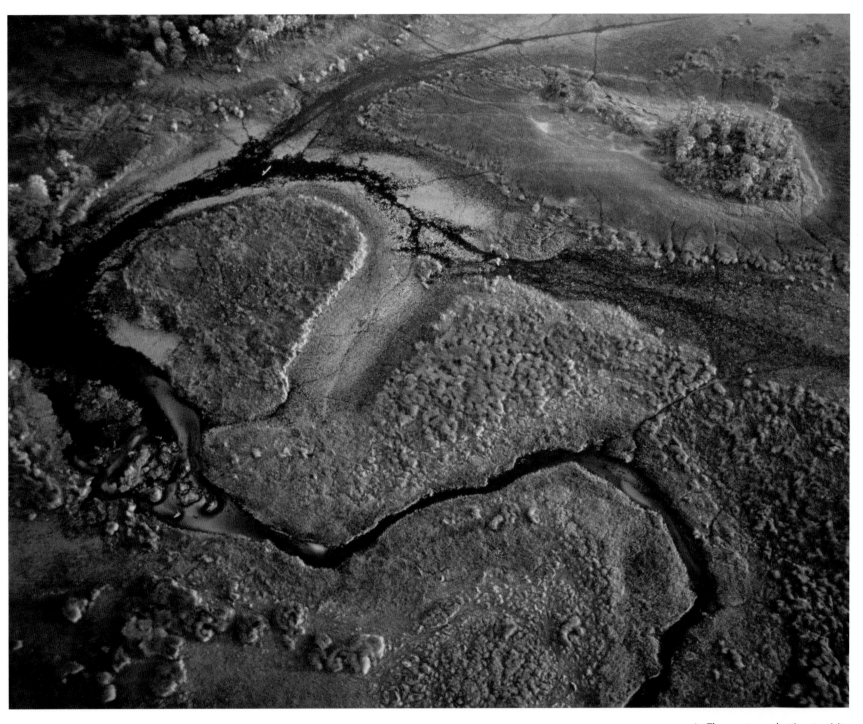

The most popular time to visit the Okavango is during winter when the flood waters from Angola stream into the maze of waterways and canals of the delta. But the summer or green season (when the water is low) is also an excellent time to go, since the colours of the landscape are vibrant and the migratory birds are in residence. (1992)

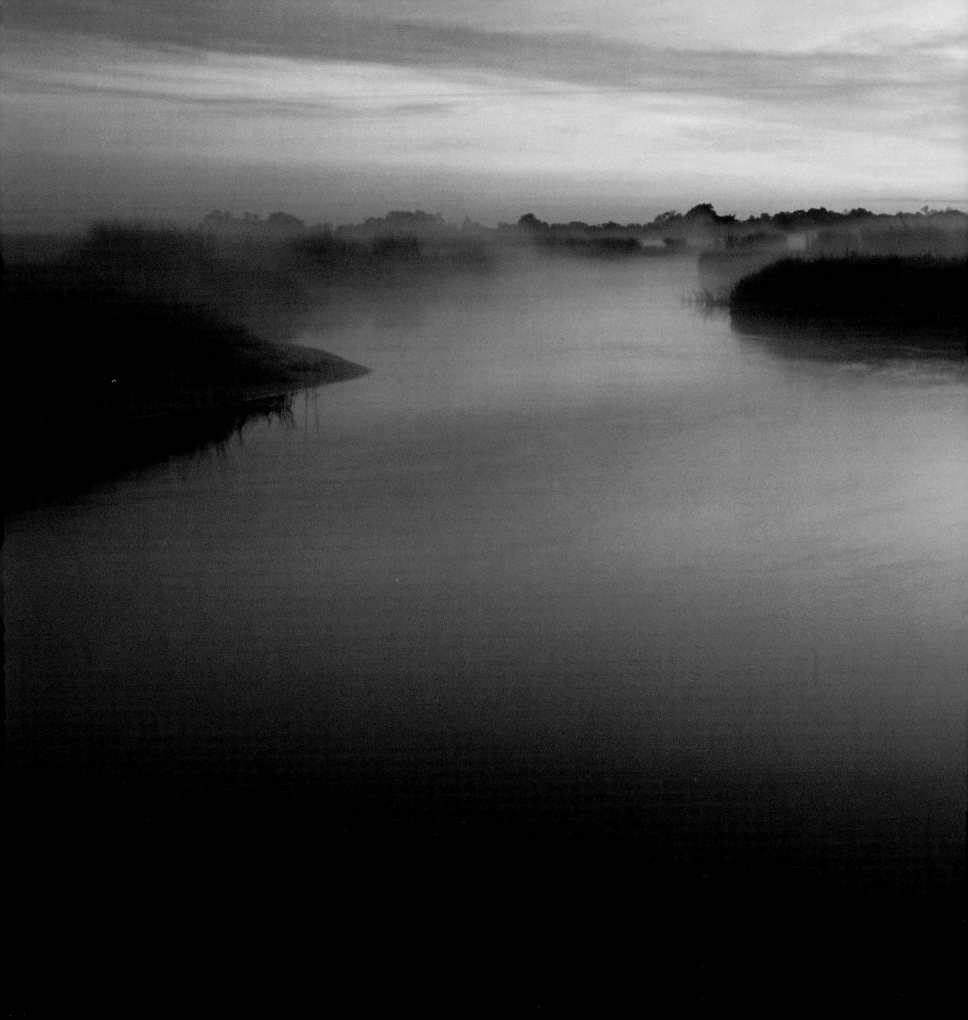

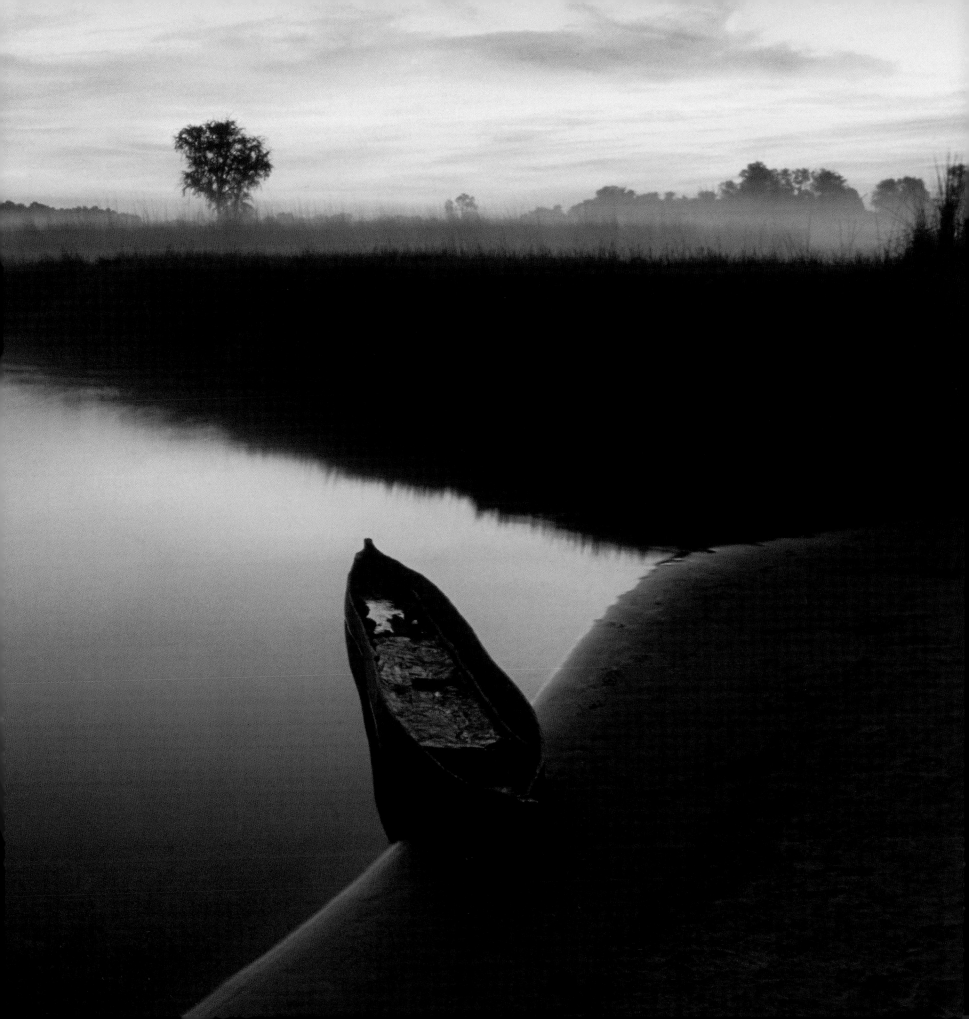

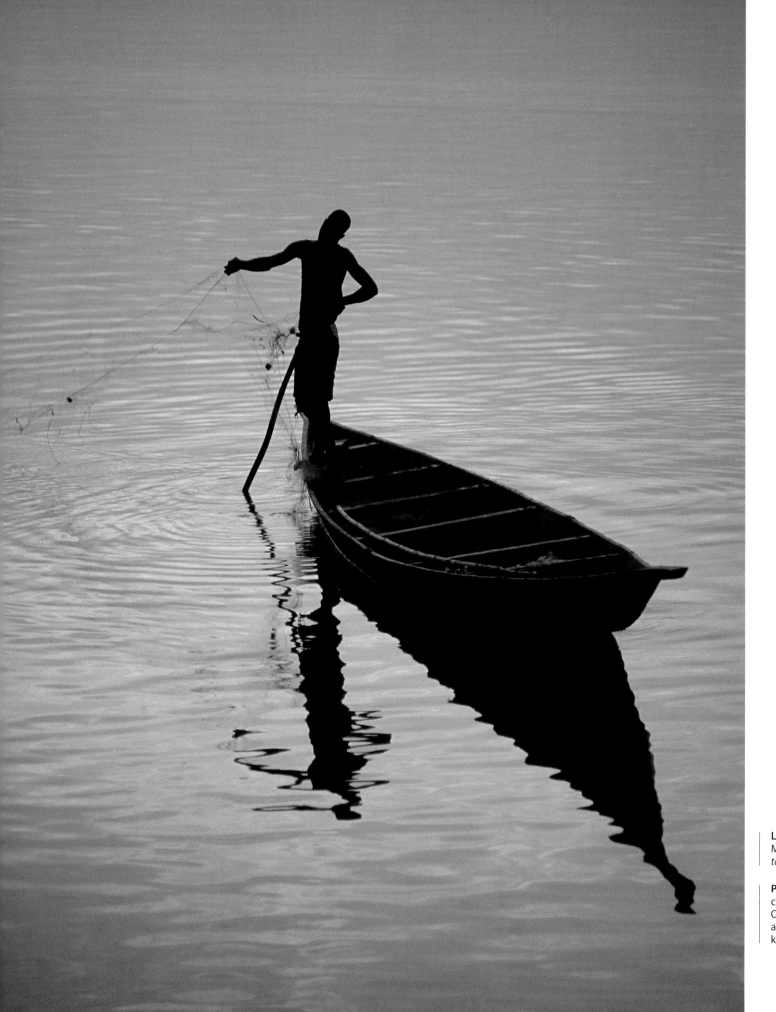

LEFT: A fisherman from Ségou, Mali, brings in his catch of *capitaine* (Nile perch). (2002)

PREVIOUS SPREAD: On a chilly winter morning in the Okavango, the Boro River and adjacent flood plains are blanketed in layers of mist. (1992)

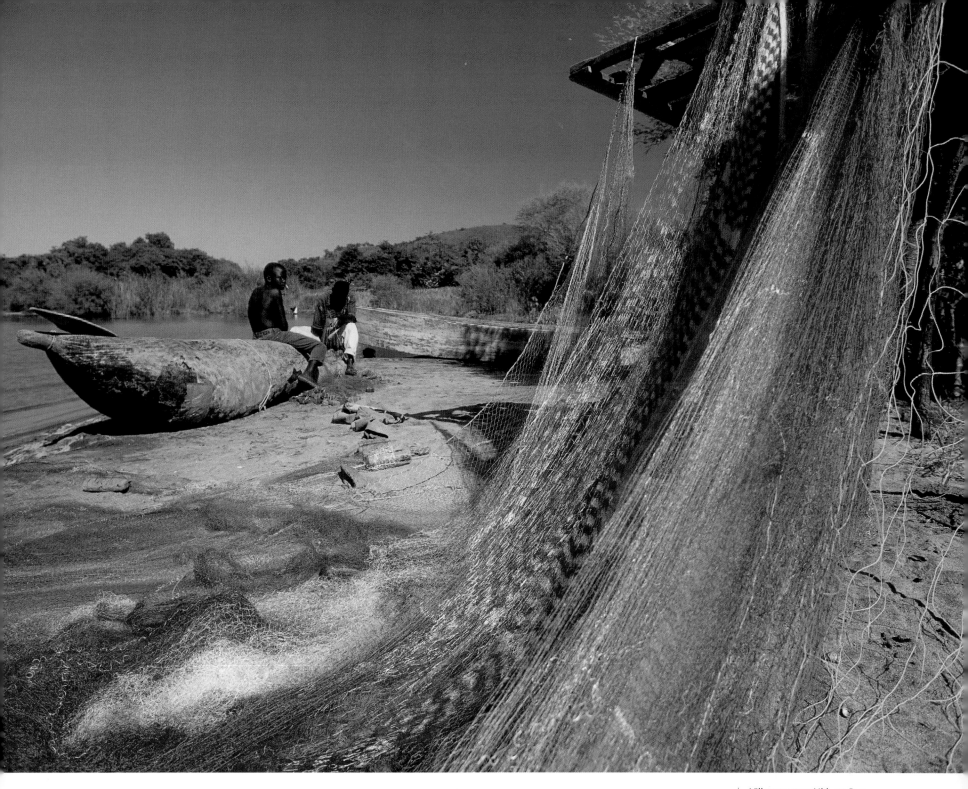

Villagers near Nkhata Bay, Malawi, mend their nets after a night of fishing from dugouts. (2007)

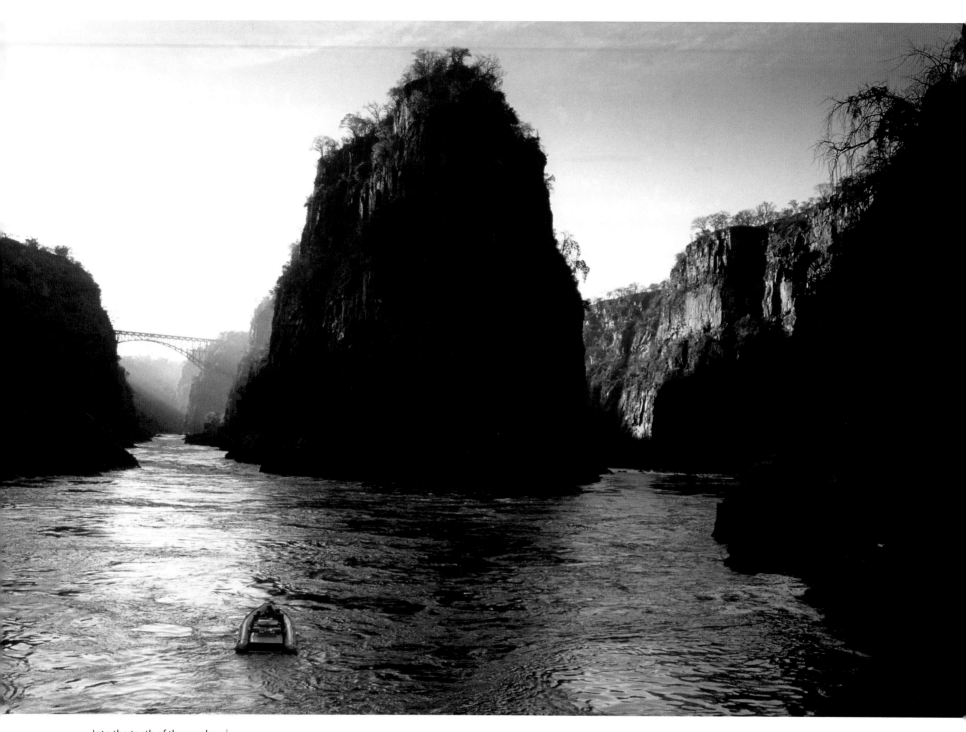

Into the teeth of the smoke that thunders, Victoria Falls. (2002)

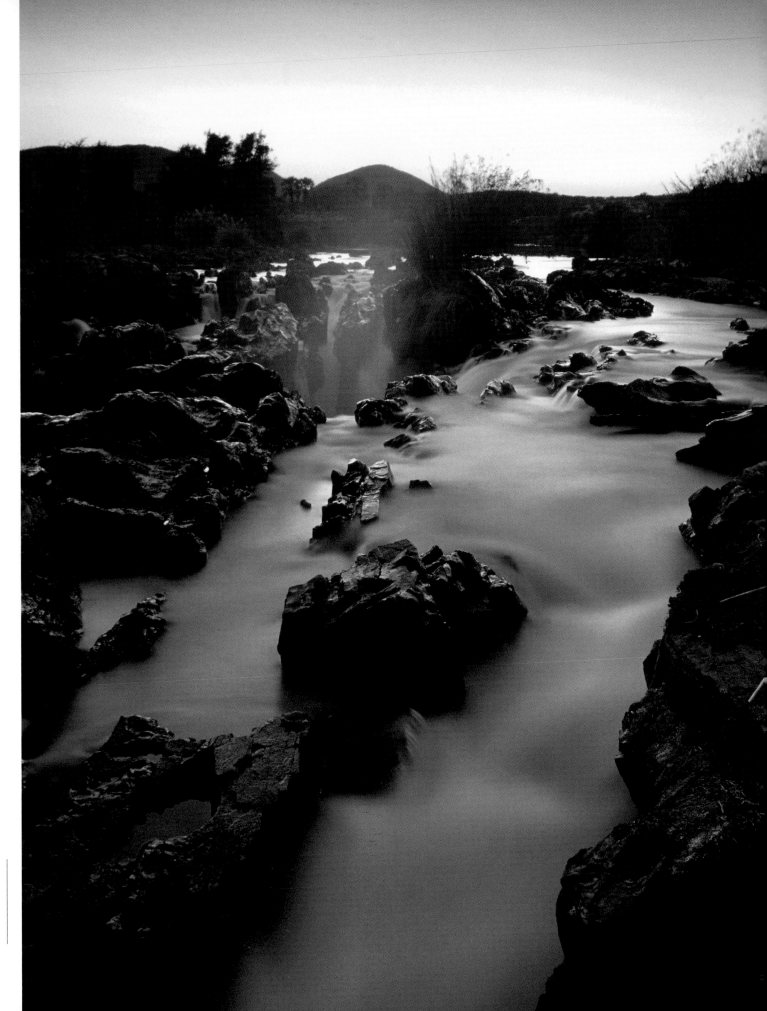

Epupa is a Herero word that describes the sound of falling water. This image shows the top of the falls during Kaokoland's characteristic golden glow, which appears about 30 minutes before sunrise. (1991)

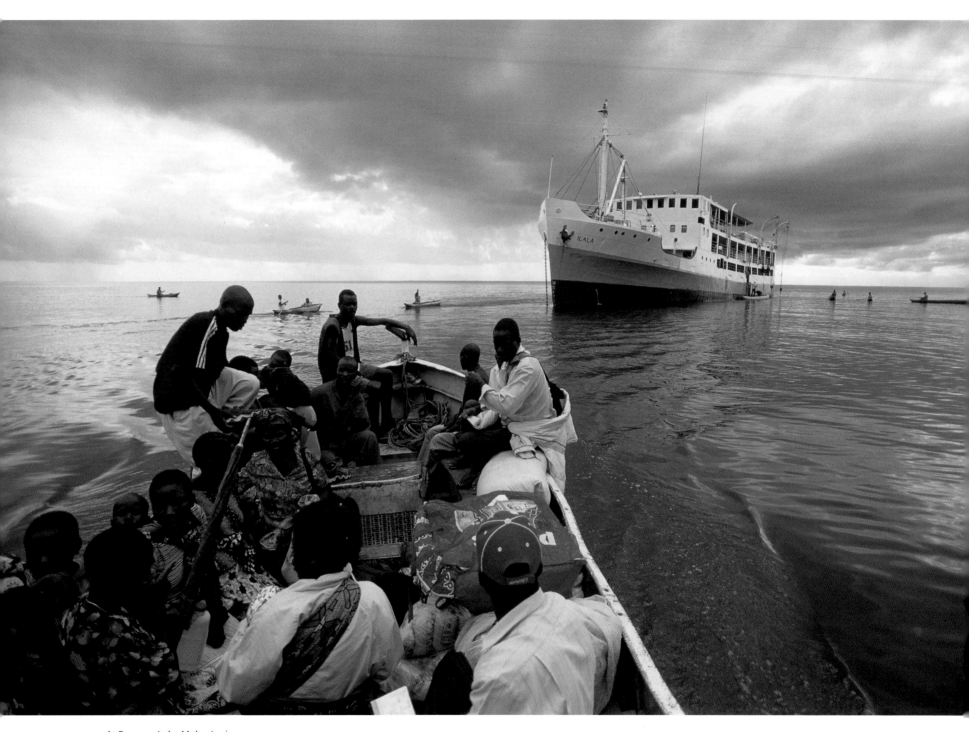

At Ruarwe, Lake Malawi, passengers from the MV *Ilala* are ferried ashore in old lifeboats while dugout canoes gather round the ship selling produce. (2007)

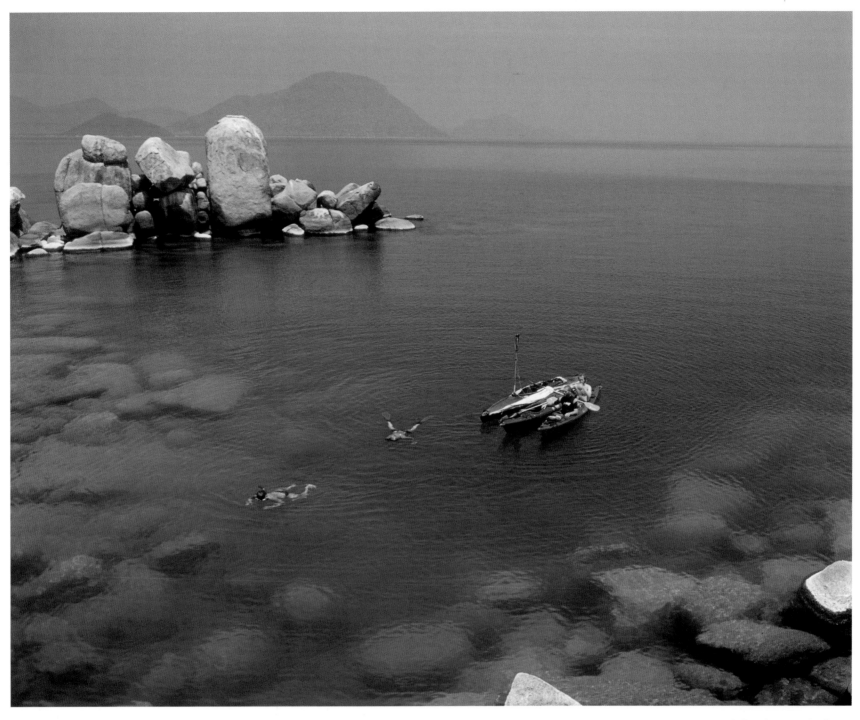

Snorkelling from Kayak Africa's camp on Mumbo Island in the Cape Maclear National Park, Malawi. (2002)

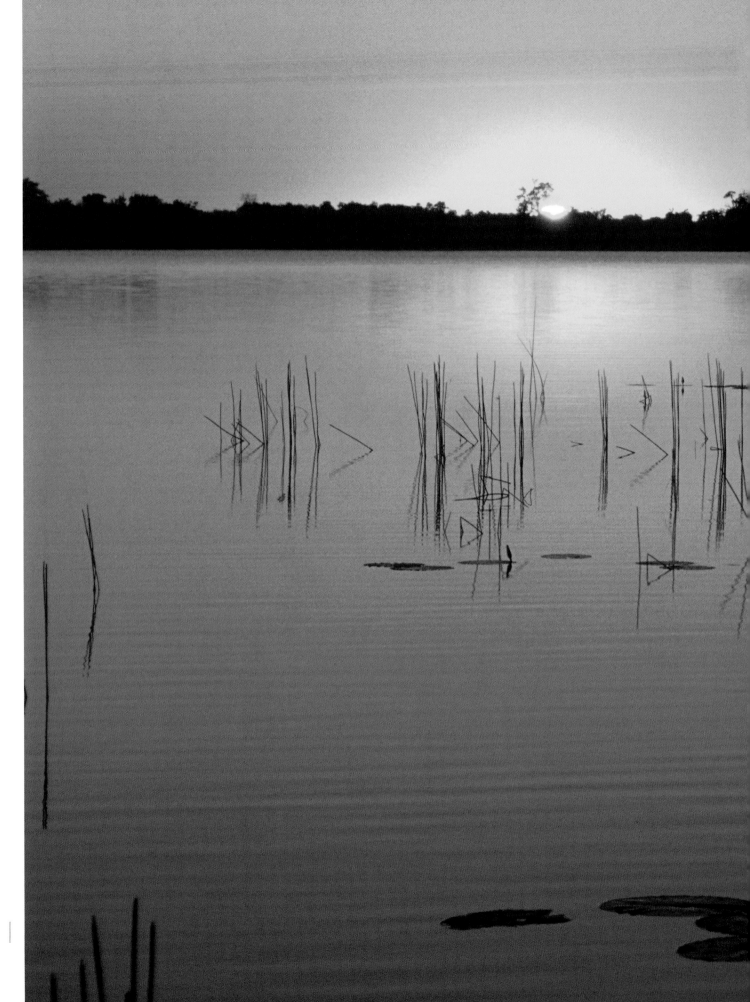

A *mokoro* glides for home in the Okavango Delta. (1995)

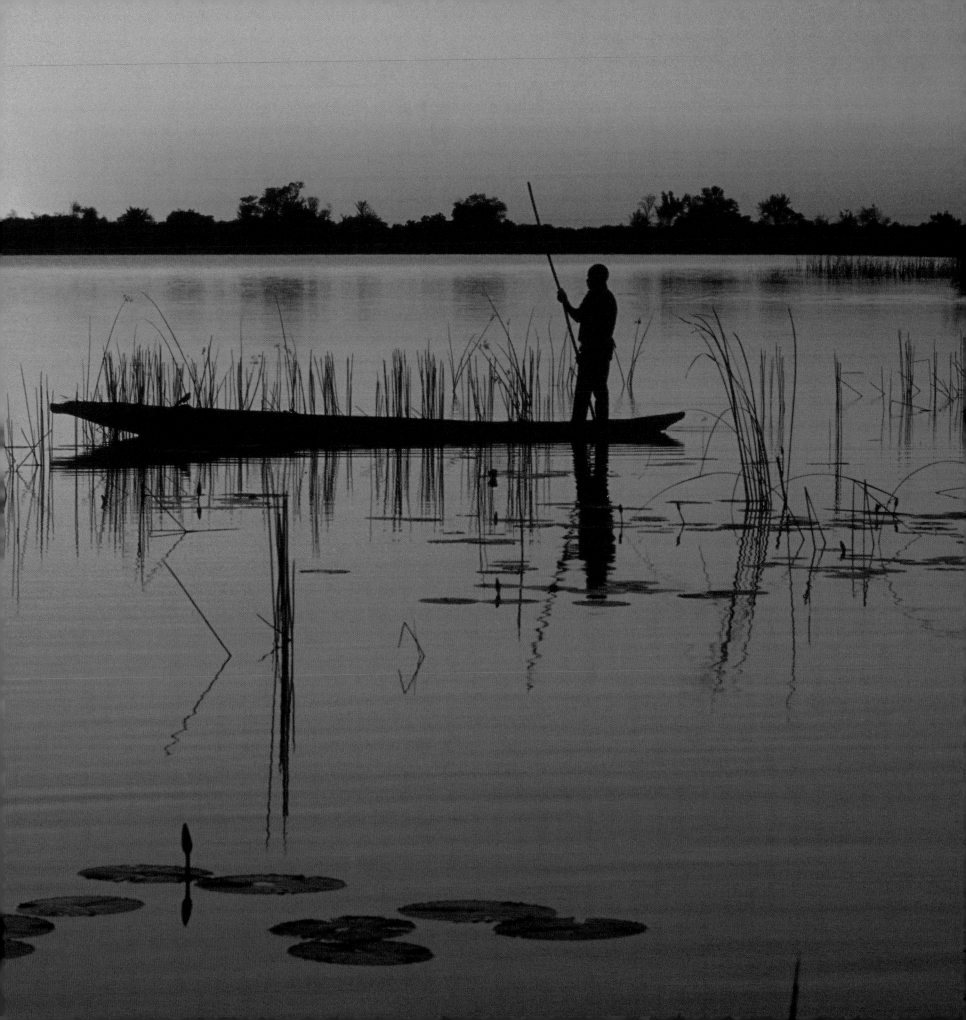

Oceans
and Isles

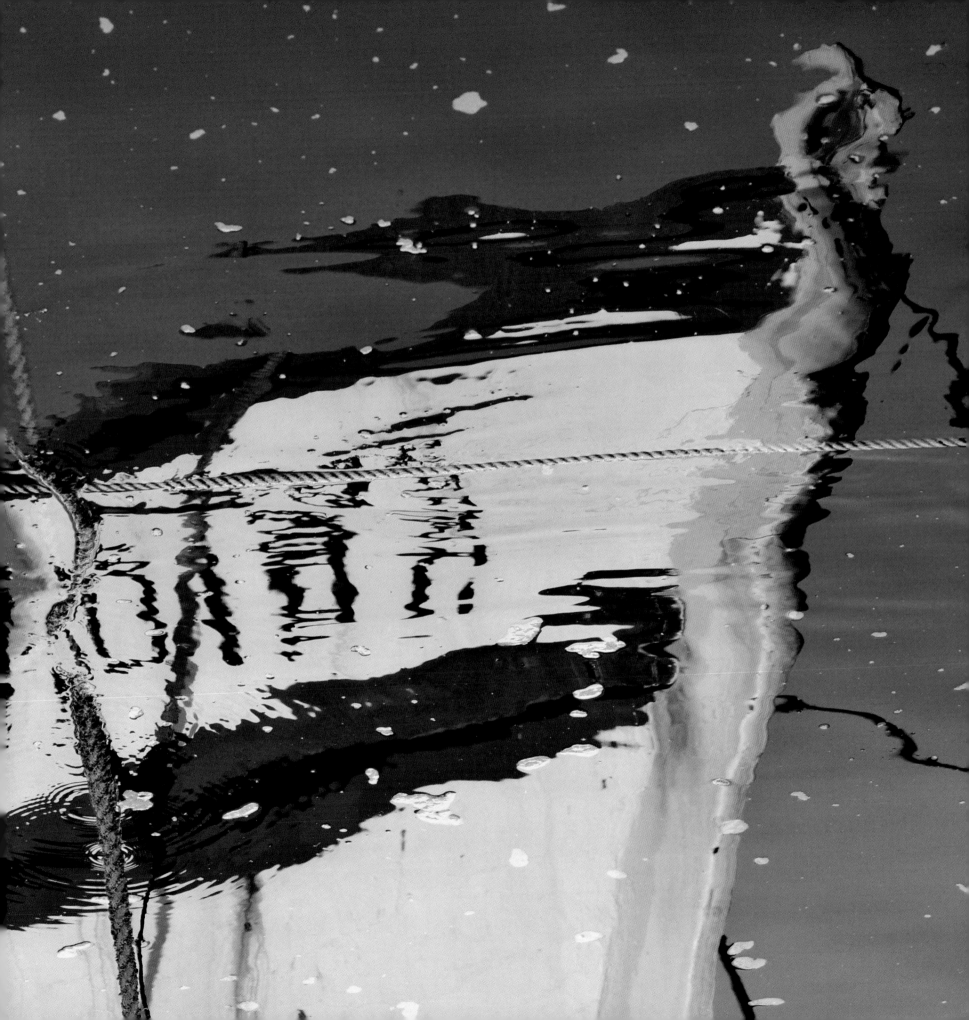

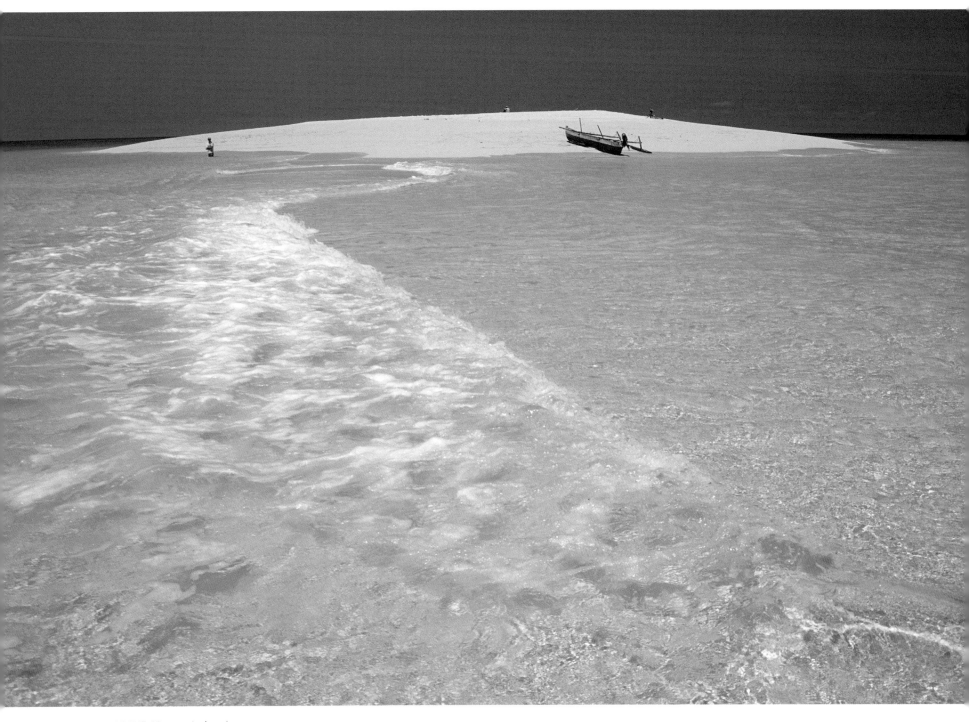

ABOVE: Mayotte is the only island in the Comoros Archipelago encircled by protecting coral. Dotting this partly broken reef are numerous sand banks, which make for pleasant day excursions on outrigger canoes. (1995)

PREVIOUS SPREAD: Fishing boat reflections in Kalk Bay harbour, Cape Peninsula. (2009)

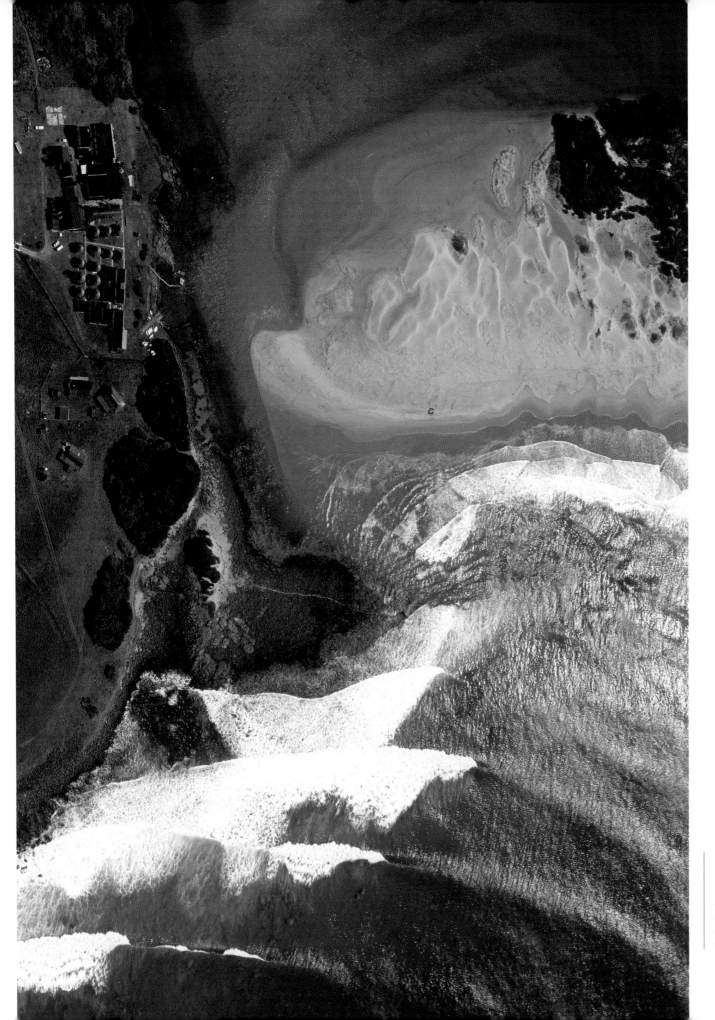

Laid millions of years ago during the breakup of Gondwanaland, the dolerite sill jutting into the ocean keeps the water table high, which is why Wavecrest on the Wild Coast has swamps and wetlands. (2000)

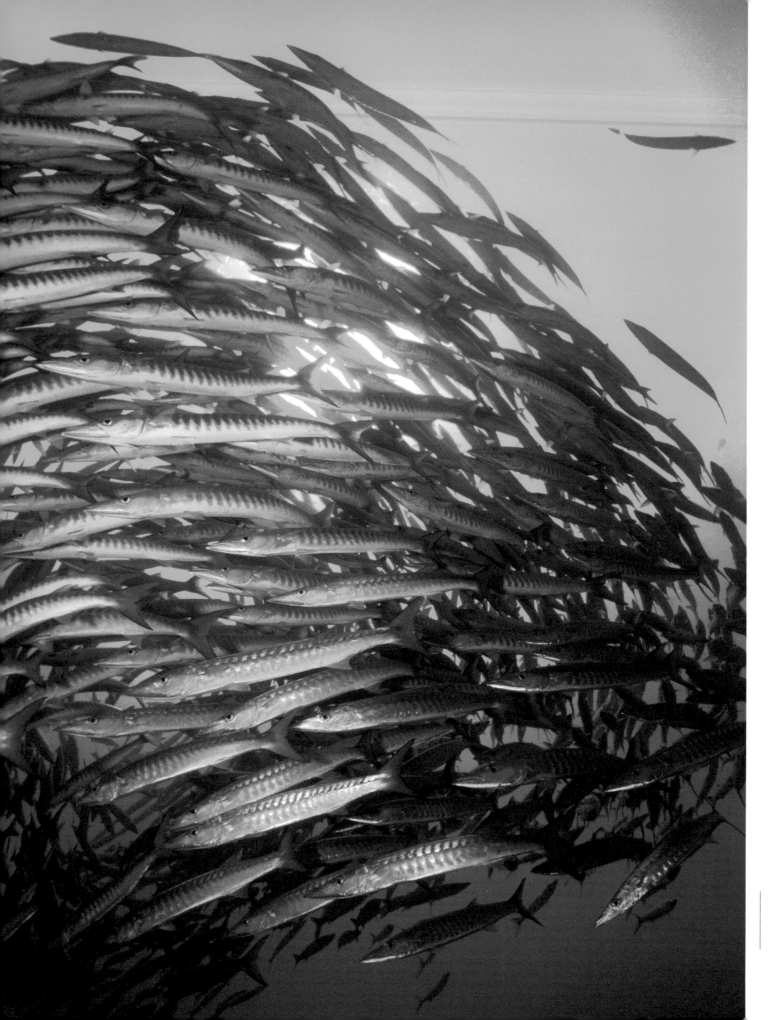

A highlight of diving Egypt's Ras Mohammed is the schools of barracuda that dart through the depths like flights of glittering arrows. (1995)

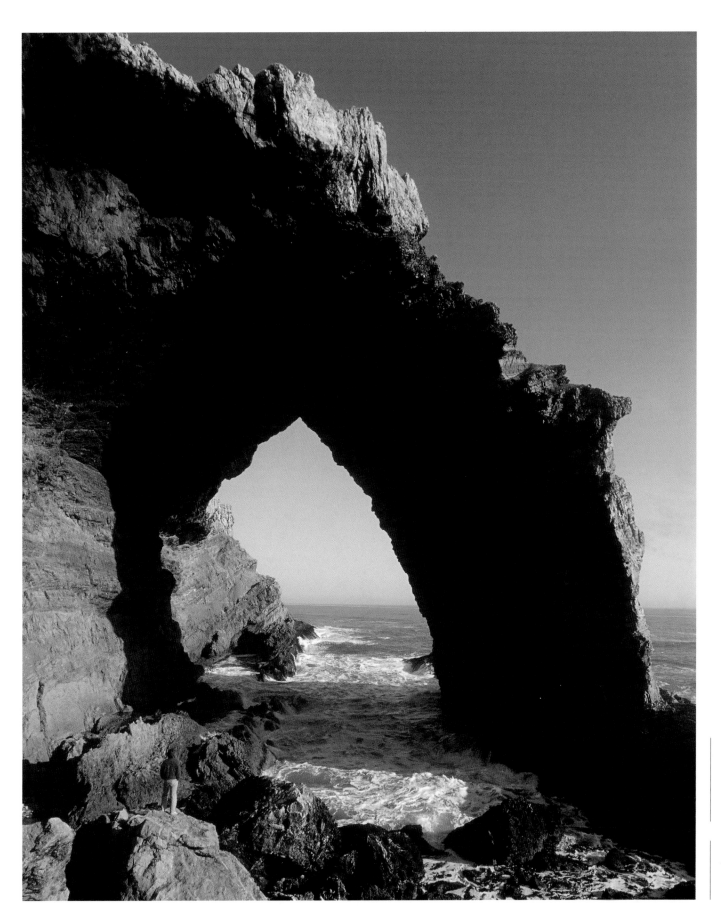

LEFT: Bogenfels ('rock arch' in German) is a coastal landmark 100 kilometres south of Lüderitz in Namibia. The 70-metre arch has been carved out of the black dolomite by wave erosion. (1994)

FOLLOWING SPREAD: Medjumbe Island in Mozambique's Quirimbas Archipelago has a short runway that stretches the length of the island. (2008)

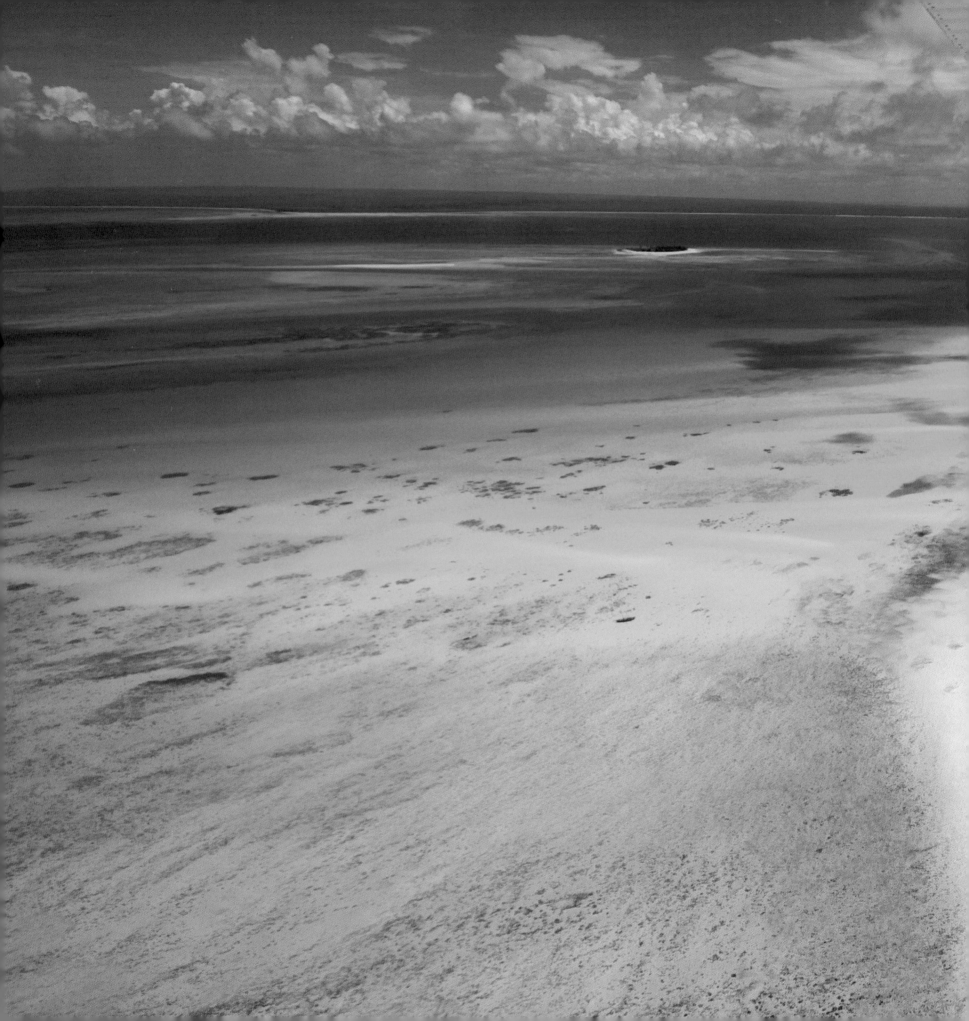

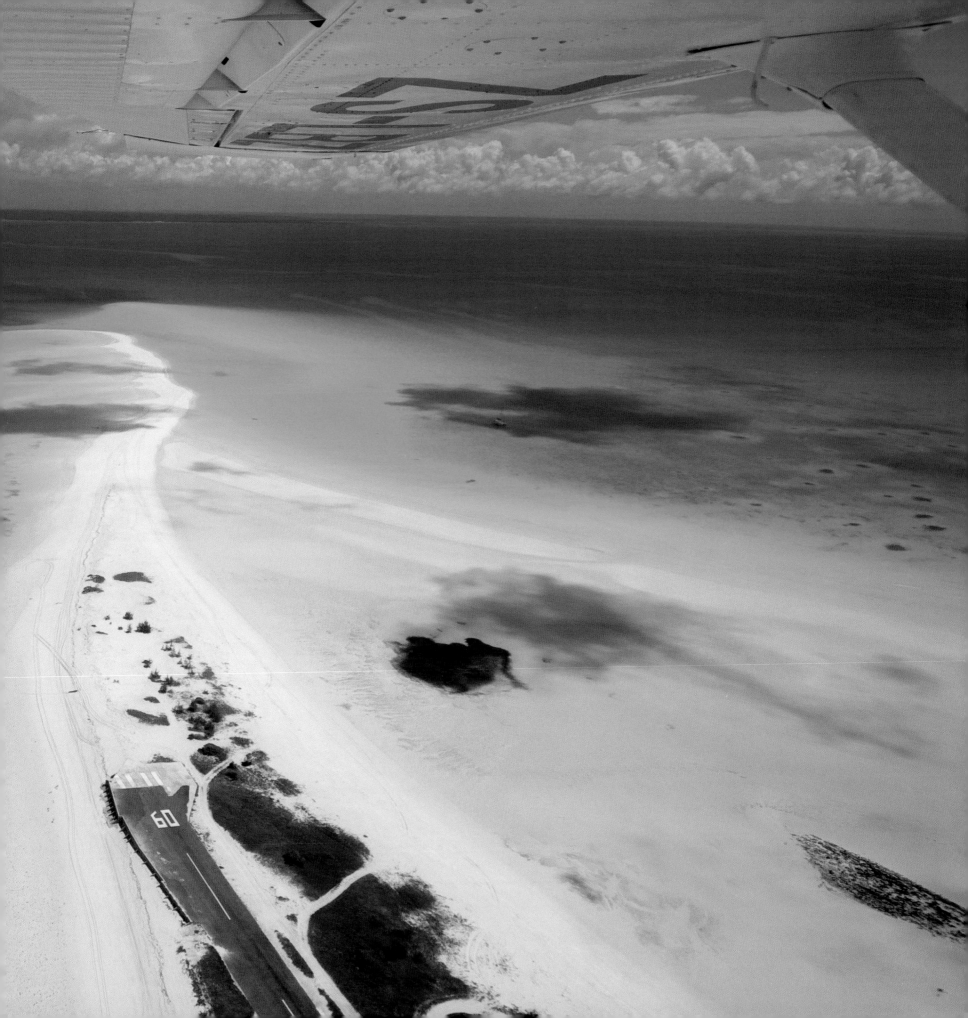

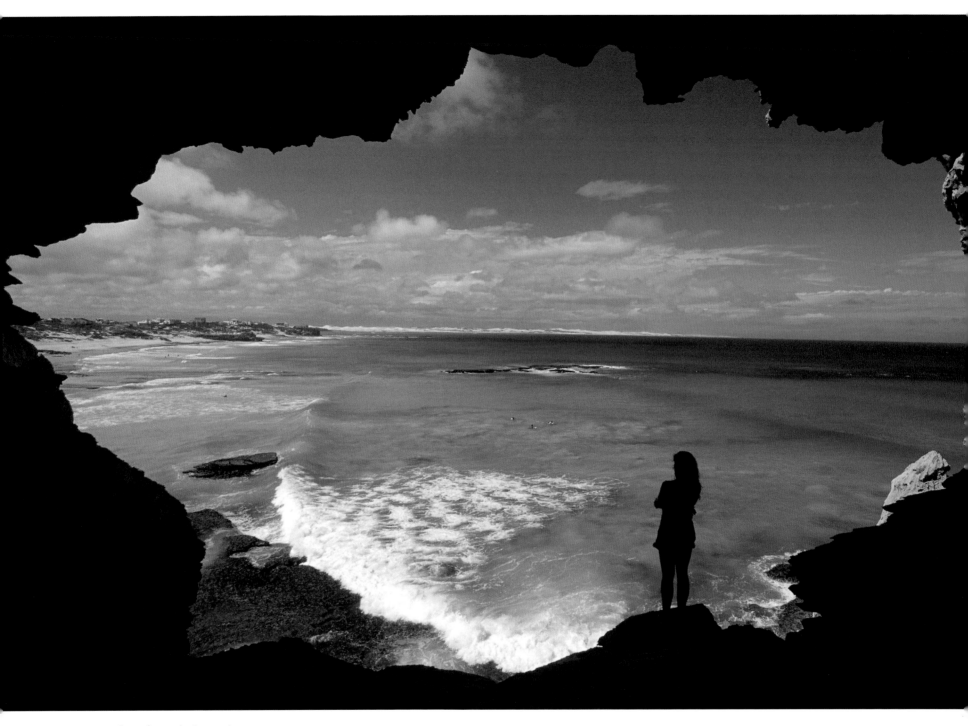

Coastal cave, Arniston,
southern Cape. (1997)

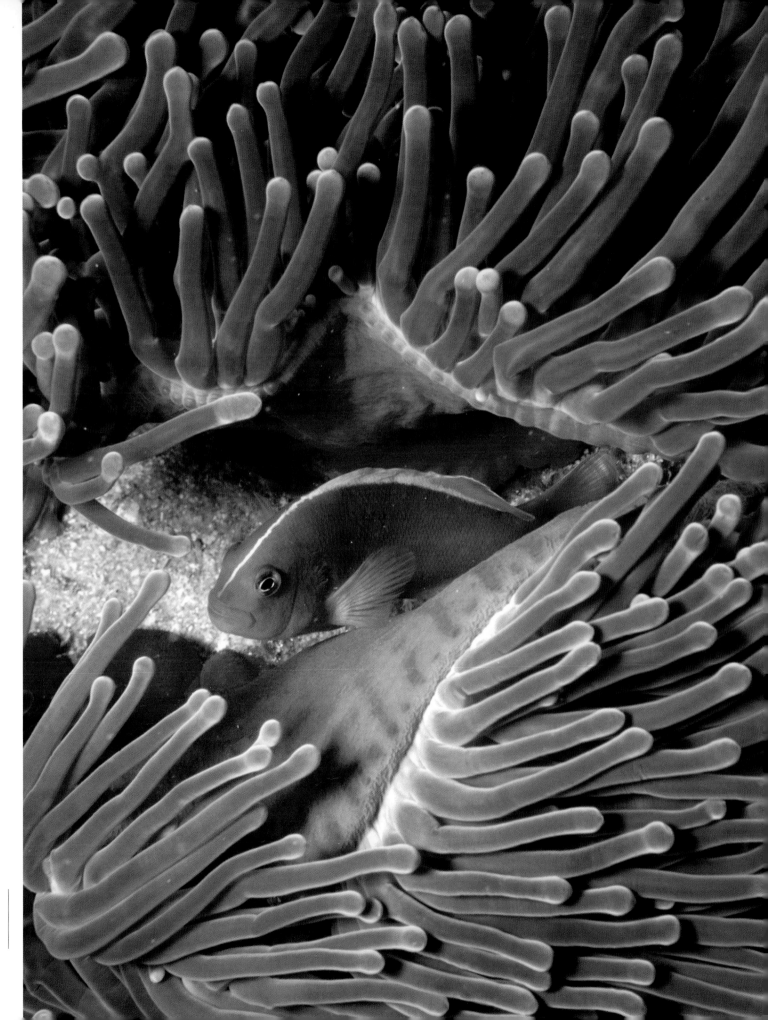

A nose-stripe clownfish, tucked away among the tentacles of an anemone, photographed during a diving trip to Mozambique. (1998)

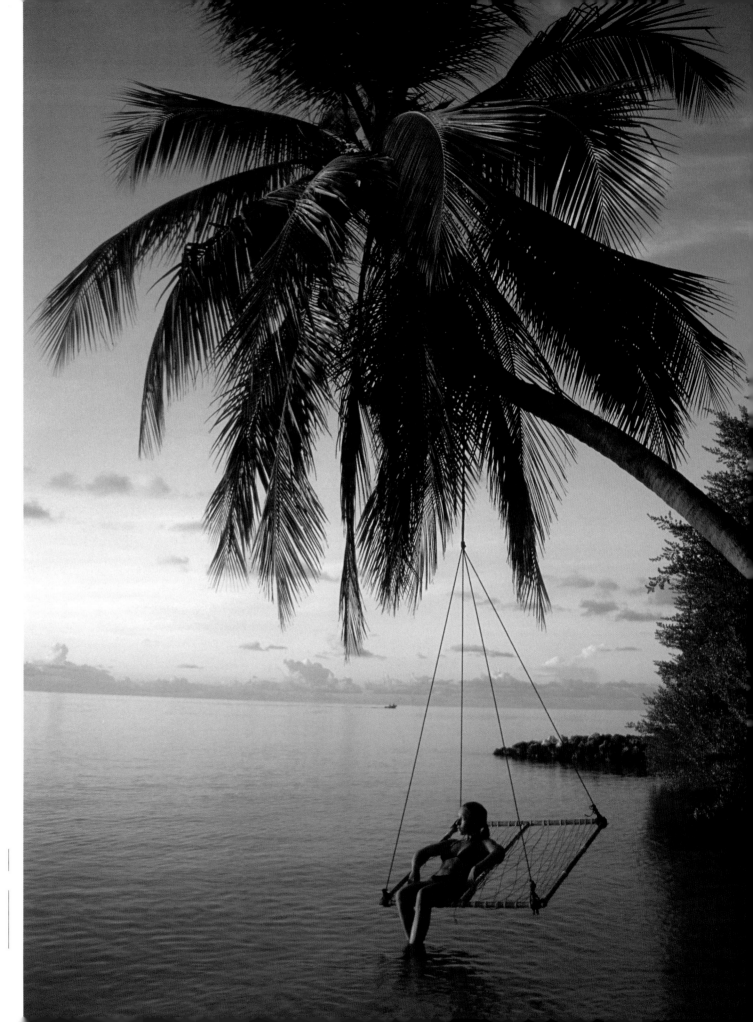

RIGHT: Sunset at Lohifushi in the Maldives. (1999)

OPPOSITE: Dhows are moored in the translucent shallows round Marlin Lodge in the Bazaruto Archipelago, Mozambique. (2000)

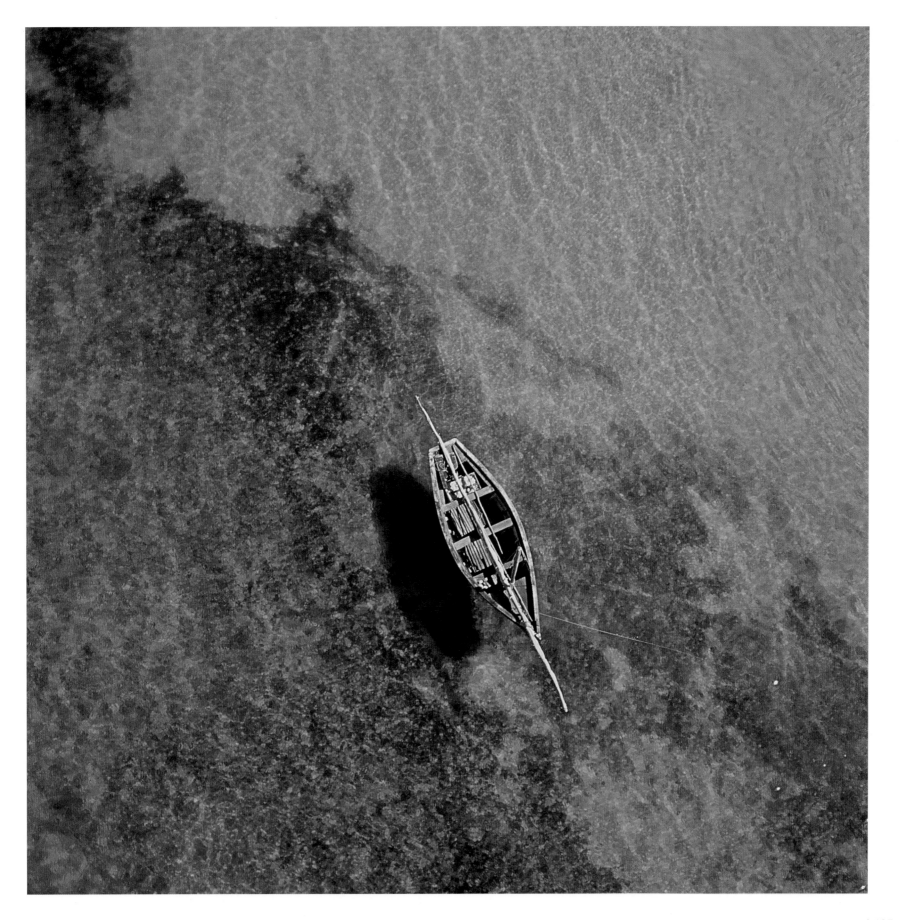

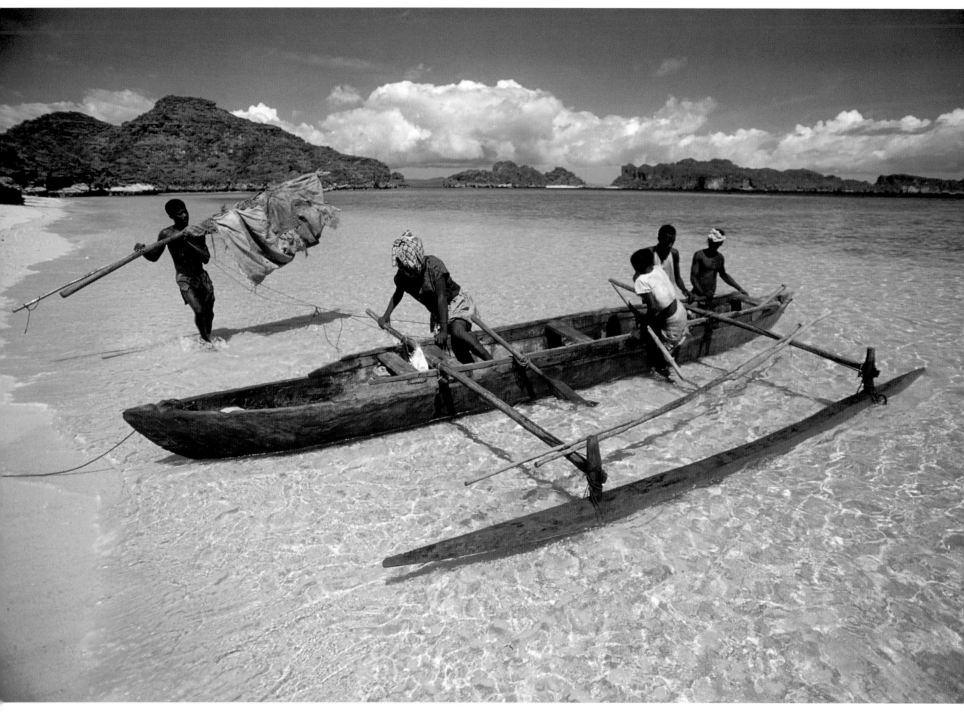

The crew of an outrigger canoe launch from the uninhabited Nosy Anjombavola in northern Madagascar. Their haul is mainly sea cucumbers from the nearby reefs, bound for the lucrative Far East market. (1994)

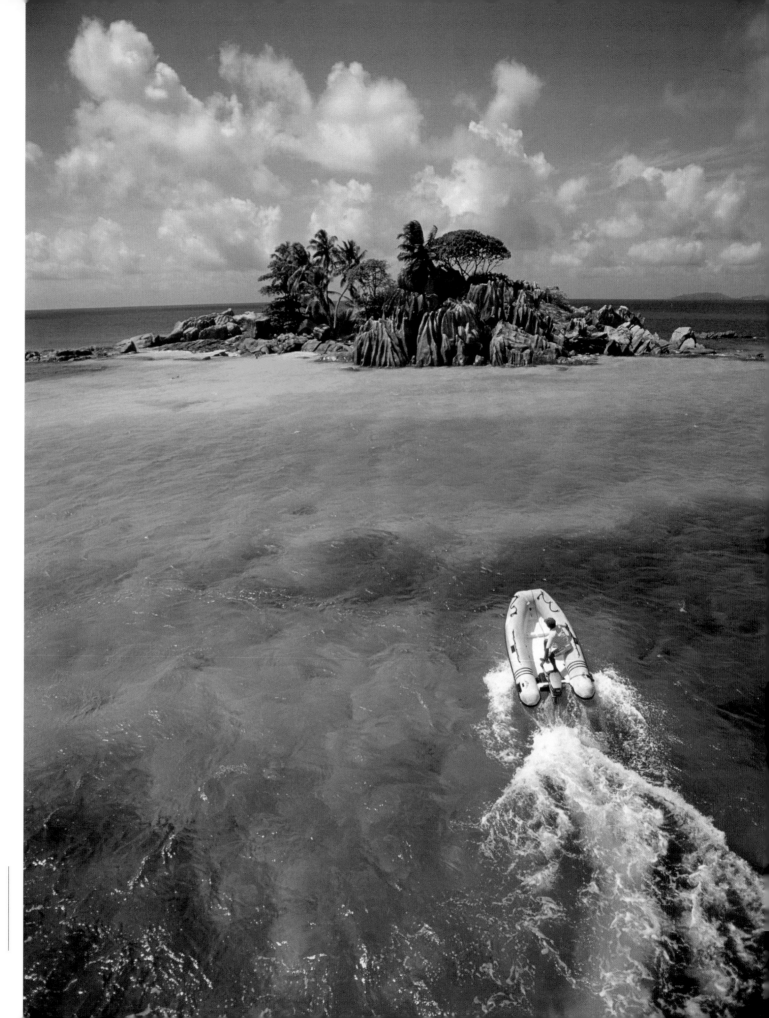

Approaching St Pierre Island, Seychelles, Patrick Wagner climbed into the fish-spotters' tower of the catamaran *Tam Tam*, from where he took this shot that became a best-selling *Getaway* cover. (1993)

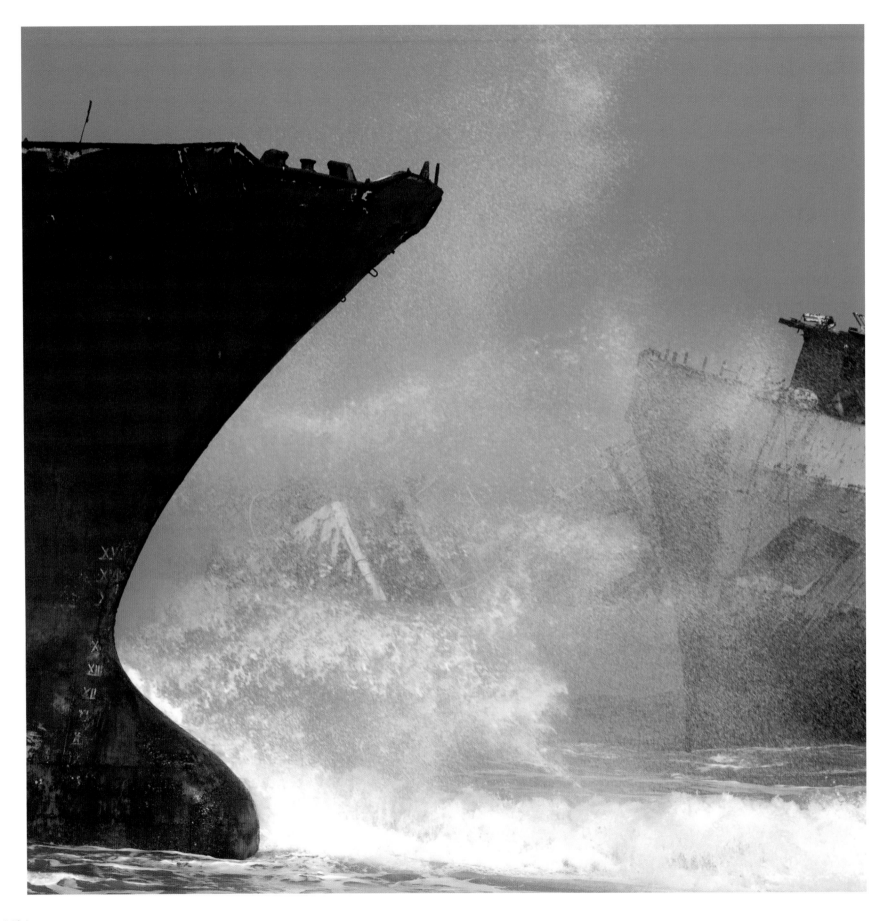

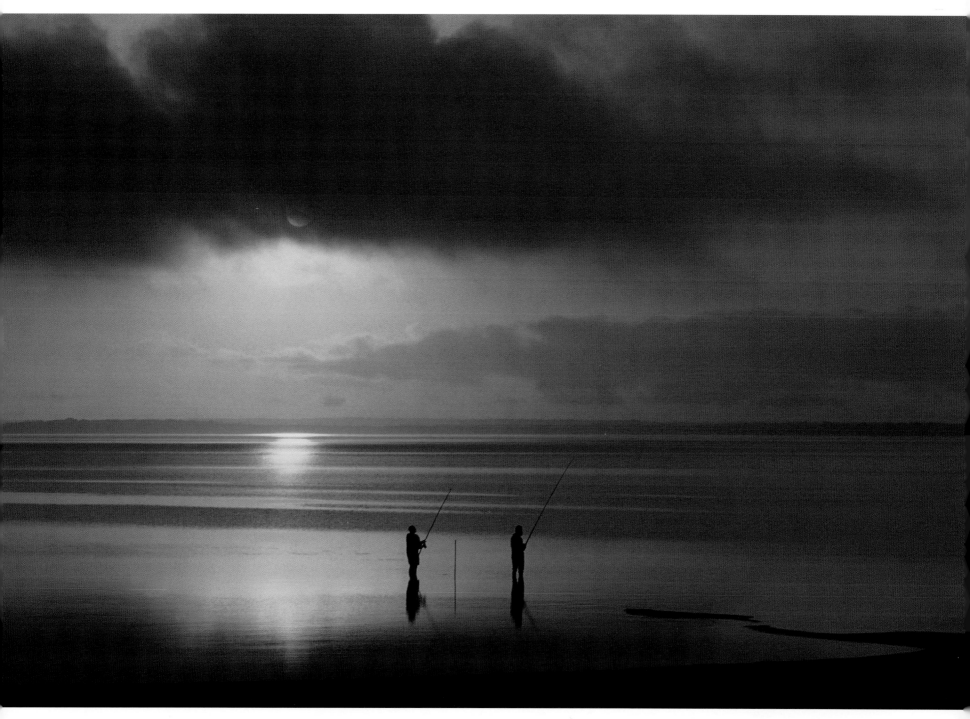

ABOVE: Two fishermen practise hunter-gathering at Lake Sibaya, KwaZulu-Natal. (2004)

OPPOSITE: Don Pinnock joined Kingsley Holgate on a trip around the outside edge of Africa for the leg from Namibia to the Democratic Republic of Congo. 'North of Luanda, there's a stretch of beach where more than 30 ships lie stranded,' said Don. (2007)

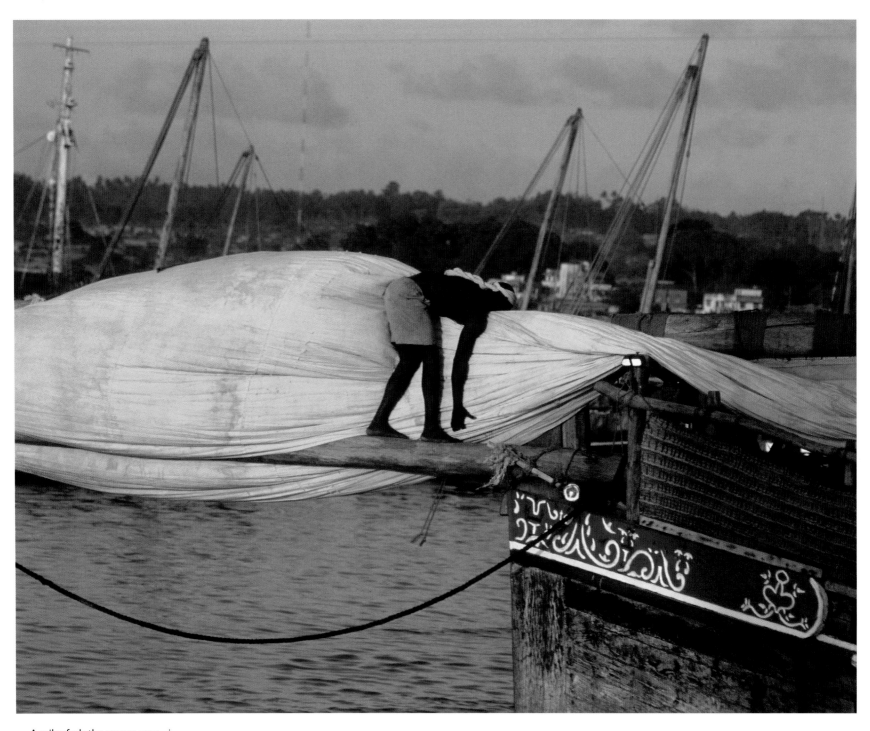

A sailor furls the canvas on a large trading dhow in Stone Town harbour, Zanzibar. (1999)

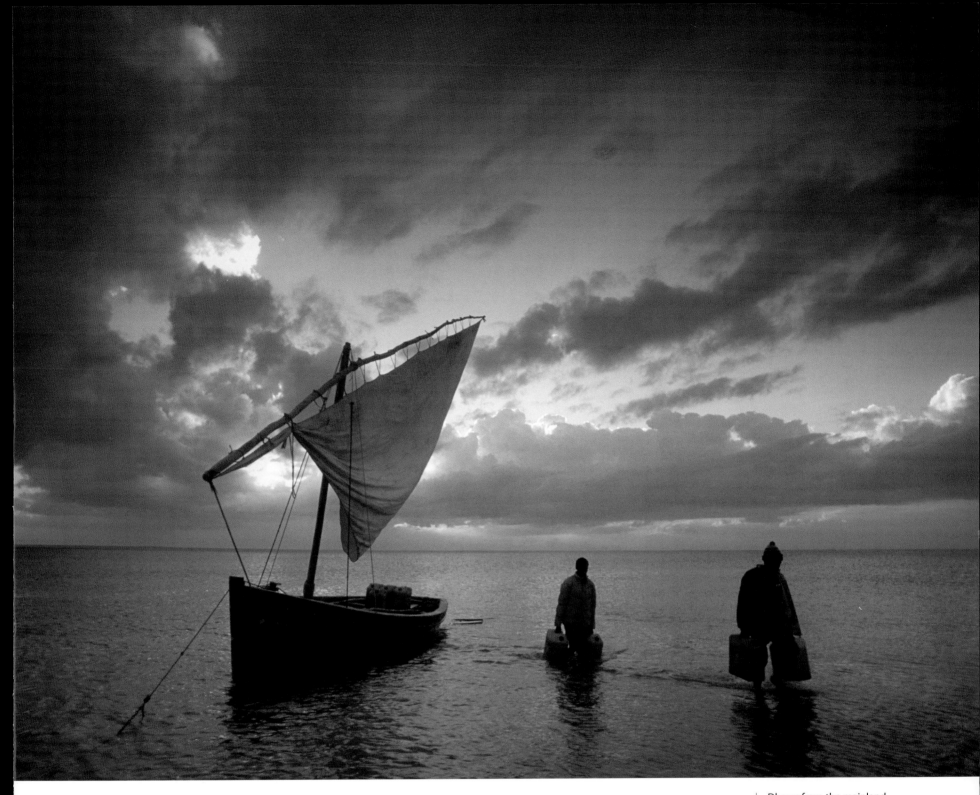

Dhows from the mainland deliver provisions to Benguerra Island, Mozambique. The dhow is the mule of the Western Indian Ocean and a link with this corner of Africa's romantic maritime past. (2000)

Acknowledgements

I'd like to thank all the members of the team who've contributed to the production of this book, from those who helped with the selection of images to those who've read and commented on the text and captions: Robyn Daly, Evan Haussmann, Rob House, Kirsty Pike, Keryn Rheeder, Sue Walker, Alison Westwood and Marion Whitehead. In particular, I'd like to thank Fatima Jakoet for her tireless efforts in tracking down many of these images and Sandra Hansen for an elegant design. Truida and Nigel Wagner were kind enough to let me trawl through the late Patrick Wagner's archive of images shot on *Getaway* assignments. My gratitude, also, to Jacqueline Lahoud and Don Pinnock (RamsayMedia), and Kerrie Barlow and Bridget Impey (Jacana), who are responsible for publishing this book. Lastly, I wish to thank the photographers whose professionalism and dedication to 'getting the shot' have resulted in this remarkable portfolio of work.

PHOTOGRAPHIC CREDITS

David Bristow: pages 20, 38, 104, 105, 124–125 | **Robyn Daly:** 36, 56, 62–63, 107, 109, 120, 129, 141 | **Cameron Ewart-Smith:** 32, 54, 96, 102 | **Justin Fox:** 10, 13, 18–19, 31, 39, 41, 51, 52–53, 58–59, 65, 69, 90, 95, 101, 112, 118, 119, 122, 132–133, 137, 143 | **Jazz Kuschke:** 46, 80–81, 86, 91 | **Cathy Lanz:** 40, 123 | **Don Pinnock:** cover, 11, 26–27, 32–33, 66–67, 76, 79, 82, 89, 97, 103, 114, 126–127, 140, 142 | **Scott Ramsay:** 72, 73 | **David Rogers:** 12, 15, 17, 22, 23, 28–29, 30, 43, 44, 77, 94, 113, 136 | **Gillian Scoble-Lilley:** title page | **David Steele:** 108 | **Patrick Wagner:** back cover, end-papers, contents page, 8–9, 14, 16, 21, 24, 25, 33, 34, 35, 37, 45, 48–49, 50, 55, 57, 60–61, 64, 68, 70–71, 74–75, 78, 83, 84–85, 87, 88, 92–93, 98–99, 106, 110–111, 115, 116–117, 121, 128, 130, 131, 134, 135, 138, 139 | **Alison Westwood:** 42, 47, 100.